Art and Sex

To the memory of my uncle, Adam Watson

Art and...

Contemporary art can be difficult. Reading about it doesn't need to be.
Books in the *Art and...* series do two things.

Firstly, they connect art back to the real stuff of life – from those
perennial issues like sex and death that trouble generation after
generation to those that concern today's world: the proliferation
of obscene imagery in the digital age; our daily bombardment by
advertising; dubious and disturbing scientific advances.

Secondly, *Art and...* provides accessible theme-based surveys which
energetically explore the best of contemporary art. *Art and...* avoids
rarefied discourse. In its place, it offers intelligent overviews of art –
and the subjects of art – that really matter.

Art and... Series List
Art and Advertising
Art and Death
Art and Laughter
Art and Obscenity
Art and Science
Art and Sex
Art and War

Art and Sex

Gray Watson

I.B. TAURIS
LONDON · NEW YORK

Published in 2008 by I.B.Tauris & Co. Ltd
6 Salem Road, London W2 4BU
175 Fifth Avenue, New York NY 10010
www.ibtauris.com

In the United States and Canada distributed by Palgrave Macmillan, a division
of St. Martin's Press
175 Fifth Avenue, New York NY 10010

ISBN: Pb 978 1 84511 665 1
 Hb 978 1 84511 664 4

A full CIP record for this book is available from the British Library
A full CIP record for this book is available from the Library of Congress

Library of Congress catalog card: available

Typeset in Rotis by Dexter Haven Associates Ltd, London
Printed and bound in the UK by T.J. International, Padstow, Cornwall.

Contents

Acknowledgements ix

List of Illustrations xi

Introduction 1

1. The Body 7

2. The Celebration of Female Sexuality 17

3. Divergent Sexualities 28

4. Intercourse 40

5. Sex, Money and Modernity 52

6. Sex and Nature 63

7. Sex and the Sacred 74

8. The Theatre of Cruelty 88

9. Stories of the Eye 101

10. Beauty and Beastliness 114

Afterword 127

Notes 131

Bibliography 143

Index 149

Acknowledgements

I owe an immense debt of gratitude to Lucy Bradnock, without whose assistance this book would probably never have been completed. Her competence and helpfulness have been invaluable. I would like to thank Chris Townsend for originally suggesting the book; Adrien Sina for some stimulating ideas early on in the writing process; Sarah Wilson of the Courtauld Institute of Art for some useful contacts, including Lucy and Adrien; and Paul Holberton and Karen Knorr for reading through the penultimate draft. I would also like to thank Stella Mutuma for her emotional and logistical support; and my close friends and family, especially my father, Basil Watson, for their support and encouragement. My thanks are due to Wimbledon College of Art in the University of the Arts London for allowing me the time and space for research. Finally, I would like to express thanks to all those artists mentioned in the book who have given their time to help me achieve a better understanding of their work.

List of Illustrations

1. Louise Bourgeois, *Fillette (Sweeter Version)*, 1968–99, latex over plaster, 23 x 10 x 7 inches, 59.6 x 26.6 x 19.6 cm, Hauser & Wirth Collection, Switzerland. Photo: Christopher Burke. 11

2. Helen Chadwick, *Piss Flower #1*, 1991–92, bronze, cellulose lacquer, first of 12 parts, each approximately 70 x 65 x 65 cm. © Helen Chadwick Estate. Courtesy Leeds Museums & Galleries (Henry Moore Institute Archive) and the Helen Chadwick Estate. 15

3. Carolee Schneemann, *Interior Scroll*, 1975, performance photograph. Photograph: Anthony McCall. Courtesy the artist and Anthony McCall. 20

4. Annie Sprinkle, *Sluts and Goddesses Workshop*, 1992. Courtesy the artist. 22

5. Ron Athey, *Solar Anus*, Hayward Gallery, London, 2006. Photo: Regis Hertrich. Courtesy the artist and Regis Hertrich. 32

6. Isaac Julien & Sunil Gupta, *Looking for Langston: Nudes With a Twist 1953*, 1989. © Isaac Julien & Sunil Gupta. Courtesy the artists. 33

7. Del LaGrace Volcano, *Tongue in Cheek*, London 1992, black and white fibre-based print, 50 x 60 cm. Courtesy the artist 38

8. Carolee Schneemann, *Fuses*, 1964–67, film still from self-shot 16 mm film. Photograph: Carolee Schneemann. Courtesy the artist. 41

9. Dorothy Iannone, *I Begin to Feel Free*, 1970, acrylic and collage on
canvas, 190 x 150 cm. Courtesy Galerie Steinek. 42

10. Jeff Koons, *Manet*, 1991, silkscreen on canvas, 60 x 90 inches,
152.4 x 228.6 cm. © Jeff Koons. 43

11. Marina Abramović and Ulay, *Rest/Energy*, 1980, performance.
© DACS 2007. 46

12. Nobuyoshi Araki, *Untitled* from *Tokyo Lucky Hole*, 1997. © Nobuyoshi
Araki, Tokyo. Courtesy Galerie Bob van Orsouw, Zurich. 53

13. Cosey Fanni Tutti, *'Journal of Sex' Magazine Action*, 1978.
Photograph: Szabo. Courtesy the artist. 54

14. Thomas Ruff, *ma 27*, 2001, Laserchrome and diasec, 44.09 x 55.12
inches 112 x 140 cm, edition of 5. © DACS 2007. Courtesy David
Zwirner, New York. 61

15. Ana Mendieta, *Imagen de Yagul*, 1973, lifetime colour photograph. ©
The Estate of Ana Mendieta Collection. Courtesy Galerie Lelong, New York. 65

16. Paul McCarthy, *The Garden*, 1991–92, wood, fibreglass, steel, electric
motors, latex rubber, foam rubber, wigs, clothing, artificial turf, leaves,
pine needles, rocks and trees. Photo: Tom Powel Imaging. Courtesy
Deitch Projects. 69

17. Rebecca Horn, *Feathered Prison Fan* from *Der Eintänzer*, 1978.
© DACS 2007 72

18. Francesco Clemente, *Geometrical Lust*, 1985, 35 x 51 inches,
90.17 x 129.5 cm. © Francesco Clemente. Courtesy Gagosian Gallery. 75

19. Hermann Nitsch, *107. Aktion*, 30 June and 1 July 2001, Schloss
Prinzendorf, Austria. Photo: Achim Lengerer. © Hermann Nitsch. 80

20. Maria Klonaris and Katerina Thomadaki, photograph from the series
Angélophanies (The Angel Cycle), 1987–88. © Maria Klonaris and
Katerina Thomadaki. Licensed by DACS 2007. 83

21. Rachel Rosenthal, *Performance and the Masochist Tradition*, 1981. 91
Photo: Mary Collins. © Rachel Rosenthal. Courtesy the artist.

22. Roberta Graham, *Whether the Storm?*, 1982, lightbox, box
dimensions: 2 x 2 x 1 inches, 61 x 61 x 30.5 cm. © the artist.
Courtesy the artist. 97

23. Gilbert & George, *Cunt*, 1977, 241 x 201 cm. © the artist. Courtesy
Jay Jopling/White Cube (London). 99

24. Merry Alpern, *Untitled #2*, from *Dirty Windows Series*, 1994.
© Merry Alpern. Courtesy Bonni Benrubi Gallery, New York 105

25. Marlene Dumas, *Stripper*, 1999, oil on canvas, 50 x 60 cm. Courtesy
the artist and Frith Street Gallery, London 108

26. Jemima Stehli, from *Flirt*, 1999, 12 Polaroid photographs, 43 x 52.5 cm
overall. Courtesy the artist and Lisson Gallery, London 109

27. Marc Quinn, *Another Kiss*, 2006, marble, 39 3/8 x 25 3/16 x 26 3/4
inches, 100 x 64 x 68 cm. Photo: Todd-White Art Photography. Courtesy
Jay Jopling/White Cube (London) 118

28. Hannah Wilke, *S.O.S. - Starification Object Series*, 1974, performalist
self-portrait with Les Wollam. © DACS, London/VAGA, New York
2007. Courtesy Ronald Feldman Fine Arts, New York. 122

29. Franko B, *I Miss You*, Brussels 2005, performance. Photo: Hugo
Glendinning. © the artist and Hugo Glendinning. 124

Introduction

This is a book about how recent art has dealt with sex. It is about sex as the content of artworks; not about the sexual exploits of artists or the supposed sexiness of the art world – except in so far as these factors may directly inform the art itself. It primarily focuses on Western art, that is art produced in Europe and North America, but by no means exclusively so. In particular, it acknowledges the vast contribution made in this field by art from East Asia. By 'recent' art I mean predominantly art of the last forty years or so, though there is no definite starting date. In some cases – I am thinking of artists like Hans Bellmer and Pierre Molinier – work made earlier than that was so ahead of its time that it seems to belong naturally with later work. During the 1960s, at least in the West and at least in 'advanced' art circles, the whole notion of what constituted art underwent a profound change. There are therefore good reasons for starting any book on recent art from around that time, but in the case of art about sex it makes especially good sense. For it was also at that time that a massive acceleration took place in the extent to which sex was discussed and sexual images were produced; and art has been very much part of that trend.

One of the main developments – again, at least in the West – which came out of the innovative ferment of the 1960s and began to take root in the following decade was an improvement in the social position of women, and it is no coincidence that feminism was among the most prominent forms of subject matter in 1970s art. Meanwhile the massive widening of the definition of what constituted art made it possible to explore these and other issues in especially provocative and productive ways, and this has continued. Since then, art has no longer been defined primarily in terms of its physical form or medium but of the context in which it is presented; even this has increasingly been blurred, as the border between high art and more popular and commercial forms has become ever more permeable.

In the case of art about sex, there is inevitably a relationship with commercial pornography. In this book I shall not seek to establish a barrier between art and pornography – nor shall I

designate the 'erotic' as somehow acceptable and the 'pornographic' not – but shall rather propose the model of a spectrum, between the relatively basic and aesthetically unaware, at one pole, and the most aesthetically and intellectually sophisticated, at the other.[1] There is a considerable difference of function, for example, between an estate agent's photographs of a house and Turner's Petworth interiors or Mondrian's architectonic compositions; yet all are to do, in their different ways, with buildings and architecture, and the lack of aesthetic ambition in no way renders the estate agent's photographs invalid. Nor shall I adopt a Kantian criterion of indifference: it is reasonable enough that art of the highest quality should arouse emotions relevant to its subject matter; and if in this case one of those emotions is lust, that seems highly appropriate. There is also a case for saying that high art has much to gain from sometimes taking on board the directness and simplicity characterising the more 'basic' end of the spectrum. Nevertheless, this book will concentrate on work towards the more 'sophisticated' end, especially on art in the sense of what is presented in the context of the art world. This can be in many different media, so I shall attempt to engage with all of these; but since some of these media, such as photography and performance, are also central to milieux outside the art world, I shall also at least touch on these other milieux to the extent that they share art's aesthetic and intellectual ambitions.

Paradoxically, one of the ambitions that has frequently haunted recent art arises precisely out of a sense of the need to get outside the art frame. The impossibility of making any precise definition of what counts as 'art' is further underlined by the fact that a number of artists have presented work both in the art context and outside it. Before he became an internationally acclaimed artist, Nobuyoshi Araki's work had long been published in Japanese pornographic magazines; Ron Athey and Franko B have worked in both art galleries and gay fetish clubs; and while Annie Sprinkle's claim that 'almost all the top women performance artists today have at one time worked in commercial sex' may be a slight exaggeration, it is certainly true of many.

One of the key intellectual reference points for art made since the 1960s has been psychoanalysis; hardly surprisingly this has been especially true in the case of art which deals with sex. Even if some artists working in this area have been hostile or indifferent towards psychoanalysis, there can be no denying that the writings of Freud and his followers, naturally including the more rebellious ones, have both been a source of inspiration and, because of the central position accorded to sex in the psychoanalytic picture of the world, provided a highly suitable framework by means of which art about sex can be discussed. Doubts about the scientific validity of psychoanalysis, which have been problematic for many in the medical profession as well as for laymen with a positivist turn of mind, are largely irrelevant in the art context, where it is Freud's powers as a creative thinker and the creative thinking he set going in others which have made the psychoanalytic contribution so crucial.

The first art movement to be seriously influenced by Freud's thinking was Surrealism. Its leader and principal spokesman, André Breton, had read Freud as a medical orderly in the First World War and used Freud's charting of the unconscious to go beyond the dead-end nihilism

of Dada, at least as propagated by Tristan Tzara, out of which, historically speaking, Surrealism grew. Breton's definition, in the *First Surrealist Manifesto* (1924), of Surrealism as 'pure psychic automatism', can be seen as taking the apparently arbitrary Dada preference for chance techniques, avoiding deliberate moral and aesthetic choice, and providing this with a rationale as a method for evading the censorship mechanism inherent in repression. His call, in the *Second Surrealist Manifesto* (1929), for the 'hand-painted dream photograph' reflected his disillusion with what he believed to be the misuse of automatism for aesthetic purposes. Rather, he favoured a more conventional, illusionistic form of painting which, by pursuing Freud's 'royal road to the unconscious', would not be deflected from the more crucial purpose of helping to bring about psychic, and ultimately social, liberation.

Of all twentieth-century art movements, Surrealism almost certainly provided the most important precedent for recent art dealing with sex. Important though Surrealism as a whole has been, however, it is not so much the mainstream Surrealism promoted by Breton that has had the most significant effect, but rather the more extreme and darker wing, associated with such figures as Antonin Artaud, Georges Bataille and Hans Bellmer. As a man of the theatre, Artaud's influence has been felt most strongly in the area of performance art, as well as the types of visual and physical theatre and dance which come close to it. Bataille has been a crucial figure in recent art: as a thinker and writer, his influence has been felt more evenly among artists using different media. As for Bellmer, despite the ease with which his anatomical rearrangements could superficially be dismissed as misogynistic, the interest shown in his art by many young female artists is testimony to a growing realisation of the rich ambiguities of meaning to be mined from it. Less surprisingly, the work of female Surrealist artists has become a source of inspiration for many women artists in recent decades.

Many of the concerns and ambitions of the Surrealists, above all the quest for total liberation, were brought to a wider audience by the youthful 'counter-culture' of the 1960s. This counter-culture was vastly creative; and its creativity was more often than not linked with sex, most obviously in the area of rock music. Within the art world, two developments in the 1960s were to prove especially significant. One was art's emergence from its ivory tower and recognition of the importance of popular culture. The other was the massive widening of the definition of what constituted art, that came in with movements such as Conceptual and Performance Art.

Although the main form of popular imagery dealing with sex is pornography, almost all popular culture – advertising, fashion, comics, TV and cinema – is infused with sex in one way or another. The first art movement which engaged with this, and reflected this proliferation of sexually charged imagery at the end of the 1950s and beginning of the 1960s, was Pop Art. The popular culture which was its subject matter came primarily from America but British artists were the first to examine it intellectually. Richard Hamilton's collage *Just What Is It that Makes Today's Homes So Different, So Appealing?* (1956) was virtually a manifesto of Pop; and the inclusion, in this work about domestic consumerism, of a nearly nude man and woman, in the beefcake and cheesecake pin-up traditions respectively, was far from incidental. It is

natural that, given its subject matter, Pop Art should soon become a primarily American phenomenon. The works which probably most fully encapsulated the smooth, plastically sexy 1960s ideal of the pin-up woman were Tom Wesselmann's *Great American Nude* series; while Mel Ramos and Wayne Thiebaud developed the photographic girlie pin-up in a direction whose predominant texture was more creamy than plastic. With his sculptural sensibility, Claes Oldenburg was able to embrace both these textural qualities; and indeed used them, more than overtly sexy imagery, to create a sensual, at times almost cuddly, tactility. In this, Oldenburg was at the opposite extreme from the voyeuristic Warhol, who famously declared that he did not want to be touched because it hurt too much, and whose work drew attention to the sense of distance inherent in the mediated image.

Every bit as crucial to all subsequent art as the recognition of the importance of mass media was the embracing of a multiplicity of new forms and media in which art could legitimately be made. Artworks could now be made of absolutely any materials; could incorporate the dimension of time; could make use of new photographic-based and other technologies; could address senses other than the visual, for example the aural and the olfactory; could involve live human presence, most usually the artist's own; and need not even have any physical existence at all, as in the most extreme instances of Conceptual Art. The international Fluxus movement investigated the possibility of creating art as an instruction or score for acts that could be performed by anyone at any time. Some Fluxus pieces were more obviously sexual than others: among the most enduring were the cellist Charlotte Moorman playing her cello, naked, in a piece devised by her and the Korean video artist Nam June Paik in 1965 and their similar later work *TV Bra for a Living Sculpture* (1969). The medium which was to prove the most significant for artists dealing with sex was live performance; certainly this was the medium in which the most radical work was produced. Indeed, several of the pioneers of Performance Art and Body Art in the 1960s produced work so radical that it was excluded from the artistic mainstream at the time and only began to be seriously appreciated in the following decade, when a far larger number of artists were engaging in similar activities.

My approach throughout this book is to treat the artworks themselves as primary, and only to bring in theoretical considerations in so far as these follow up and, I hope, enrich the implications inherent in the art. Alongside Freud himself, most, though not all, of the theoretical writers on whose ideas I draw are directly or indirectly indebted to psychoanalysis. However, they often differ strongly from each other in both style and substance, and in some cases are implacably opposed. I believe it is important to bring this range of different points of view to bear, not least to do justice to the open-endedness of the art and to recognise that every interpretation is necessarily partial.

* * * *

The first seven chapters of the book will follow what could be seen as a general movement from the individual human being outwards towards the world. To me, this seemed from the start

the most potentially fruitful way of proceeding. I was therefore pleased, much later on in the writing process, to stumble across the following statement by Vito Acconci about the development of his own art, which seemed to chime with my own initial instinct: 'Sometimes when I look back, it seems like I was a child growing up. First a person looks at himself/ herself, then realizes there's another person there and interacts with him, then that there's a mass of people and interacts with *them*, then realizes the entire world exists, and so on.'[2] The two subsequent chapters can be linked with a specific pair of perversions, before the last chapter addresses connections between beauty and beastliness.

Chapter 1 examines art dealing with the human body as a locus of sexuality. Chapter 2 focuses on art by female artists that explores and, above all, celebrates female sexuality as something other than merely responsive to its male counterpart. Chapter 3 investigates art that overtly celebrates homosexuality and other divergences from the 'norm', both in terms of what Freud called 'object' and what he called 'aim'. From sexuality, which still primarily expresses the structure of an individual's psychosexual constitution, to actual sex, which (except in the case of masturbation) involves at least one other being: Chapter 4 is on art which presents sex in terms of intercourse, or communication with others. Chapter 5 looks at art that deals with sex in relation to the space of the modern city, now extended into cyberspace, and the notions of trade and commerce that it engenders. Chapter 6 focuses on art which evokes erotic connections with the natural environment – animal, vegetable and mineral – and ultimately the cosmos. Chapter 7 considers art which links sex with the sacred, often drawing on ancient mystical and symbolic traditions.

The two pairs of perversions with which the next two chapters can be linked are sadism and masochism, and exhibitionism and voyeurism, though these terms are only starting points. Chapter 8 is on art in the tradition of Antonin Artaud's 'theatre of cruelty' and Chapter 9 on art which focuses on the scopic dimension in sex. In both cases, the wider implications are brought out: especially of sadomasochism as a model of political and social interaction; and of exhibitionism and voyeurism as a model of the functioning of art. Chapter 10, drawing on elements from all previous chapters, concentrates on art which presents beauty or beastliness or a combination of the two, and posits the interaction of these two apparent contraries as a central principle of sex; before a short final afterword, which raises certain questions and suggests certain lines of further enquiry.

Chapter 1

The Body

There is an element of truth in Philip Larkin's witticism that 'Sexual intercourse began in 1963 (Which was rather late for me)'. Certainly a new-found and optimistic openness about sex and the quest for sexual liberation were among the defining features of that 'swinging' decade, widely characterised as the era of 'free-love' as a result of the sexual revolution brought about in part by the advent of the contraceptive pill. The body as the site of sexual experience became not only a tool for enjoyment but also for ideological and political expression. This cultural shift was reflected in the realm of art, where the body achieved an unprecedented focus as both the subject of art and its medium. Artists keen to express their hostility to the commodification of the art world engendered by the production of plastic artworks for sale in commercial galleries began to use their own bodies in performative works. This shift represented too a refutation of the cool aesthetic of purely Conceptual and Minimal Art, though it shared some of the same rhetoric.

Widespread critical, theoretical and academic interest in 'the body' followed in the late 1980s, when countless books and articles with the word 'body' in their titles began to appear, swiftly followed by courses in art colleges and universities. Part of the attraction of the term has lain in the fact that nobody knows precisely what it means. Clearly its meaning starts out from the (human) body in a literal sense but it soon branches out in a number of directions creating a rich web of ambiguities and multiple interconnections. The fascination with 'the body' could also to some extent be seen as a reaction against the prevalent post-structuralist focus on 'the text', or at least as a means of reintroducing sensuous reality into theoretical discourse. On the other hand, partly no doubt to provide intellectual legitimacy, the body has itself often been presented as a text or language; this despite the effect of lessening the impact of highly provocative works that such a de-corporealising tendency can have. It is significant that one of the most important early books on Body Art, written by Lea Vergine in

1974, was entitled *The Body as Language*.[1] As Vergine stressed, this use of the body as language in art could easily take a violent, possibly sadomasochistic, turn. At the same time, the revaluation of the body as a source of language has been central to feminist art and theory for several decades.

Though the human body had long been represented in art as the site of erotic contemplation, the recent focus on the erotic body within art has been far more complex; the body has become a means of addressing a wide range of psychosexual issues. In the theoretical discourse around the body, sex plays a central role, not least because this discourse has been heavily influenced by psychoanalysis, with its focus on the effects of unconscious desires. Freud's theories regarding the constitution of the self were deeply rooted in the body. If, as psychoanalysis maintains, the unconscious can best be understood in terms of a language which gives expression to thoughts and feelings whose origins can ultimately be traced back to bodily urges, then it makes perfect sense that its contents should so frequently be of a sexual nature.

Freud's model is one that underpinned a significant proportion of post-war critical thinking throughout the sphere of the human sciences. One of the most intellectually daring authors to have extended Freud's thinking further is Norman O. Brown, whose book, *Love's Body* (1966), is radical in both its form and its poetic approach to unifying seemingly contradictory philosophies and their theoretical subtexts. Mostly dismissed, perhaps on account of its apocalyptic tone, merely as a prophetic handbook for the 1960s counter-culture, it in fact prefigured nearly all the major concerns of post-structuralism; but with an inspirational open-endedness all too often deadened in later theoretical writing. Despite its powerful logical thread, *Love's Body* functions in some ways more like an artwork or annotated poem than most theoretical writing: suggesting at times astonishingly original ways of looking at the world and bringing into play the reader's own imaginative powers.[2] Even when arguing against particular elements of psychoanalytic theory, other writers since the 1960s have largely worked within psychoanalytic terms of reference. Moreover, even when other approaches, such as phenomenology, are more predominant, few accounts of 'the body' fail to acknowledge the fundamental importance of sexuality in corporeal experience.

The erotic potential of the body was directly mobilised in the 1960s by the new phenomenon of Body Art. It sprang from the new focus on the body as a medium that characterised the wider Performance Art movement, though many artists shunned the term 'performance' for its theatrical connotations, preferring instead terms such as 'action', 'happening' or 'live art'. This development had been made possible on the one hand by Harold Rosenberg's characterisation of Abstract Expressionist 'action painting'[3] and on the other by the delayed influence of Marcel Duchamp, whose valorisation of the business of everyday life was epitomised in his claim, late in his life, that every breath he had taken was as important artistically as any of the artefacts he had happened to make. It drew too on the visual theatre inspired by the theories of Antonin Artaud and Jerzy Grotowski, and the Butoh dance theatre, departing from traditional theatrical characterisation and scripting. This focus on the

immediacy of the body was enacted by a young generation of artists who displayed their own, often naked, bodies in the public sphere, and extended by some who made their own bodies the theme of their artistic exploration. Pioneers included: in America such practitioners as Vito Acconci and Carolee Schneemann; and in Europe Günter Brus and the Viennese Aktionists, as well as Gina Pane and Marina Abramović. The rise of Body Art in the 1960s was followed by a relative decline, though recent years have seen the resurrection of Body Art by a later generation of artists such as Ron Athey and Franko B.

In addition to the adoption of the body as a tool for expression, much recent art has focused on particular parts of the body, and such art should be understood in relation to ideas about fragmentation of the body implying fragmentation of the psyche.[4] In traditional naturalistic representations, the human body was shown from the outside and implicitly whole. It was against the Neoclassical ideals of wholeness that the Romantic cult of the fragment arose, first in the relatively frivolous Picturesque form of the fake ruin, then more seriously in German Romantic philosophy and literary theory, notably in Friedrich von Schlegel's 'Fragments' (1798–1800). It is no coincidence that it was the Romantics who first explored the inner recesses of the self, without relying on religious guarantees of unified integrity, an exploration carried further by the Symbolists and, in a more scientific spirit, by Freud. In Surrealism, the first artistic movement to be deeply affected by Freud's thinking, the body began to be used as a language primarily of desire, which could be manipulated in myriad ways. There is no more perfect example of Surrealist fragmentation than Hans Bellmer's *Dolls*, the first of which he produced in 1933, where the body is endlessly disjointed and rearranged in ways which are biologically impossible and sexually disturbing.

Melanie Klein developed the distinction between 'whole objects' and 'part objects', the ability to see a person as a whole being contrasted with the tendency to concentrate on only one body part – for example the mother's breast – or by extension a part of someone else's personality. It would be hard to find more perfect examples of artworks that represent or embody Kleinian 'part objects' than a number of sculptures made by Louise Bourgeois from the 1960s to 1980s. Certainly her work has been subject to multiple psychoanalytic readings. Her latex sculpture *Fillette* (1968) – the piece which, in probably the most famous photograph of her, taken by Robert Mapplethorpe in 1982, she is holding under her right arm while she smiles an endearingly naughty smile – is immediately suggestive of a penis; it even has two balls at its base. Yet the multiple pun of the title alerts us to additional levels of intended meaning. Literally, it translates as 'little girl', so that Freud's equation 'girl = phallus' is quite deliberately invoked. Bourgeois has spoken of this sculpture as a sort of person: 'If you take a look, you can see two eyes on top, a sort of thin mouth below.'[5] The title also suggests 'fillet', in the sense of a cut of meat, thus invoking castration and mutilation, and these associations are entirely appropriate to the piece. Like several other of her sculptures of that period, it is exhibited hanging from a hook, as if in a butcher's shop; and at least one way of reading the imagery is that the tip of the penis has been flayed. Yet Bourgeois, in addition to endowing the

penis with feminine characteristics, has also compared it to a baby, insisting that her feelings towards it are benign and protective.[6]

A knife can be used on a penis; but a penis can easily be symbolically equated with a knife. Thus Bourgeois' equation of a woman with a knife in her smooth pink marble *Femme-couteau* (1969–70) again simultaneously feminises the phallus and phallicises the whole female form. Her bronze *Fragile Goddess* (1970) looks more or less like a penis and balls, except that the balls read equally clearly as the goddess' breasts, and below them is a swelling which appears like a pregnant belly. This sculpture is also headless or, if it does have a head, it is so small that it is merely a continuation of the long neck. Paired penises in Bourgeois' Janus series evoke comparison with breasts; *Janus fleuri* (1968) also has the suggestion of a vagina where the two penises/breasts join. The penis/breast analogy is used frequently by Bourgeois. As she herself has said: 'Sometimes I am totally concerned with the female shape – clusters of breasts like clouds – but often I merge the imagery – phallic breasts, male and female, active and passive.'[7]

The multiple breasts in *Blind Man's Buff* are certainly phallic, while the title implies that they are more to be touched than seen. On the other hand, as she has indicated, breasts can just be breasts. *Mamelles* (1991) is a pink rubber wall relief, showing a whole line of breasts nestling rather like peas in a pod. Bourgeois' own interpretation of this work is that it refers to 'a man who lives off the women he courts, making his way from one to the next. Feeding from them but returning nothing, he loves only in a consumptive and selfish manner.'[8]

Adrian Stokes, who was himself analysed by Klein, extrapolated Klein's identification of the 'part object' into a discussion of art. In some senses, modern art's frequent preoccupation with fragments, and in particular with isolated body parts, can be seen as a form of deliberate psychological regression. Stokes suggested that much of the attraction of antique Classical sculpture for the modern observer lay in the fact that, though it would have originally portrayed the body as a whole, it usually reaches us in battered form, often with one or more limbs missing.[9] An original and partly parodic take on the Classical ideal of wholeness is provided by Marc Quinn's series of sculptures (2001–04) of disabled people whose limbs are truncated or missing in real life. The installation of Quinn's portrait sculpture of *Alison Lapper Pregnant* (2000) on a plinth in Trafalgar Square, London, has made it famous, although it is less of a novelty in the square than is generally realised, in that, as Quinn has noted, 'Nelson on top of his column has lost an arm.'[10] Of the same generation of British sculptors as Quinn, Jake and Dinos Chapman have made numerous sculptures involving horrific rearrangements of the body, including the notorious *Fuck Face* (1995), in which a young girl is endowed with a penis in place of her nose. These might superficially show the influence of Bellmer, while intellectually they are indebted to Bataille and to Antonin Artaud's conception – later developed by Gilles Deleuze and Felix Guattari – of a 'body without organs'. If these are present in the Chapman's work, however, they are imbued with a distinct sense of irony.

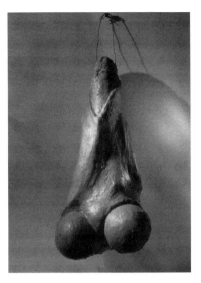

1. Louise Bourgeois, *Fillette (Sweeter Version)* (1968–99).

Freud's essay on 'Infantile Sexuality' (1905) outlines the role of the erotogenic zones and the associated phases of sexual organisation in the child's development. The first of these is the oral. Freud comments:

Here sexual activity has not yet been separated from the ingestion of food … the sexual aim consists in the incorporation of the object – the prototype of a process which, in the form of identification, is later to play such an important part.[11]

Perhaps one of the most powerful evocations in art of the cannibalistic implications of oral eroticism is Bourgeois' sculpture *The Destruction of the Father* (1974). An arrangement of protruding rounded forms that surround a group of smaller bulb-like shapes, the ensemble suggestive of a mouth, it has been described by the artist as 'a very murderous piece'. It evokes the *vagina dentata*, the threat of the devouring female sex, so popular in Surrealist iconography. Many of the work's elements were carried over into her large installation piece *The Confrontation* (1978), centred on a long table, which she also turned into a performance, entitled *A Banquet, A Fashion Show of Body Parts.* Bourgeois' indefinite shapes which resemble penises or breasts can, especially when arranged approximately in a line, also suggest teeth, aggressive in their potential to bite, break and consume.

The second stage of libidinal development identified by Freud is the anal; indeed Freud linked the origin of artistic creativity with the anal erotic delight of playing with one's faeces. In Yoko Ono's six-minute silent black-and-white film usually referred to as *Bottoms* (1966)[12], supposedly intended to encourage dialogue on world peace, a number of famous people bared themselves to the camera. Gillian Carnegie's much more recent series of 'bum paintings' (2004) play on the tension between their subject matter and concerns specific to the medium and history of painting. Like Ono's film, these paintings are more likely to elicit amusement than shock.

Simplifying somewhat, the final stage in a child's libidinal development, and that which prefigures what in lay terms is recognisable as normal adult sexuality, is the genital. It is at this stage, of course, that the question of sexual difference becomes crucial. In art, the number of different ways in which the genitals of both sexes have been represented is impressive. Possibly one of the most remarkable representations of the female genitals is Henri Maccheroni's series of *2.000 photos du sexe d'une femme* (*2,000 Photos of a Woman's Sex*). Taken between 1969 and 1974 they are not photographs of different women's genitals, but of one woman's

only: their variety, as well as tenderness, is extraordinary. Concentrating on the biological functions of the genitals and thus needing to go beyond what is externally visible, Kiki Smith made a pair of bronze sculptures of both the male and female reproductive systems: *Uro-Genital System (Male)* and *Uro-Genital System (Female)* (both 1986).

Nobuyoshi Araki's *A Part of Love* (1987) is a photograph of a snail on the tip of an erect penis. For the exhibition *Das Bild des Körpers* (Frankfurter Kunstverein, 1993) he made a 21-part work, *Part of Love*, containing photos of vaginas with snails and other things in them, all stressing the gelatinous and somewhat marine quality of vaginas, reminiscent of Nagisa Oshima's film *Ai No Corrida* (also known as *Empire of the Senses*; 1976) and ultimately in a long tradition of Chinese and Japanese art, bringing to mind the Taoist conception of the 'jade gate'. There is a strong case for saying that the excitement of very literal depictions of the genitals such as these is entirely dependent on the existence of taboo: indeed, they must be shockingly graphic to work at all.

Of the vast number of images of penises made in various media, Robert Mapplethorpe's photograph *Cock* (1986) – black, not erect, coming out over the top of draped material – is justly one of the most famous. As a gay man, he naturally concentrated on the male body, not infrequently including the male member. He also did, however, make a photograph of the artist Veronica Vera, from behind, showing only parts of her buttocks with her vulva displayed between. The concentration on one particular body part, or a symbolic substitute for it, is the basis of fetishism. For Freud, notably in his essay 'Fetishism' (1927), the fetish always stood for the missing female penis, and constituted a simultaneous denial and acceptance of the fact that women do not possess a penis; against this terrifying realisation, experienced as a threat of castration, the fetish is erected as a means of defence. Mapplethorpe's photographic studies of the nude seem to broaden this focus on a metonymic part of the body in order to fetishise, that is phallicise, the whole body. While it is normally the male body that is subjected to this process in his work, even the female body is depicted as highly muscular, showing a direct line of descent from Michelangelo. Particularly pertinent in this context is Julia Kristeva's distinction between the sense of diffused *jouissance* that is expressed through colour and light in Venetian painting and the Florentine insistence on a hard, bounded, sculptural form that is resolutely fetishistic.[13]

In comparison with the vagina, the penis, as well as being more overt, is in principle more separable from the rest of the body and perhaps for this reason has been seen as more amenable to personification. Vito Acconci, in his Super-8 film *Trappings* (1971), dressed his penis in doll's clothes and spoke to it as if it were another person, making explicit a metonymic status of the penis, though he assigned his penis to the feminine. Norman O. Brown, in *Love's Body*, identifies personality with representation, and speaks of

> the establishment of a part, a part which is no longer a part...because it is the whole. Pars pro toto; a part of the body which represents the whole... The genital is the representative organ[14]

– in much the manner in which a Member of Parliament is a representative within the framework of the body politic. Klein spoke of the endowment of various body parts with the attributes of a whole person, most famously in the distinction she believed that children – whose tendency to personify is evident to any observer in their treatment of toys – make between the 'good breast' and the 'bad breast', thereby endowing the mother's breasts with moral characteristics.

In addition to being easily personified, the male member has sometimes been heroicised as the creative organ *par excellence*. Renoir's well-known claim 'I paint with my prick' was made literal by Paul McCarthy in his *Penis Painting* (1973). Jackson Pollock's drip technique has been seen in these terms, often mockingly by feminist writers for whom it is linked with Pollock's supposed heroic masculinity; and there is an especially strong sense of paint as a spermatic medium in the work of Willem de Kooning. The sexual implications of Pollock's technique were brought out more clearly in the 1960s by Yves Klein in his *Anthropometry* performances in which naked women rolled in paint then pressed their bodies against canvases – one is reminded again of Freud's symbolic 'girl = phallus' equation.

Marcel Duchamp's *Paysage fautif* (1946) looks at first sight like an abstract painting but was in fact entirely made with the artist's semen, and apparently dedicated to a woman he desired but who was beyond his reach. In his 1970s mail artwork, Genesis P-Orridge produced a white booklet, each page of which was stained with his semen, entitled *Wanks for the Memory*. In addition to the use of actual bodily fluids in art, there have been countless representations of them in a variety of media. Kiki Smith's sculpture *Untitled* (1988–90), consisting of over two hundred representations of spermatozoa made by hand in lead crystal glass, possesses an iridescent beauty, as well as projecting a more obviously reproductive potential.

Andres Serrano has made photographs depicting a number of bodily liquids, for example his series *Blood and Semen* (from 1990), combining a life-sustaining fluid with a life-giving one. In that both can be tainted, some observers have related Serrano's work to AIDS, though this was not his own focus of interest. Usually massively enlarged when exhibited in a gallery context, his photographs tend to monumentalise their subject matter, a tendency increased by the crucial if not always overt references in them to the history of painting. As in painting, there is a spectrum in his work between the figurative and the abstract; and the pictures of bodily fluids tend towards the more abstract pole. Possibly his most famous work, on account of the controversy it unintentionally stirred up, is *Piss Christ* (1987), which shows a plastic crucifix immersed in a glass of urine. While this is not directly sexual, it is inevitable that all depictions of waste products are potentially erotic, if only because of the proximity of the sexual organs to those of excretion, famously troubling to St Augustine.

Helen Chadwick's *Piss Flowers* (1991–92) was made by her and a male friend urinating in the snow and casts being taken of the cavities made. The result is an inversion in that the resulting shapes, which do indeed resemble flowers, centre on a phallic form which was in fact

made by the female urine stream, surrounded by more labial forms, in fact made by the male. Chadwick's *Cacao* (1994) is a seething and bubbling whirlpool of chocolate which, both visually and in its title, draws the familiar parallel between chocolate and shit, and, by virtue of its enticing deliciousness, teases the viewer with thoughts of coprophagy. As in much of her work, there is a strong element of mischievous humour. This quality is also present in much of the work of Gilbert and George, who have been especially prolific in showing bodily products. Sperm, blood, urine and faeces have turned up with great frequency in their mostly photograph-based work. A typical example is *Shitted* (1983), which depicts several gigantic orange-brown turds floating down in the background while the artists sit in the two bottom corners facing us with their tongues, represented in the same orange-brown as the turds, out.

Less obvious as a sexual metaphor is the brain, which takes on an erotic physical presence in Chadwick's series of works based on photographs of the human brain which were exhibited as cibachrome transparencies back-lit by fluorescent strip lights. These include *Eroticism* and *Organism in Love* (both 1990) and *Self-Portrait* (1991), in the last of which the artist's hands are shown cradling the brain in a gesture of respect. Writing together with Rachel Armstrong, à propos of these works, Chadwick observes: 'the brain's embryology observes "female" development in the absence of critical cues of "male" determination. The brain is marked with masculinity; I chose to address the "unmarked"'.[15]

Contemplating the brain in relation to sex reminds us that sex is not entirely of the body, that it lies, rather, on the threshold between mind and body. This is at least part of the reason that it was so crucial for Freud, seeking, as he was, to ground the study of mental phenomena in the physical. It has been said of Freud, often mockingly, that he saw a penis in every convex form and a vagina in every concave one; and this essential difference between the male and female organs was indeed fundamental to Freud's theory of symbol formation. One of the main binary oppositions in terms of which the body is represented is that between inside and outside, not least because the inside/outside opposition is often used as a metaphor for that between mind and body. It may even be that there is more than a metaphorical connection. According to Freud:

> the ego is ultimately derived from bodily sensations, chiefly those springing from the surface of the body. It may thus be regarded as a mental projection of the surface of the body, besides…representing the superficies of the mental apparatus.[16]

This would make sense both in terms of the ego being a mediator with the outside world, and of the symbolic importance of the skin.

Matta's highly visceral *Inscape* paintings of the late 1930s and 1940s, which he described as 'psychological morphology', play with the relationship between the physical interior of the body and 'inner experience' in the psychological sense. An interaction between the literal and the metaphorical, between the physical and the psychological, is undoubtedly implicit in Mona

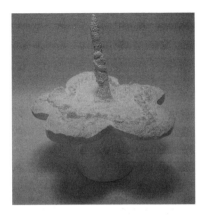

2. Helen Chadwick, *Piss Flower #1* (1991–92).

Hatoum's video installation *Corps étranger* (*'Foreign Body'*) (1994). It consists of a white cylindrical room inside which a video, which makes use of the modern medical imaging techniques of endoscopy and coloscopy, is projected onto a circular screen which takes up most of the floor. The camera passes slowly over the surface of the artist's skin, transforming it into an unfamiliar landscape through distortions of scale, until it comes to an orifice; then we are taken on an extraordinary inward journey along 'glowing subterranean tunnels lined with pulsating animate tissue, moist and glistening.'[17] When the camera can go no further, it backs up to the surface again and we travel across more of the exterior bodily landscape until we come to another orifice, at which point we re-enter the interior by means of a different tunnel: this continues until all orifices has been explored. There is an accompanying soundtrack, made from the artist's heartbeat – intercut during the external sequences with her breathing.

One way in which the inside/outside dialectic has been explored by artists is through the image of the body as house. According to Anish Kapoor, '[o]ne might almost say a building is a metaphor for the self,' an idea at the core of Gaston Bachelard's analysis of literary images relating to the house in his classic study *The Poetics of Space* (1958). The metaphor of the house has been taken up by both male and female artists. Francesco Clemente's *My House* (1982) depicts a spiral staircase leading up from a relatively normal sitting room to an awe-inspiring space which could be a temple. *Perseverance* (also 1982) is based on a dream in which, naked, he is holding the Pantheon, Rome – or what, if these things were logical, would be a model of it – in his arms.

While the image of the house acts in Clemente's works as a metaphor for the psyche, it may also take on a more specifically female-gendered role that rests on the traditional and now much contested conception of the womb as protective vessel.[18] This imagery suggests the related binary notion of public and private space in which sex involves a literal and metaphorical invitation to enter. The body as house appears a central theme in Louise Bourgeois' work, announced unequivocally with her *Femme-maison* series of paintings and drawings from the late 1940s, which literally combined images of the female body with ones of houses.[19] After that, architectural motifs appeared frequently in her sculptural work, sometimes recognisably, sometimes in a more abstract way: these works ranged from the open and transparent *Maison fragile* (1978) to the solid and impermeable *Curved House* (1983). In all these cases, whether the house or architectural motif was or was not easily recognisable,

the body, though always implicit, was never explicitly alluded to. But in 1983 she made a marble sculpture once again using the title *Femme-maison* in which an actual woman's body was substituted by a mountain of sensuous drapery with swirling folds, perched on top of which was a small very geometric and rectilinear motif which could easily be read as a building. But it could also be read as a neck, one not leading to a head, since this sculpture is closely related to the headless figures of the subsequent two years.[20] *Maison* (1986), largely deriving from *Maison fragile* in its open structure, resembles a shelving unit; on each shelf sit clusters of phallic-cum-breast-like forms.

The many ways in which recent art has represented, or in the case of Body Art presented, the body, together with an opening out to the many implications of the 'body' beyond its literal meaning, have created immense opportunities for re-thinking sex and sexuality. However, for both biological and socio-historical reasons, the experience of sex is inevitably very different for men and for women. Of all the binary oppositions relating to the body, certainly in relation to sex, that between male and female is the most fundamental of all, as the ambiguity in the term 'sex' itself suggests. It is time now to address the issue of the gendered body. Whereas in the past, exploration of sex in art was almost exclusively the preserve of men, in recent years this has shifted radically, to the extent that now it is women to a much greater extent than men who are pushing the boundaries and charting hitherto uncharted territory.

Chapter 2

The Celebration of Female Sexuality

Linda Nochlin's essay 'Why Have There Been No Great Women Artists?', published in *Art News* in January 1971, signalled the beginning of a decade that would attempt to redefine women's place in the art historical canon and the contemporary art world. In 1979, Judy Chicago would present a roll-call of female historical, literary and artistic figures in the installation of her *Dinner Party* (1974–79), laying their places in an alternative canon with plates whose design was decidedly vulvic. The conspicuous increase in prominence of female artists went hand in hand with a massive change in the position of women in society, at least in the West, and was accompanied by a corresponding rise in feminist theory. Much theory, especially initially, concentrated on the destructive effects of patriarchal male desire, with a predictably puritanical influence on the arts. However, many female artists chose rather to express, explore and celebrate their own experience of female sexuality – a development which has on the whole come to be supported by feminist critics, since newer, subtler and more sex-positive forms of feminist theory have evolved.

Many of the broader theoretical debates that have surrounded the representation of female sexuality in recent decades have been influenced by the question of the extent to which one can speak of an inherent gendered identity, or whether femininity is a social construct. Joan Riviere's 1929 essay 'Womanliness as Masquerade' had challenged traditional notions of the essential difference between men and women. Though applied to a specific situation, it was later extrapolated to apply to femininity in a much wider sense.[1] Simone de Beauvoir's 1949 feminist text *The Second Sex* proposed the famous statement that 'one is not born a woman; one becomes one', continuing the notion that the female sex is something that is defined by the social structures of patriarchy. Judith Butler's 1990 book *Gender Trouble* presented a model of the performative nature of gender. Butler posited the construction of both gender and sexual difference

through repeated bodily acts, allowing the possibility of unpicking the binary male-female model.

In some circles Constructionism has become a new and zealously defended orthodoxy. In response to this focus on the social delineation of gender, Camile Paglia asserts certain inherent differences between the genders; in her model, the female genital metaphor is based on the mystery of the hidden, as opposed to the male metaphor of concentration and projection, and the sexual act for women represents the nest-building impulse, in contrast to the male speculative quest. Luce Irigaray's position, outlined in *This Sex Which Is Not One* (1977), is difficult to ascribe with any certainty to either side of the debate. It seems rather to draw from both, though is more stridently and recognisably – albeit idiosyncratically – feminist than Paglia's in its clear anti-patriarchal stance. For Irigaray, female sexuality is conceptualised according to the masculine parameters of a desire not her own, so that she becomes an 'obliging prop for man's fantasies', her genitals a lodging for the male organ.[2] Irigaray bases her argument on the conception of the female genital as a double form that allows constant autoerotic contact, though *'woman has sex organs more or less everywhere.* She finds pleasure almost anywhere. [...] the geography of her pleasure is far more diversified, more multiple in its differences, more complex, more subtle, than is commonly imagined.'[3] Irigaray's proposed escape from repressive patriarchal structures emphasises the necessity to discover a specifically female mode of erotic pleasure.

In terms of art dealing with sex, two of the most important movements of the twentieth century were Surrealism and Pop Art: the former because of its focus on erotic desire as a motivating unconscious force and the latter because of its appropriation of the sexualised commercial imagery of the pin-up, sex symbol and screen icon. Although both movements were overwhelmingly expressions of male sexuality, art historians have begun to qualify this picture with the benefit of a hindsight informed by feminism, devoting their attention to the recuperation of the careers of many female Surrealists in particular, such as Claude Cahun, Leonora Carrington, Meret Oppenheim and Dorothea Tanning. Especially remarkable has been the career of Louise Bourgeois. Although it would be wrong to classify her as a Surrealist – indeed her early work was largely conceived in explicit opposition to Surrealism – her work does provide a direct link between the Surrealist milieu of the late 1930s and 1940s and the most advanced art of the early twenty-first century. Her longevity has enabled her to reinvent her work several times, as well as to enjoy the satisfaction, albeit belated, of success and widespread acclaim. Indeed the extent to which Bourgeois has been a prime beneficiary of the greater recognition that has at last been given to female artists, as well as what now appears the shocking tardiness of that recognition, is underlined by the fact that the retrospective exhibition that the Museum Of Modern Art, New York, gave to her in 1982 was the first that it had ever devoted to a female artist. By contrast, the ebullient and sexually assertive work of the female Pop artists Pauline Boty and Evelyne Axell, both of whom died young, achieved little critical attention in their lifetimes and is only just beginning to receive some of the credit it deserves.

The massive widening in the 1960s of the definition of what constituted art offered female artists new means of expressing their sexual identity. A large part of the attraction of performance, together with such related media as installation and experimental film, lay precisely in its novelty, as well as the potential to enact literally the feminist cry 'the personal is the political'. With painting and sculpture, due to their past domination by men, it was almost impossible to determine which of the aesthetic values taken to be inherent in the medium were really gender-specific; but with these new media, artists were free to make up the rules to suit their own needs as they went along. One performance piece that could be seen to comment directly on this situation was Shigeko Kubota's *Vagina Painting* (1965), in which she squirted paint from her vagina, ridiculing the notion that language, art and other symbolic systems of communication need be the privileged preserve of men.

In nobody's work was the potential offered by these new media more evident than in that of Carolee Schneemann. As a pioneer feminist artist working in the 1960s, Schneemann had initially to struggle, as a woman, to have her work taken seriously. Her emphasis on the tactile and her rooting of the visual in bodily experience were for her partly a means of attacking what she saw as the typically male over-cerebral nature of most of the work which was at that time receiving recognition. Of her use of her naked body as a material in *Eye Body: 36 Transformative Actions*, she was later to write that it 'challenged and threatened the psychic territorial power lines by which women, in 1963, were admitted to the Art Stud Club'.[4] In *Naked Action Lecture* (ICA, London, 27 June 1968) Schneemann spoke about her own visual works, dressing and undressing several times during the 30-minute lecture. Her principal question was, in her own words (including her neologism 'istorian' in place of what she deemed the gender-specific word 'historian'):

> Can an artist be an art istorian? Can an art istorian be a naked woman? Does a woman have intellectual authority? Can she have a public authority while naked and speaking? Was the content of the lecture less appreciable when she was naked? What multiple levels of uneasiness, pleasure, curiosity, erotic fascination, acceptance or rejection were activated in an audience?[5]

Schneemann used her work to express her active sexual desire, both in so far as that was centred on her experience of her own body and in so far as it was turned outwards towards others, as in her film *Fuses* (1964–67), which recorded her making love with her then lover, James Tenney. One of her most powerfully celebratory works was *Meat Joy* (1964), an orgiastic group performance that presented a writhing mass of naked or near-naked youthful bodies of both sexes, including the artist, mixed with paint, paper, sausages, raw chicken and fish. *Meat Joy* was performed three times, all in 1964: first in Paris (at the Festival de la Libre Expression) in May, in London in June, and in New York (at the Judson Church) in November.

In 1975 Schneemann performed *Interior Scroll* in which, standing naked on a table, she read from a scroll as she pulled it slowly from her vagina. The words on the scroll attacked

the overly cerebral sterility of a structuralist approach, proposing instead an art that reclaimed 'the personal clutter/the persistence of feelings/the hand-touched sensibility/ the diaristic indulgence/the painterly mess'.[6] This would become an iconic performance,

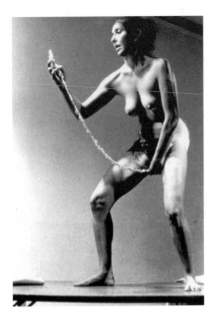

3. Caroline Schneemann, *Interior Scroll* (1975).

one that can be read in terms of its bringing out a specifically female wisdom from a previously hidden private realm into the public cultural arena. Schneemann's message conveyed the importance of a specifically female consciousness and sexual experience, not only to women but to society as a whole. Paradoxically, her celebration of heterosexual pleasure was to lead, after 1970, to criticism from the other side: from the first wave of feminist theory to achieve ascendancy in the art world, in which a certain puritanism, and sometimes androphobia, played a significant part. Although this further delayed her receiving the recognition she deserved, she has now been acknowledged as the key figure she is in the development of feminist art.

Like Schneemann, Yayoi Kusama was based in New York in the 1960s, making work that prefigured the more overt handling of sex which characterised that of a large number of female artists since 1970. Kusama's soft sculptures, which incorporate endlessly proliferating phallic forms, are less straightforwardly celebratory; indeed she has stated that the motivation for making them was her fear of sex and of the male organ in particular.[7] Nevertheless, there is no denying the sense of liberation and pleasure that permeates her work. Kusama is depicted in numerous photographs posing naked in her installations: one such photograph shows her lying on her sofa consisting of hundreds of penises made of sewn and stuffed cloth. Her work also contains a great sense of humour, arising from the sheer sense of absurdity when chairs, ironing boards, rowing boats, shoes and all manner of familiar objects are invaded by hosts of phalli. Certainly the obsessive proliferation can be related to Kusama's precarious mental balance, and the title at least of one of the series of her performative photographs, *Self-Obliteration* (1966– 67), has a worrying aspect. While it is largely the sense of real psychic danger which gives Kusama's art its edge, this is balanced by a hedonistic sense of delight, visible, for example, in a photograph of her lying peacefully in semi-foetal position, apparently asleep, on her large pink sculpture *My Flower Bed* (1965–66). Kusama's pioneering art of

the 1960s belongs, to some extent at least, to that decade's ethos of flower power and faith in love.

This is less true of the slightly later work of Hannah Wilke and Valie Export. Despite the very different visions of the world these two artists project, it can fairly be said of both that, while their work is undoubtedly erotic, the balance has shifted to a more critical stance. Following her phallic and experimental sculptures of 1960–63, Wilke pioneered the use of vaginal and vulvic imagery as a signature feminist statement, demanding in 1973: 'who has the guts to deal with cunts?'[8] She made a large number of tiny sculptures out of brightly coloured chewing gum, the folded shapes of which resemble fortune cookies and, more significantly, female labia. She also stuck them all over her own body, suggesting both sexual abundance and wounds, to create works such as the photographic series *S.O.S. Starification Object Series* (1974). The installation of Wilke's *Ponder-r-rosa* series (1974–75) continued this vulvic imagery on a much larger scale, in delicate overlapping pink forms that evoke flower petals and exhibit 'a sexy wet look that emphasises the labial structure,' while recalling in its sensuous title Duchamp's 'Rrose Sélavy' (eros, c'est la vie).[9]

For Export, the female body was something of a feminist battleground, her art an attempt to reclaim it for the female subject. In her iconic performance *Genital Panic* (1969) she cut away a triangle from the front of her trousers to reveal her pubic hair and genitals and walked through a cinema that was showing porn films. In *Eros/ion* (1970) she rolled naked over broken glass, then over a pane of glass and finally onto a sheet of paper, on which she left small traces of blood, in an evident echo and rebuttal of Yves Klein's *Anthropometry* performances. Her photograph *Body Sign Action* (1970) shows a tattooed garter on her thigh, the garter functioning, for Export, as 'a sign of past enslavement...a symbol of repressed sexuality'.[10] Roswitha Mueller comments that this piece is 'a powerfully literal example of...the body as field of inscription by a social code'.[11] In one of her earliest works, *Touch Cinema* (1968), Export wore a box-like prosthetic device, through which members of the public were able to fondle her breasts. In a similar humorous and teasing vein was Orlan's *Le Baiser de l'artiste* (1977), in which she invited visitors to insert a five franc coin into a slot at the top of a prosthetic naked torso attached to the front of her body. The coin rattled down a vertical conduit into a triangular container situated between her legs. In return they were granted a kiss.

While Orlan's work made playful reference to commercial sex transactions, reclaiming the female body as a site of exchange, Cosey Fanni Tutti drew on her personal experience of the sex trade, as later did Annie Sprinkle. Both artists presented highly positive representations of sex, finding within the sex industry opportunities for female sexual enjoyment and empowerment. In actions such as *Womans Roll* (1976), Cosey revelled in the beauty of her own body, combining her awareness of the visual vocabulary of erotic posing with the potential for fluid movement inherent in yoga. In actions like that performed at the Hayward Gallery, London, in 1979, she created a magic circle using pleasurable objects such as feathers, strawberries, eggs and mirrors, with

which she then interacted, producing a sense of enchantment as well as an intense erotic charge.

With a background in burlesque, Sprinkle's work with Linda Montano, a crucial figure in the American performance art scene, confirmed her as an artist.[12] Her first performance in an art gallery was the provocatively titled *Deep Inside Porn Stars*, at Franklin Furnace, New York, in 1984. In this and subsequent performances, she refigured the restrictive language of the sex industry in order to find within it a positive vision of female sexuality. She declared: 'I was hooked on telling my own truth, expressing my reality – not simply performing someone else's sexual fantasy.'[13] The show transferred to The Kitchen, where it sold out, but was then greeted with a public outcry. Increasingly concentrating on helping other women to enjoy their own sexuality, Sprinkle went on in 1991 to found the Sluts and Goddesses Workshop, which was to be the basis of *The Sluts and Goddesses Video Workshop – Or How To Be A Sex Goddess in 101 Easy Steps* (1992).[14]

For Janine Antoni, interaction with her own sexual identity has taken the form of *Lick and Lather* (1993), self-portraits cast in chocolate and soap, which the artist licked and washed to slowly erase her own features. Antoni views the process as a loving one: 'chocolate is a highly desirable material and to lick myself in chocolate is a kind of tender gesture.'[15] She regards chocolate as a material infused with erotic qualities, not least, as she points out, because 'it has the product fenylamine in it. That product is the chemical that's produced in our body when we're in love.'[16]

Many female artists took as their subject the bodily experiences that are specific to women, often working against the visual taboos sometimes associated with such depictions: menstruation, pregnancy and childbirth. Judy Chicago's pioneering *Red Flag* (1971) is a photo lithograph of her removing a fully saturated used tampon from her vagina. Given the context, the deliberately provocative title made a clear link between the personal and the political. Her installation *Menstruation Bathroom* (1972) featured a trash can spilling over with used tampons and spots of

4. Annie Sprinkle, *Sluts and Goddesses Workshop* (1992).

blood on the floor. Less overtly polemical and more celebratory than Chicago's menstrual works, Carolee Schneemann's *Blood Work Diary* (1972), which consisted of one hundred squares of tissue and silver paper blotted with menstrual blood, presented an extremely beautiful image of menstruation.

Like many of Schneemann's works, including *Meat Joy* and *Interior Scroll*, the performance *Fresh Blood – A Dream Morphology* (1981) had its origins in a dream, which occurred on a night during which she began menstruating. In the dream, she accidentally stabbed a man's

thigh with a red umbrella, producing a spurt of blood.[17] It thus enacted the inversion of gender, or an androgynous ambiguity, in that it was a man rather than she who had started to bleed; this was reinforced by the symbolism of the umbrella. When stating that convex objects in dreams symbolised the phallus, Freud gave some specific examples, of which the umbrella was one: indeed, it had a special advantage, in that it was 'capable of erection'. The umbrella in Schneemann's dream was indeed phallic in the sense that it stabbed the man's thigh. However, it was pointing downwards and not opened out, so that its V-shape more closely resembled a vulva. Along with the umbrella, another image which remained from the dream was a bunch of dried leaves with small dolls' or babies' heads tucked into it, which again made a V-shape. Schneemann researched objects and images from several different spheres – sacred and erotic art, popular culture, science and nature – with the same shape, creating a visual and morphological vocabulary, as well as words beginning with the letter V, including vulva, vagina, victory, velocity and vector. These formed the basis of a performative lecture, which Schneemann gave holding an umbrella, as drawings of the dream images, together with the material resulting from her research, were projected on the wall behind her.

The final version of *Fresh Blood – A Dream Morphology* was altered by a series of further dreams, in all of which unwelcome female figures made an appearance, including a drunken grandmother, a nurse holding a pair of bloodied underpants on the end of a stick, and a messenger from Western Union chanting 'Don't forget...it all comes back...in other forms.' Schneemann interpreted these 'interruptions' as referring to aspects of her feminine self which she had thus far failed to integrate. It was clear from the dreams that her alter ego should be played by an African American woman. 'Her guises,' Schneemann has written, 'connected to cultural suppressions that had diverted women from our active links in a shared if disparate history – personal, social, racial, political, and sexual.'[18]

More recently, Pipilotti Rist's playful video *Blutclip* (1993) shows her naked body covered with coloured glass beads as blood runs down her leg to her feet. The resulting imagery is highly decorative, allying menstruation with the preciousness of gemstones, so that drops of blood take on the rich properties of rubies. Chen Lingyang's *Scroll* (1999) was an installation of tissues 'painted' in menstrual blood. Her more lyrical series *Twelve Flower Months* (2000–01) consisted of photographs of herself during each of her periods for one year and combined these with images of twelve different flowers, one for each month. The work highlights menstruation's links with the lunar path and the earth's cycle of continual regeneration; though menstrual blood signifies the unfulfilment of the reproductive potential of sex, it simultaneously points to a ongoing state of fertility.

The depiction of the pregnant body has offered some artists a way in which to break another visual taboo regarding the female erotic experience. One example is Susan Hiller's *Ten Months* (1977–79), a series of photographs taken by Hiller of her body during pregnancy, alongside excerpts from her journal from that period. They are arranged in ten 'lunar' months of 28 days each.[19] Kiki Smith made a series of four pregnant bellies (the last dated 1990), each

a unique cast in plaster taken from friends' bodies. Tinted to resemble the colour of skin, each sculpture has a hand-modelled, shieldlike rim.[20] Smith's use of the secondary title *Shield* for these works transposes a term traditionally the preserve of the male-dominated battlefield onto the image of the protective maternal body. Feng Jiali's *The Period of Pregnancy Must Be Art* (1998–99) displayed photographs of herself naked towards the end of her pregnancy, in some adorning her naked body with text or holding a butterfly to her abdomen.

Such reassertions of the pregnant body in the visual realm have been accompanied by a considerable amount of theoretical writing, much of it drawing on the language of psychoanalysis. Rosemary Betterton has explored the way in which the visual art practice of, among others, Susan Hiller, Marc Quinn, and Alison Lapper disrupt maternal ideals in visual culture through differently imagined body schemata. By examining instances of the pregnant body represented in relation to maternal subjectivity, disability, abortion and 'prosthetic' pregnancy, it asks whether the 'monstrous' can offer different kinds of figurations of the maternal that acknowledge the agency and potential power of the pregnant subject.[21] More poetic is Julia Kristeva's evocation of the crisis of identity which pregnancy entails for the mother:

> Cells fuse, split, and proliferate; volumes grow, tissues stretch, and body fluids change rhythm, speeding up or slowing down. Within the body, growing as a graft, indominatable, there is an other. And no one is present, within that simultaneously dual and alien space, to signify what is going on. 'It happens, but I'm not there.' 'I cannot realize it, but it goes on.' Motherhood's impossible syllogism.[22]

Kristeva's attempt to configure the complex processes of motherhood was influential for Helen Chadwick, whose collage work *One Flesh* (1985) updates the traditional iconography of the Madonna and Child with the inclusion of the physical realities of birth: the placenta and cutting of the umbilical cord. As in the traditional images to which it refers, the mother gestures towards her offspring's genitals, though here the child is female. At the top of the picture, in the position traditionally occupied by God the Father, is a gilded vagina shape, placing the organ of female sexuality in the role of the Creator.[23] Chadwick's work offers a considerably more positive and erotically charged view than Mary Kelly's earlier account of the subjective experience of motherhood. Kelly's work *Post Partum Document* (1973–79) chronicled the formative development of her son in terms of his acquisition of language, her reaction and a Lacanian psychoanalytic reading of the process. It is hard to see this as entirely celebratory. In the six consecutive series that constitute the work, Kelly presents a maternal narrative that is beset by conflict, in which motherhood is not natural and instinctual but a traumatic process of nurturing and separation.[24]

Still very much in play in many of the works so far discussed in this chapter are the stereotypical images of woman as whore, as virgin, and as mother that have informed representations of women and their sexuality for centuries. Whether countering such

images or adopting and overplaying them, female artists of recent decades have conjured with these visual iconographies in their battle to reclaim their own sexual bodies and assert their own subjective experiences. More subtle images of woman have reflected another archetype: woman as weaver, inspired simultaneously by the myth of Penelope and that of Arachne. Freud speculated that the female invention of plaiting and weaving might have its origins in an imitation of the way that pubic hair grows at the time of sexual maturity to veil the genitals.[25] Norman O. Brown relates this to the child's 'endless task' of resolving the trauma caused by the experience of witnessing the primal scene. For Brown, this impossible task is pursued through 'weaving a lie, a veil, a fetish', continuing through adulthood in the form of creating social and ideological systems: 'a tangle of hairs, a tissue of lies. The web of social action.'[26]

Janine Antoni's *Loving Care* (1993) is exemplary of the way in which female artists have incorporated hair into their work; Antoni dips her hair in paint and then mops the floor with it. This performance brings together the themes of hair and work, raising questions which go beyond the normal terms of debate about art in relation to domestic crafts and traditionally female forms of labour. Anoli Perera used lace, beads, broken porcelain and thread in her solo exhibition 'In the Entangled Web' (2001). 'I weave my work,' she said, 'like a spider weaving its web. I see the woman as that spider. She weaves her complex net of social, economic and cultural relationships around her. It becomes her safety net as well as the family to whom she is bound.'[27] Bourgeois' fabric sculptures, like *Seven in a Bed* (2001) and *Spiral Woman* (2003) relate both to her *Spider* sculptures of 1994 and her early memories of her father's tapestry works.[28]

Lin Tianmiao's installation *Proliferation of Thread Winding* (1995) makes the sexual connotations of thread explicit, as it spills out of a large almond-shaped gash in a bed. The sewing or stitching of lace or other materials may partly operate as a metaphor for displaced female sexual desire, a result perhaps of the rhythmic back-and-forth action of sewing. A more unsettling use of twine is that by Chiharu Shiota, such as in her installation *During Sleep* (2000), in which she encased beds in cocoons of black wool, dark webs that reach floor and ceiling, creating an uncertainty as to whether the environment is protective or constricting. In the following year, Shiota created her equally disturbing installation *Memories of Skin*, where large sculptures depicting dresses suspended on hangers also resemble carcasses or, as the title implies, detached skins. Bourgeois, for whom clothes assume a massive emotional importance, also links them with the skin and the body, as well as with memory.

A rather more usual explanation for the proliferation in women's art of clothes, very much including shoes and make-up, is that women have traditionally been defined by their appearance, by the image which they have become. As a consequence of this, women have identified with the image itself in a way that men have not. That is the main reason, according to Sylvia Eiblmayr, why work by female Surrealist artists was apparently less radical, certainly less destructive of the image, than the work by their male counterparts. In destroying the

image, they would have been destroying themselves. Rather, they were more likely to show themselves disappearing into the image, or into the wallpaper. Excellent examples of such pictures are Dorothea Tanning's *Jeux d'enfants* (*Children's Games*, 1942) and *On Fire* (1949).

For Helaine Posner, women's self-portraits tend to be more ambiguous than those of their male counterparts, which may be taken to be self-revelatory. Writing about Yayoi Kusama, Ana Mendieta and Francesca Woodman in the context of Surrealism, she claims:

> Situated somewhere between exposure and disguise, their multiple self-representations simultaneously reveal and conceal both their bodies and identities. As opposed to any initial expectation of a simple assertion of the self, we are struck by the tension that exists between an assertion and a corresponding denial of self.[29]

For Paglia, this typically female playing with exposure and disguise relates to the 'profound significance' of striptease, the particular visual dynamic of which will be discussed later in this book.

Where female artists in the 1960s and 1970s challenged the objectification of the male gaze by asserting their own ability to invite it, with art that centred on empowering their own bodies, some more recent work has reflected that gaze back towards the male body. Sam Taylor-Wood's famous video portrait of the sleeping *David Beckham* (2004) is a notable example that focuses on an image of masculinity in a private or emotionally revealing state. Such an approach has remained, however, the exception rather than the rule.

With women becoming the authors of images, the traditional sense in which 'woman is the picture' is inevitably transformed. Now the looked-at becomes, also, the looker. To the extent that female spectators traditionally saw images of their own sex through male eyes, as Laura Mulvey has argued, this too has changed. Female authorship and female spectatorship are explored in especially interesting ways in the work of Maria Klonaris and Katerina Thomadaki. They have emphasised the notion of the 'loving gaze', by which the subject in front of the camera ceases to be objectified. Frequently they have filmed each other, now one behind the camera and the other, the 'actante', in front of it, then with roles reversed. Part One of *Double Labyrinth* (1976) consists of six actions performed by Thomadaki and filmed by Klonaris; Part Two of six actions performed by Klonaris and filmed by Thomadaki. If the camera can be seen as a mirror, it is so in a very special sense. In relation to *Double Labyrinth,* they have written:

> Immersion. From now on our focal point will be the unconscious and the domain of the imaginary. Events taking place on the other side of the mirror. The body as identity, the identity as territory of the body... the camera lens as mirror, the loving gaze as revelation.[30]

The Unheimlich Cycle (1977–81) posited the return of the feminine in terms of the Freudian 'uncanny'. References to the archetypal and mythological female figures from their native Greece are infused with the intellectual sensibilities of their adopted Paris. They cite Luce

Irigaray's formulation: 'it seems to me that the first question one should ask is what the repressed feminine could be in what is currently termed unconscious...whether the feminine *has* an unconscious or *is* the unconscious?'[31]

In a gesture that defies the more usual personification of the male member, Carolee Schneemann adopted the personification of 'Vulva', resorting to the third person as a means of expressing the struggle to define female sexuality in the face of the overwhelming competition of theoretical and political claims for it:

Vulva goes to church and discovers she's obscene...
 (quote St Augustine)
Vulva deciphers Lacan and Baudrillard and discovers she is only a sign, a signification of the void, of absence, of what is not male...(she is given a pen for taking notes...)
[...]
Vulva studies Freud and realizes she will have to transfer clitoral orgasm to her vagina....
Vulva reads Masters and Johnson and understands her vaginal orgasms have not been measured by any instrumentality and that she should only experience clitoral orgasms...
Vulva decodes feminist constructivist semiotics and realizes she has no authentic feelings at all; even her erotic sensations are constructed by patriarchal projections, impositions, and conditioning...
[...]
Vulva interprets essentialist feminist texts and paints her face with her menstrual blood, howling when the moon is full...[32]

Historically, in art as in all parts of society, female sexuality has been an unknown quantity, conceived around an enigma, the hidden, the unknown and the unconscious, offering not a finite destination but a realm in which to search. The necessity for female artists to express their own sexuality and authentic desires has been counterbalanced by an impulse to deconstruct the limitations of a male vocabulary: representations of female sexuality appear alongside examinations of the means of representation itself, creating new ways of affecting as well as reflecting female sexual experience. Certainly female sexuality is still something to be created collectively, an open-ended quest, in which artists can play a leading part. It need hardly be said that this gives an enormous sense of opportunity.

Chapter 3

Divergent Sexualities

Just as the innovative ferment of the 1960s led to the rise of feminism and the improvement of the position of women in society over subsequent decades, it also led to a more accepting attitude towards homosexuality and other divergences from the sexual norm. Although homosexuality is still viciously repressed in many parts of the world, and is by no means universally accepted in the West, the extent to which attitudes have changed in recent decades is remarkable. Overtly homosexual imagery has become increasingly plentiful, in art as well as elsewhere. Again, changes in public attitudes have been accompanied by developments in theoretical writing. More recently, not only homosexuality but a diverse range of sexualities have been celebrated in 'queer theory', which has proved highly influential on critical writing in the arts. It should not be forgotten, however, that during the 1960s homosexuality remained largely taboo; so that, as with the pioneering work of feminist artists like Schneemann, Wilke and Kusama, work of that decade which included gay subject matter was courageously innovative.

Nevertheless, in New York a discernible change occurred around 1960 in the character of the artists who were receiving most attention. Whereas their predecessors in the 1950s had typically been thoroughly masculine, hard-drinking and roughly dressed, the new generation – still predominantly male – tended to be more feminine, dapper and, in many cases, gay. With artists like Robert Rauschenberg and Jasper Johns, who produced little or no overtly sexual imagery, the change consisted, as with John Cage and Merce Cunningham, in a different sensibility: less heroic, subtler and more inclusive.

Andy Warhol shared this sensibility; but he did also begin to introduce overtly homosexual imagery. This happened first, albeit mixed in with heterosexual imagery, in some of his films, including *Kiss* (1964), *Couch* (1964) and *Vinyl* (1965). *Blow Job* (1964) is ambiguous: we are shown only the head and shoulders of a young man in a mounting state of excitement as, we

may presume, fellatio is performed upon him by an unseen person. In 1965 Warhol began the practice of letting other people co-direct his films, some of which had an exclusively gay content, notably *My Hustler* (1965), made with Chuck Wein, and *Lonesome Cowboys* (1968), made with Paul Morrisey. Warhol later explored issues of gender in a series of silkscreen portraits of drag queens, entitled *Ladies and Gentlemen* (1975), and then in a series of polaroid self-portraits in drag in the early 1980s. Exploring objects of desire rather than questions of identity, his *Torsos* series of silkscreens, which he exhibited in 1977, were based on polaroids of attractive young men, cropped below the neck and above the knee to emphasise the genitals and buttocks. Whereas importing erotic images into the arena of high art had traditionally involved softening the sexual content, Warhol increased it so that the images, while referring to the high-art tradition of the male nude, unmistakably resemble gay pornography.[1] Images graphically depicting gay sex taking place followed with the suite of six silkscreen prints entitled *Sex Parts* (1978).

Overtly homosexual imagery appeared much earlier and more uncompromisingly in the work of Kenneth Anger. His film *Fireworks* (1947), made when he was seventeen, depicted the onanistic fantasy of a youth dreaming of being beaten up and eviscerated by a group of sailors. His violent and occultist *Scorpio Rising* (1964) centred on a gang of gay motorcyclists and quickly assumed a gay cult status. In one scene, the lingering shots of studded leather, torn denim and chains donned by a young biker are accompanied on the soundtrack by *Blue Velvet*, the softness of the velvet worn by the girl in the song's lyrics sensually contrasted with the roughness of the young man's outfit. The film offers a celebration of his sexual persona, the trappings of exaggerated masculinity. This raises the question of whether Riviere's notion of femininity as masquerade can be extended to apply to both genders, so that one could with equal justice speak of a 'masculine masquerade'. Anger's *Kustom Kar Kommandos*, made the following year, continued to explore similar themes, undermining the macho violence implied by the KKK of its title with the camp embodied in a fluffy white duster polishing shiny chrome. Many avant-garde film-makers working in the USA in the 1960s used the medium to explore their own homosexuality. The work of Gregory Markopoulos centred on romantic male love with reference to Greek mythology and imagery, including the films *Twice a Man* (1962–63) and *The Iliac Passion* (1964–66), which starred, among others, Andy Warhol and Jack Smith.

Smith's own fame as a film-maker rests chiefly on his comic, fantasmagoric and trashily beautiful black-and-white *Flaming Creatures* (1962–63), and to a lesser extent its even more luxuriant follow-up *Normal Love* (1963), the visually lush quality of which derived largely from the out-of-date colour stock which Smith used to make it. Jonas Mekas, a leading figure in the American avant-garde film world, said of *Flaming Creatures* that in it Smith had 'attained for the first time in motion pictures a high level of art which is absolutely lacking in decorum; and a treatment of sex which makes us aware of the restraint of all previous film-makers'.[2] Indeed, the androgynous appearance of the 'creatures' would make their gender difficult to divine,

were it not for the exposure of their genitalia. Initially banned in the state of New York and almost everywhere else where it was attempted to be shown, the film has now achieved iconic status for those seeking a history of queer aesthetics.

Working in Britain, Francis Bacon created paintings that, though they should not be read solely in terms of homosexuality, contain a distinct homosexual subject matter, clearly visible in works such as *Two Figures* (1953) – which depicts two male bodies in a sexual embrace on a bed – and *Two Figures in the Grass* (1954). These paintings were produced within the highly repressive situation of the 1950s, when their evidently sexual subject matter and Bacon's own homosexuality remained largely unremarked upon. The dark sensibility of Bacon's paintings, which powerfully convey the raw tragedy of the human condition, may be seen to stem in part from the frustration engendered by such repression. Later, that element which in Bacon's paintings remained necessarily implicit would be brought into the open in John Maybury's film *Love is the Devil: Study for a Portrait of Francis Bacon* (1998), which focuses on the relationship between the painter and George Dyer. A small-time criminal, Dyer dropped through a skylight intending to rob Bacon's studio but was instead taken to bed. Their tumultuous relationship would end, after Bacon increasingly sought his kicks elsewhere, in Dyer's suicide.

Where Bacon's visual distortions functioned in part to mediate the controversial subject matter of his paintings, David Hockney was, during the 1960s, one of the first British artists openly to celebrate his homosexuality, in works that are characterised by a comparative sense of sunlight and visual clarity. His early paintings, still showing the influence of pictorially radical styles like Art Brut, included *Doll Boy* (1961), a tribute to Cliff Richard upon whom he had a crush, and *We Two Boys Together Clinging* (1961), the title of which was taken from a poem by one of his heroes, Walt Whitman. The imagery in *Domestic Scene, Los Angeles* (1963), showing two men taking a shower, was largely derived from *Physique Pictorial*, one of the few magazines which featured nude men at that time, and was painted before he went to Los Angeles himself. His discovery of that city, with which he fell instantly in love, coincided with his turn to acrylic paint and the flat, almost photo-realist style for which he was long famous. Key works in the new idiom include *The Room, Tarzana* (1967), which depicts a boy lying face down on a bed, dressed only in a white T-shirt and white socks, and *Peter Getting Out of Nick's Pool* (1966). As well as featuring young male buttocks, both suggest a hot, langorous, erotically charged afternoon.

Hockney's open assertion of his gay artistic identity paved the way for other artists – although the extent to which gay painting became identified in England with Hockney was one of the reasons that Derek Jarman diversified and took up film-making, inspired too by the underground film-makers of the USA. Jarman would use both painting and film-making in parallel throughout his life. His first films were the Super-8 home movies that chronicled his flamboyant lifestyle, in which homosexuality played a large part. His first feature film, *Sebastiane* (1976), with Latin dialogue, drew on the traditional status of St Sebastian as a homoerotic icon. The film showed naked Roman soldiers engaging in evidently homoerotic and

sadomasochistic acts. Later feature films included biographical studies of famous gay historical figures, emphasising their sexuality in order to reinsert homosexuality into the heteronormative historical canon: *Caravaggio* (1986); *Edward II* (1991), based on Marlowe's play; and, less usual to be considered in this light, *Wittgenstein* (1993). Jarman also made a considerable body of video work, including a pop promo for the Pet Shop Boys. In his final years, as he was dying of AIDS, he produced furiously made paintings, resembling Abstract Expressionism but including scrawled words, with titles like *Dead Sexy, Evil Queen, Scream* and *Fuck Me Blind* (all 1993). Jarman was throughout his career a gay – or 'queer', as he came to prefer – activist, and his art was always in large part at the service of that cause. Nevertheless, despite its crusading zeal, it always possessed both a visionary and poetic quality and a thoroughgoing sense of humour.

While Jarman epitomised the swinging scene in London in the early 1970s, Gilbert and George placed themselves apart by dressing always in formal suits and ties at a time when most young men wore flared trousers and long hair. Masters of self-promotion, one of their earliest performance pieces was *The Meal* (1969), for which they invited David Hockney to dinner. Their photographic works nearly always include images of themselves, often alongside graphic sexual and scatological imagery. *The Dirty Words* series (1977), which took individual titles from graffiti found around the city, included such overtly homosexual references as *Bent, Queer* and *Bugger* at a time when such words were considered terms of insult. *Shame* (1980) shows a naked youth, head bowed, surrounded by an arch of thorned plants, inevitably suggesting an element of martyrdom. Apart from themselves, the other human presences in their pictures are mostly male adolescents. Among their non-photographic works, executed in a crude graphic style, is *Hunger* (1982), which shows two men greedily sucking each other's penises, while in its companion piece *Thirst*, streams of urine from crossed penises into opposing mouths are so straight that they resemble drinking straws.

Also working in London, Jean-Marc Prouveur made photographic works which juxtaposed homoerotic images of young men with images of, for example, the elements earth and water, or deserted streets and parks at night, evoking multiple erotic associations. The figures in his series *The Fall* (1989) are naked, sometimes appearing in twos or threes, and seem to be floating or suspended in space. The accompanying landscape images are mostly taken from the heavily overgrown Abney Park Cemetery, London, a well-known gay cruising ground, and also include pictures of the kind of pebbles used on graves. Prouveur made a number of works on the theme of war and its remembrance, in which photographs of actual war memorials, sometimes including naked soldiers, featured prominently. Stressing the stillness inherent in both sculpture and photography, Prouveur's work is informed by a Neoclassical sensibility in which he locates a latent necrophiliac element.

Robert Mapplethorpe imbued the Classical male nude with an explicit sexuality that was widely considered controversial. His homoerotic photographs display a distinctly sculptural quality, the smooth skin of toned and youthful male bodies reminiscent of the marble of Classical statues. In addition to the obvious fetishistic subject matter of many of his works,

there is a sense in which the smooth, cool and hard-edged style of Mapplethorpe's photographs may be considered more broadly in terms of the separable borders of the fetish. Julia Kristeva's discussion of Renaissance art in terms of a distinction between the Florentine representation of the 'body as fetish', on the one hand, and the Venetian dissolving of the body into 'luminous, chromatic differences', might be extrapolated to understand Mapplethorpe's work as belonging resolutely to the former category.[3] It was perhaps this element of Classicism that ultimately defended Mapplethorpe's work against numerous accusations of 'pandering obscenity' levelled at him from conservative and religious organisations.

The gay club scene offered a cultural outlet for many key artists of these decades, providing an invaluable performance venue and visual reference point. One of these was the club legend, performer and costume designer Leigh Bowery, whose collaborations included the dancer Michael Clark, and the photographer Fergus Greer, who documented Bowery's flamboyant creations between 1988 and 1994. Bowery, who died in 1994, was the subject of Ron Athey's *Trojan Whore* (first performed in January 1998). In 1981, aged nineteen, Athey began performing in underground galleries in Los Angeles in a collaboration called *Premature Ejaculation*. Heavily tattooed across his entire body, he has made a number of solo and collaborative performance pieces centring around issues of his sexuality and HIV-positive status. His solo performance *Solar Anus* (first performed in October 1998) was inspired by Georges Bataille's 1927 text with the same name.[4] It refers too to the sunburst tattoo that surrounded Athey's anus – a literalisation of the vulgarism 'the sun shining out of his arse' – and draws attention to the classic analogy between gold and excrement. Athey appeared wearing boots with an extra heel that projected backwards just above the ankle, with which he sodomised himself. Bending over, he slowly pulled a long string of pearls out of his anus. Throughout the performance his eyelids were held open with hooks, and he wore a gold crown, a degraded but eternally vulnerable 'Sun King'. *Solar Anus* is reminiscent too of the self-portraits made by Pierre Molinier between 1966 and 1970, which include a photograph of the artist in silk stockings sodomising himself with a dildo – alongside a text describing his degradation as a means to ecstasy in a spirit extremely close to that of Bataille – and another of his leg in a dildo-heeled shoe.

More tender is the work of Isaac Julien, which centres around black male desire. He studied at St Martin's School of Art, London, and his work straddles, as did Derek Jarman's, the worlds of art and film. The film *Looking for Langston* (1989) is a lyrical and homoerotic tribute to Harlem Renaissance poet Langston Hughes. Julien creates a dream-like montage of archival and imagined scenes, layering visual references to the work of African American photographers George Platt

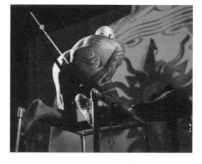

5. Ron Athey, *Solar Anus* (2006).

6. Isaac Julien and Sunil Gupta, *Looking for Langston: Nudes With a Twist 1953*, (1989).

Lynes and James van der Zee, interweaving the words of poet Essex Hemphill with beautifully choreographed scenes of erotic fantasy that shift in time and place, from Harlem speakeasy to London's St Pancras Chambers. The film moves beyond the boundaries of the biographical documentary to question the wider historical importance of a homosexual black contribution and its repression, the 'impossibility of a homosexual or gay desire being articulated through Black cultural icons', a concern that informs much of Julien's work.[5]

The implications of inter-racial homosexual desire, explored perhaps most strikingly in *Frantz Fanon: Black Skin, White Mask* (1996), is a recurring theme. The protagonists of Julien's 1993 film *The Attendant*, a black uniformed male museum guard and a young white male visitor, enact an erotic sadomasochistic fantasy against the backdrop of the academic history painting *Slaves off the Coast of Africa* (1833, hung in the abolitionist Wilberforce Museum in Hull), which comes alive to become a complicit setting for their encounter.[6] Julien's reworking of canonical images is part of a strategy that brings oblique insights to our perceptions of historical processes, one that Kobena Mercer has rightly identified with Foucault's assertion of homosexuality's 'slantwise position' as a means to access history's 'relational virtualities'.[7]

The works discussed thus far reflect the deeply personal interests of their gay male creators, whose own sexuality becomes the self-reflexive subject of their work. It seems more difficult in the case of lesbian artists to distinguish work about their sexuality from that which deals with wider feminist concerns: often these two perspectives merge. At the same time, the

creation of specifically lesbian art in recent decades has naturally been facilitated by a combination of the improved position of women artists and the more accepting attitude towards homosexuality.

The lesbian artist Sandra Lahire, most famous for her trilogy of films about Sylvia Plath, studied alongside Julien at St Martin's School of Art, London. Though the short film-loop *Eerie* (1992) does feature a lesbian kiss, Lahire seldom included directly homoerotic subject matter in her films. She and her lover, the film-maker Sarah Pucill, worked closely together. The kaleidoscopic imagery of Pucill's film *Swollen Stigma* (1998) imbues the everyday with an erotic element through lingering attention to the surface of the body, flowers, and ice and water, given a more overtly lesbian focus by the phantasmal figure of the lover who appears in brief and colourful flashes throughout. The film sets up a relationship between the tangible nature of the body and the diaphanous appearance of superimposed imagery, exploring the exchange between inside and outside, transforming the stigma as a mark of disapproval into its fertile clitoral inverse. Lahire interprets the film in terms of 'inversion, both optical and sexual'.[8] Following Lahire's untimely death, Pucill made *Stages of Mourning* (2003), re-enacting photographs and film footage of her late lover as a means of working through her bereavement.

While London acted as a crucible of politically aware artistic ferment that produced a significant group of gay and lesbian artists and film-makers, the particularly intense political fervour that proliferated on the West Coast of the United States provided the motivation for a group of lesbian artists centred around San Francisco. Though drawing on personal sexual experience, their involvement in collaborative ventures, or participation in explicitly sociological projects made clear a shared political motivation. Working in the San Francisco Bay area from the 1960s, Tee A. Corinne made photographic portraits of lesbian poets – including Willyce Kim, Pat Parker and Judy Grahn – and authors such as Valerie Taylor, Anita Cornwall and Jane Rule. Corinne's highly aesthetic solarised photographs from the 1970s frequently depict women kissing and embracing: 'I decided on lovemaking images,' she has stated, 'because lesbians are so often defined by sexuality, but loving images were, at that time, very difficult to find.'[9] This emphasis does not, however, preclude highly sexual imagery: *Some Come in Threes #1* (1973) shows three women fused in explicit orgiastic embrace in an image that appears almost baroque in its sculptural composition. *Woman in a Wheelchair with Able-bodied Lover #1* (1979) shows the couple kissing in a manner reminiscent of Rodin. Corinne was one of the founders of *The Blatant Image: A Magazine of Feminist Photography*, which had grown out of annual meetings known as 'Feminist Photography Ovulars', and was published each year between 1981 and 1983. Also a co-facilitator of the Ovulars was the photographer Carol Newhouse, who had co-produced the book *Country Lesbians* (1976).

Another key vehicle for the publication of the work of this group of West-Coast lesbian photographers was the influential San Francisco-based magazine *On Our Backs*, founded in 1984 to counter the anti-pornography tendency in mainstream feminist and lesbian circles. Its title was a rebuttal of the lesbian newspaper *Off Our Backs*, and it proudly proclaimed itself

'Entertainment for the Adventurous Lesbian', a reworking of *Playboy's* 'Entertainment for Men'. From its second issue it was edited by Susie Bright, a prolific writer and publicist on sexual issues, who would adopt the moniker 'Susie Sexpert' and later collaborated with Jill Posener on the book of photographs *Nothing but the Girl: The Blatant Lesbian Image* (1998). Among those artists whose work was reproduced in *Off Our Backs* was Bright's partner Honey Lee Cottrell, who had started taking pictures of herself and her lovers around 1968, as a means of documenting her 'interior states as well as situating this experience in the world'.[10] A series of gallery exhibitions in the mid-1970s, and the 1979 publication, *I Am My Lover*, which showed a series of photographs of women pleasuring themselves, established Cottrell as an important figure in the photography circles of the West Coast.

Exploring for some time the edges of gender and sexuality, Maria Klonaris and Katerina Thomadaki would, in the 1980s, make art that specifically focused on androgyny. The *Hermaphrodite Cycle* (1982–85) took as its starting point the Hellenistic sculpture of the *Sleeping Hermaphrodite* in the Louvre. *Mystery I: The Sleeping Hermaphrodite* (first version 1982; second version 1983) investigated the fascination which that sculpture has always exerted. They created a mysterious environment using slides and loops of Super-8 film projected onto screens arranged at different angles throughout the space. True to its source, this work explored both the ambivalence inherent in the image of the hermaphrodite – on the one hand a symbol of perfection and totality, the overcoming of the opposition of the sexes, and on the other a neutered and rejected creature – and also the theme of sleep, described by the artists as 'the charismatic state which opens us up to our own transparency and the transparency of the world'.[11] The performance installation *Orlando: Hermaphrodite II* (1982) conjured Woolf's eponymous hero(ine) through colour, light and texture: 'masked games inverted, *transvestments*, slippages on the transparency of the frontier of the sexes'.[12]

The starting point for their cycle of work on *Angels and Archangels* (1985–2003) was a photograph in the collection of Klonaris' father, a gynaecological surgeon, of a blindfolded figure with female genitalia but a male body: not so much a being with the attributes of both sexes as one almost without sex or, in the neologism coined by Lacan and used by Catherine Millot in her essay on transsexuality, 'horsexe'.[13] Despite the supposedly 'clinical' nature of this photograph, for Klonaris and Thomadaki it was so resonant that they continued to use it, reworking it, digitally altering it and transforming it in myriad different ways, for eighteen years. Their 'Intersexuality Manifesto' points to the figure of the Angel as a means to go beyond the gender binary:

> If the hermaphrodite incarnates the ancient myth of sexual duality coexisting in one single body, if the transvestite reverses sex, displacing it towards its opposite, the intersexual questions the very constitution of sexual binarity. Our reflection on gender has progressively focused on the intersexual figure, the Angel, because s/he formulates the most radical position: neither a synthesis, nor a reversal, but an in-between in transit. The trespassing of the dichotomous male/female embodied by this figure is interconnected

with the trespassing of other dichotomies, such as body/spirit, subject/object, I/other, I/World.[14]

Vivien Lisle's *Legitimate Journey* (1982) is based on the memoirs of the nineteenth-century French hermaphrodite Herculine Barbin, which were republished in 1980 with an introduction by Michel Foucault.[15] Brought up as a girl, Barbin had confessed to her local bishop her sexual desires for another woman, been referred to a doctor and eventually reclassified as a man. *Legitimate Journey* built upon Lisle's earlier performance *Vertical Courage* (1980), which centred around themes of St Sebastian and bondage; however, whereas the earlier work was conceived largely in terms of polar opposites, the later piece countered the notion of binary classification, proposing androgyny as a model for accepting ambiguity.

The exhibition 'Transformer: Aspekte der Travestie' held at the Luzern Museum in 1974, reflected an androgynous sensibility that was widespread in the 1970s (and would continue into the 1980s with the exhibition 'Androgyn' in Berlin in 1986). The show's title alluded to the album *Transformer* by Lou Reed, which had been released in December 1972. As well as the cross-over between genders, the exhibition also emphasised that between art and rock music, including David Bowie, Brian Eno and the New York Dolls. It centred on the work of Urs Lüthi, whose self-portrait *I'll Be Your Mirror* (1972) shows the artist with long hair appearing very feminine; he looks straight at the viewer, the words of the title inscribed beneath his crossed arms, while the entire photograph is surrounded by a wide frame to appear like a mirror, fully implicating the viewer. The exhibition also included work by Andy Warhol and Pierre Molinier, alongside much younger artists like Luciano Castelli, Jürgen Klauke and Katherina Sieverding, the only woman in the exhibition. Through its catalogue, Molinier discovered Castelli's work, inviting him to stay in March 1975. That spring, Molinier made a further series of photographs on the theme of androgyny, using the artist Thierry Agullo as his model: Molinier insisted that Agullo shave his legs although his face appears highly masculine, even in make-up.

Michel Journiac's *Piège pour un travesti - Greta Garbo* (1972) may be considered to anticipate the ideas expressed by many works in the 'Transformer' exhibition, implicating the viewer even more directly than Lüthi's *I'll Be Your Mirror*. It consists of a series of three photographs of the professional transvestite Gérard Castex and a mirror on which Garbo's name is inscribed. In the first photograph Castex is dressed as a man; in the second he is naked but conceals his sex; the third shows him dressed and made up as Greta Garbo. The mirror which ends the series constitutes the 'trap' (piège) of the title, forcing the viewer to interrogate his (or her, but one suspects especially his) socially constructed identity. The fascination with the glamorous figure of the female diva is perhaps best embodied in the work of Yasumasa Morimura, who has made a number of self-portraits in which he impersonates female film stars, including one of the most well-known, *Self Portrait - Red Marilyn* (1996). In addition to Monroe, Morimura has produced works that show him dressed up as Marlene Dietrich, Greta Garbo, Liza Minelli, Brigitte Bardot and Sylvia Kristel. The irony in Morimura's work, evident also

in his self-portraits restaging famous works of Western art, is typically postmodern; the trans-gender implications mark it out as belonging squarely to within the territory of 'camp'. While there is an element of camp in a fair amount of the work by gay men discussed in this chapter, it is perhaps most spectacularly present in the work of Pierre et Gilles, which also underscores the point that the camp sensibility relishes an affectionate albeit ironic engagement with the icons of popular culture. It is a sensibility notoriously resistant to definition, although artifice, extravagance and frivolity are clearly central to it. Towards the end of her classic essay 'Notes on "Camp"' (1964), Susan Sontag attempts to explain why there is a 'peculiar affinity and overlap' between camp and male homosexuality, suggesting that it reflects an almost political strategy: 'Homosexuals have pinned their integration into society on promoting the aesthetic sense. Camp is a solvent of morality.'[16] More recently, there has been the suggestion that queer theory should involve 'queering theory', that is, introducing a dose of frivolity and playfulness into the theoretical arena.

Nan Goldin's engagement with marginal social scenes is evident throughout her work; she first started photographing drag queens in 1972, aged eighteen. She strongly admired and identified with those she was photographing, seeing them as 'a third gender that made more sense than either of the other two'.[17] In their exploration of a trans-gender aesthetic, both she and they were inspired by works such as Jack Smith's *Flaming Creatures*. In 1990 Goldin returned to the subject of drag queens, taking a new series of photographs including works such as *Jimmy Paulette after the Parade* and *Misty and Jimmy Paulette in a Taxi, NYC* (both 1991). If there is an element of tackiness in these images, this in no way detracts from their beauty and glamour but rather redefines these categories, infusing them with a new kind of poetic eroticism.

Moving in the opposite direction, Leigh Crow has made a career out of performing as her alter ego Elvis Herselvis, predicting that Presley could become as much an icon for gay women as Marilyn Monroe for gay men. Certainly the King of Rock seems a suitable model for drag kings; it is crucial, however, that in her performances she is not attempting a realistic impersonation but rather is playing herself as an Elvis impersonator. The notion that femininity is a masquerade has found widespread acceptance largely because, in a quite literal sense, it involves make-up and deliberate artifice. For the same reason, the notion that masculinity, often associated with rugged nature and straightforwardness, is equally a masquerade, is less obvious. If the artifice in masculinity, with all its attendant props, is exposed in work like Kenneth Anger's, it is brought out more fully in the work of predominantly lesbian women attracted to it not as a desirable 'other' but as a congenial role model for themselves. Judith Halberstam, whose book *Female Masculinity* (1998) charts the history of gendered figurations of masculine women, participates in the drag king community as 'Jack Halberstam'. Sadie Lee's painting *Raging Bull* (1994), which expresses the idea of female masculinity in the form of a short-haired, strong-armed woman in short-sleeved white T-shirt, is reproduced on the book's front cover.

Halberstam collaborated with Del LaGrace Volcano on the collection of *Drag Kings* photographs, which documented the drag-king scenes in New York, San Francisco, London, Berlin, Milan and Paris in photographs, text and interviews. These included the droop-moustached *Duke, King of the Hill* (1997), as well as *Elvis Herselvis* (1997). Produced using the name Della Grace, the 1991 photographic book *Love Bites* had provided a significant and controversial early study of lesbian sexuality documented from within the scene. The punningly-titled *Tongue in Cheek* (1992) depicts two shaven-headed women, naked save for heavy black boots, their backs arched and tongues protruding, sculpturally poised on the brink of lesbian rimming. Created under the new identity of Del LaGrace Volcano, a self-defined 'gender variant visual artist' and 'gender abolitionist', the artist's more recent work presents an identity that breaks out of the binary imperative into the more fluid realm of 'intersex by design'.[18] His psychedelic *Liquidfire* series of photographs (2000), in bright yellows, reds and greens, include intimate close-ups of hermaphrodite sexual organs and couples of indeterminate sex making love.

Catherine Opie, as well as photographing Ron Athey, has produced many photographic self-portraits and pictures of drag kings. A *Self-Portrait* of 1993 shows the artist's broad back, into which are carved stick-like diagrammatic representations of two female figures holding hands, and behind them a house. *Self-Portrait/Pervert* (1993) shows her frontally, seated, with a black hood covering her head, motifs cut into her chest above her breasts, and spikes running down both arms. *Self-Portrait/Nursing* (2003), by contrast, shows her breastfeeding a baby. Her double portrait of the hirsute *Mike and Sky* (1993) – both, like Opie herself, with tattooed right arms – is typical of her work on drag kings. Her portfolio *O* (2000) isolates sadomasochistic motifs, including handcuffs and pins piercing flesh, presenting them in seven highly aestheticised but disturbing images.

A major influence on women, including artists, interested in trans-gender issues is Patrick Califia, who has himself crossed the gender divide. He was formerly Pat Califia, probably most famous for her novel *Macho Sluts* (1989), expounding the delights of lesbian BDSM. Her first book had been the non-fiction *Sapphistry: The Book of Lesbian Sexuality* (1988). Since he became a man, his published works have included *Sex Changes: The Politics of Transgenderism* (1997) and *Speaking Sex to Power: The Politics of Queer Sex* (2001). Coming from an initially heterosexual rather than homosexual position, the artistic entity Breyer P-Orridge is

7. Del LaGrace Volcano, *Tongue in Cheek* (1992).

conceived as the merging of its two 'halves', Genesis Breyer P-Orridge, formerly Genesis P-Orridge, and his second wife Lady Jaye Breyer P-Orridge, née Jacqueline Breyer. Stressing the artificial nature of gender and of the naming process, they view current definitions as noxious limitations, seeking to transcend them through their notion of the 'pandrogyne'.

The desire to move beyond the linguistic constraints of conventional labels has been a major motivation in the recent rise of 'queer theory'. The phrase, indicative in its defiant reclaiming of a term of homophobic abuse, is believed to have been coined in 1990 by Teresa de Lauretis, though she would later abandon it. Characterised by their focus on the fluidity of identity, drawing on the work of Judith Butler among others, theorists have attempted to recover those marginal positions that challenge and destabilise heteronormativity. Queer theory and queer aesthetics might seem to be proposing a utopia in which all types of sexuality are permissible. One form of sexuality, however, which has become less rather than more acceptable – in academic and artistic circles as in society at large – is paedophilia. It is even conceivable that the increasing tolerance of adult homosexuality and an increasingly strong abhorrence of paedophilia may be directly related, that age has replaced gender as the principal criterion of taboo.[19]

Art's questioning and challenging status at the edges of society, posing questions without easy answers, echoes the marginal position mapped out by queer theorists. The diversity and proliferation of divergent forms of sexuality explored in the art of recent decades puts into very serious question the meaningfulness of any one sexual norm. Just as no one definition can be given of what might constitute female sexuality, no one definition can be given of what constitutes a desirable model for human sexuality in general. Many new possibilities have been opened up and the overall effect of this has undoubtedly been liberating and enabling. The boundaries of what is sexually permissible have, in art as elsewhere, been re-drawn; though those boundaries have certainly not disappeared, the territory they enclose is vastly increased.

Chapter 4

Intercourse

Carolee Schneemann's film *Fuses* (1964–67) shows the artist and her then lover, the composer James Tenney, making love. Extremely radical when it was made, not only in its explicitness but also in its subtlety of approach, it remains to this day one of the most significant depictions of sexual intercourse in art.[1] In the case of film, explicit depictions of sexual intercourse have almost always been either medical or pornographic, with a marked absence of emotion; while those films which have focused on emotional love have tended to draw a discreet veil over the sexual act. *Fuses*, by contrast, combines a recording of the physical facts, free of any sense of prurience, with a highly poetic visual evocation of the emotional experience of those involved. The guilt-free objectivity is achieved partly through the device of conceiving the film as if seen through the eyes of their cat, Kitch, who was in fact a frequent witness of their sexual activity. The emotional intensity is conveyed largely through the way in which the surroundings in the room and outside through the window are intercut with the lovers' actions, suggesting a free flow of thoughts, memories and feelings and an eroticisation, as far as the lovers are concerned, of the whole world.

Fuses is a non-sequential collage, composed from very short sequences of film shot on wind-up Bolex cameras, sometimes hand-held, sometimes placed on a fixed support, and sometimes suspended from the ceiling, introducing an element of chance in terms of the exact imagery that the camera captured. Schneemann's background and continuing sensibility as a painter is reflected in the complex layering of imagery in the film, as well as its strong formal structure. She manually altered the film stock, using techniques that included baking, burning and dipping it in acid, to create seductive visual effects and suggest the tactile experience of sex. Multiple print generations of the same image recur sideways and upside down, while the different speeds, exposures and angles of the camera echo the shifts in position of the protagonists themselves, as well as the different times of day and the cycle of

the seasons. Editing devices recur in counterpoint throughout the film: Schneemann's body, for example, is frequently juxtaposed with images of the sea. Each shot of female genitals is followed immediately by one of male genitals and vice versa, so that the audience cannot be tempted to identify with or enjoy either body to the exclusion of the other. As with much time-based work not ordered in terms of a story-line, the film invites a musical parallel: it is articulated by phrasing that is governed by the dense rhapsodic rhythms of texture, colour, shadow and movement.

In aesthetic terms, Schneemann's films are within the tradition of the filmic avant-garde pioneered in particular by Stan Brakhage. *Fuses* was indeed conceived partly as a response to Brakhage's *Window Water Baby Moving* (1959), a graphic and poetic depiction of his wife Jane giving birth to their first child, and it owes much to Brakhage both visually and formally. Schneemann admired the earlier film for its combination of visual directness and emotional involvement but she 'had mixed feelings about the power of the male partner, the artist subsuming the primal creation of giving birth'.[2] She had herself appeared in some of Brakhage's films and, despite her friendship with him, felt objectified. In *Fuses*, not only did she want to show the sexual act but also to show it in terms of an intimacy between two entirely equal partners, Schneemann having already been in a relationship with Tenney for ten years, characterised by equality and mutual artistic respect. Despite the impact of *Fuses* in avant-garde film circles, it has remained almost unique.

8. Carolee Schneemann, *Fuses* (1964–67).

One film that contains notable visual similarities to *Fuses* is Anna Thew's *Clingfilm* (1993), in its collage aesthetic, rapid juxtaposition of images (often highly sexually explicit) and frequent use of often ambiguous close-up shots captured by a camera sometimes placed between participants to evoke the experience of intercourse.

Indeed Thew introduces a grey cat into her scenario as a conscious tribute to Schneemann's film. Thew's film, however, is not a celebration of a single relationship, but rather an up-beat and humorous celebration of a wider range of couplings and group sex. Thew deliberately placed slightly more emphasis on the male body as an object of desire in favour of the usual focus on the female erotic body. The motivation behind the film was to promote safe sex through the use of condoms, stressing the dangers of embarrassment about the subject of protection and the vital importance of uninhibition. The explicit imagery of sexual intercourse takes its place among the visual continuum of everyday life. Nevertheless, Thew encountered an extraordinary degree of hostility,

9. Dorothy Iannone, *I Begin to Feel Free* (1970).

both during the process of production and later at several screenings.

Only just beginning to be appreciated now is the work of Dorothy Iannone; one of the main reasons for this neglect doubtless being precisely her bravery and honesty in making, as a woman, explicit works about sex. As with Schneemann in *Fuses*, Iannone's work depicting sexual intercourse reflected her own experience in a relationship with another artist. She met Dieter Roth during a visit to Reykjavik in 1967; although she was married, they both fell instantly in love and a passionate seven-year relationship ensued. Though clearly visible genitals had appeared in her earlier figurative paintings, her work after their meeting began to show them engaged in sexual contact. From the blissful early period of their relationship came her compartmentalised painting *At Home* (1969), which shows both of them several times – once together, reclining, with his hand on her sex, otherwise just doing simple domestic things. Roth replied with *Daheim* (1970), showing similar themes and also penetration, though his picture is much more abstract. From 1970 come several paintings of Iannone's that unambiguously depict sexual intercourse, and point to many powerful, sometimes apparently contradictory emotions aroused by it: *I Begin to Feel Free; I Am Whatever You Want Me to Be*. In *Let Me Squeeze* (1970–71) he is lying across her lap, Pietà-style, and she is squeezing one of his balls; yet the inscription reads 'Let me squeeze your fat cunt/Am I Your First Woman', the apparent incongruity chiming in with Iannone's idiosyncratic rendering of the external female sex organs in a somewhat testicular idiom. After their relationship ended, they remained

good friends until his death in 1998, two years after which she painted the touching *Miss My Muse.*

10. Jeff Koons, *Manet* (1991).

Iannone has spoken of her affinity with Matisse and Tantric painting – but this is in terms of a general sensibility. Highly stylised and decorative, her work is visually more reminiscent of Klimt, but it possesses too a more primitive feel; and there is a definite relationship with 1960s psychedelic graphic style. Given the widespread presence of words in her work and its strong narrative element, it is perhaps unsurprising that she produced a number of artist's books.

Soon after she met Roth, she created books which she referred to as Dialogues, and after his death she edited *Dieter and Dorothy: Their Correspondence in Words and Works* (2001). Other books chronicle the censorship which has sometimes greeted her work.[3] In addition, she has made a number of video boxes, including *I Was Thinking of You* (1975), in which the video component shows her face as she is masturbating, and *Follow Me* (1979), on the side of which is written 'Centuries of gazing at your fragility have augmented my love for your sex' which, Iannone claims, 'could be all women speaking to all men'.[4]

Far more detached and ironic are the highly explicit images of the sexual act made by Jeff Koons, whose *Made in Heaven* series of photographs and sculptures (1989–91) depicts him with the Italian actress and ex-member of parliament Ilona Staller, known professionally as La Cicciolina, at that time his wife. Drawing on the colourfully kitsch and theatrical aesthetic that La Cicciolina brought from her work in pornographic films, Koons created vivid images that are at once shockingly graphic and highly attractive. Full penetration (vaginal not anal) occurs in *Ilona's Asshole* and in *Red Butt (Close-up)* (both 1991). Works with sexually descriptive titles are made in luxuriously glossy photography or coloured glass evocative of commercial ornaments or boiled sweets. The title of the photographic work *Manet* (1991), which shows him licking Ilona's vulva, presumably alludes on the one hand to *Dejeuner sur l'herbe* and on the other to the expressions for cunnilingus, 'eating out' and, more specifically, 'lunch/dinner at the Y'.

The twenty-five photographs that make up Sam Taylor-Wood's series *The Passion Cycle* (2002) depict the different lovemaking positions of a young man and woman, a couple in a long-term relationship, whom the artist had hired. The series was inspired by shunga prints – erotic Japanese woodcuts of the nineteenth century – and this influence is visible in the composition of the images and the ornate interior that they show. Illuminated from behind, the images have a soft, painterly quality in muted warm tones, while their tiny size gives them a sense of intimacy, requiring the viewer to peer at them at close range.

In Marlene Dumas' painting *Couples* (1994), five couples occupy the starkly horizontal space of the painting; a female embraced by a shadowy and indistinct partner, their obscured

faces heightening the anonymity and emotional ambiguity of their forms. Whether this is the same couple viewed from different perspectives or five different pairings, and whether the stark contrast in the tone of their bodies is an indication of emotional or ethnic difference, is typically unclear. John Currin, though best known for his unsettling images of the female body, has most recently produced a number of paintings that graphically depict heterosexual, lesbian and group sex in a style informed by his engagement with the history of European painting, in particular the sixteenth and seventeenth centuries. As in much of Currin's work, these images exude a distinct feeling of creepiness.

Some of the most explicit depictions in paint of couples having sex are by Cecily Brown, in such paintings as *Performance* (1999), *Figures in a Landscape* (2002), *Teenage Wildlife* (2003) and *New Louboutin Pumps* (2005). The highly expressionistic handling of the paint, together with a fragmentation of the image, mean that the imagery is often hard to make out. Indeed there is a sense in which sexual imagery is present in almost all of Brown's work but is hidden to a greater or lesser degree. Since the mid-1990s Brown has claimed the territory of male Abstract Expressionist painters with works in which, as in de Kooning's, the representational image – far more explicitly sexual in her case – becomes hard to discern as it is half lost in the viscous maelstrom of the paint itself. She has spoken of her ambition – even if she has come to think it was gone about too literally in her early sexual paintings – 'for the paint to embody the same sensations that bodies would. Oil paint very easily suggests bodily fluids and flesh.'[5] She once famously replied to someone complaining of the difficulty in reading the imagery in her paintings that they should 'look for the bunnies'. There has been a certain ambivalence in her own attitude towards her subject matter and she has expressed some concern that sexual activity is too omnipresent in her work, commenting in 2005: 'I've been trying to get away from always having couples and sex.'[6]

In live performance, as opposed to painting, the direct proximity between artist and audience has been used to create a sexual situation that is potentially more confrontational and shocking. Sex on stage has occurred several times in an art context, albeit more on the fringes than in the art-world mainstream. Gloria Heilman, using the name Heilman-C and using a cast of professional sex workers, staged *Sex Acts* in 1998 at the Jack Tilton Gallery, New York, to benefit the International Sex Worker Foundation for Art, Culture and Education (ISWFACE). Part of her aim was to expose the hypocrisy of accepting the depiction of sexuality in art while retaining a censorious attitude towards those in the sex business. In 2003, the performance piece *Public Sex, Art and Democracy* by Martin Guderna was performed at the opening of his exhibition 'Labyrinth 69' at The Art of Loving, Vancouver. The artist applied paint to the bodies of two models performing 69 together, then pressed them onto a canvas, in a manner highly reminiscent of Yves Klein's *Anthropometries*, and which demonstrated a lack of role reversal that may have seemed old-fashioned to an audience aware of feminism. Atta Kim's *Museum Series* (1994 onwards) featured naked people in glass vitrines, including a male–female couple having sex. A number of avant-garde theatre groups have also shown, or

come very close to showing, sex on stage. Nevertheless, in live performance as in film and static media like painting, the explicit depiction of the sexual act in art – that is, art with any serious intellectual ambition – is rarer than one might expect.

This may seem less surprising, however, if one considers that much of the most challenging art, that which is most likely to survive, functions on many different levels at once and therefore tends to eschew too explicit a depiction of any subject matter, let alone one so powerful as to risk blocking alternative readings. Sexual intercourse is paradigmatic of the coming together of two entities, and for some artists it is the wider implications of that union that are the most interesting. Louise Bourgeois' *Twosome* (1991), for example, operates as a far more metaphorical representation of coupling. Visually uncharacteristic of Bourgeois' oeuvre as a whole but one of her favourite pieces nonetheless, it consists of two massive black steel tanks which are set onto railway tracks, the smaller of the tanks moving in and out of its larger counterpart, illuminated by a red flashing light. In so far as this piece is indeed about the sexual coupling of a man and a woman, it evokes the classic filmic euphemism of the train plunging into a tunnel. Without a doubt, too, it expresses the sexual encounter in terms of its sheer power. But Bourgeois has stated that *Twosome* is 'presexual. It's the attraction of the feminine element and the masculine element before fornication.'[7] And she claims that it also refers to the child who leaves the mother's womb only to return, unable to function beyond the realm of parental order. 'It relates to birth, sex, excretion, taking in and pushing out.'[8]

In 1996, Bourgeois began a series of soft fabric sculptures of heterosexual couples in mutual embrace. If the hard, mechanical quality of *Twosome* evokes the impersonal power of the forces associated with sex, the softness of these sculptures, often suspended, evokes the fragility of human individuals caught up in these forces. Some, like *Couple IV* (1997) in which the headless black fabric figures are exhibited in a vitrine, suggest emotional impairment; others, like many of the suspended *Couples* of 2000 and 2001, suggest genuine tenderness and the very real benefits that, despite all the difficulties, an erotic relationship can bring. This sense is increased by the fact that here, in contrast to the part objects that typify so much of Bourgeois' work, the human figure, even if simplified, is left relatively intact.

Rebecca Horn's kinetic sculpture *Kiss of the Rhinoceros* (1989) comprises two curved metal armatures, each with a small horn on the end, that slowly come together, producing a spark of electricity as they almost touch, before they gradually draw apart again. Electricity's positive and negative charges imply the masculine and feminine forces of mutual attraction. Her painting machine *Les Amants* (1991) sprays the white wall of the gallery with black ink and champagne. The sexual element of Horn's anthropomorphic machines has been interpreted in Duchampian terms. Indeed works such as *The Prussian Bride Machine* (1988) seem to operate as a reply to Duchamp, a partial reversal of his *Bride* and Bachelors: 'The Prussian Bride Machine /one-armed/three-legged/ejaculating Prussian blue/all over the brides.'[9] Horn's visions of mechanised intercourse are underlined, however, by the presence of a biological impulse: the 'hoping to penetrate for just one exquisite second/to meet at the egg's innermost heart'.[10]

Far more frequent than depictions of sexual intercourse, even in a metaphorical vein, are works which deal with intercourse between couples in the wider sense of relationships. Marina Abramović and Ulay made their twelve-year relationship integral to their art. An extraordinary bond was created from the moment they met in 1976. Among the many things they shared was the same birthday, 30 November (although they were born in different years), and the same rather particular hairstyle. The first performances they made together from their meeting until the end of the 1970s were explicitly relational, as the titles of some of the pieces make clear: these include *Relation in Space* (July 1976), *Relation in Movement* (September 1977), *Relation in Time* (October 1977) and *Work Relation* (1978). *Relation in Time* celebrated their shared hairstyle, while also being a considerable feat of endurance: they sat motionless back to back, tied together by their hair, for sixteen hours without an audience and then for a further hour after the audience had been allowed to enter. Their shared birthday was celebrated in *Communist Body Fascist Body* (1979), in which each of their birth certificates was displayed on a table: his, as he was born in Germany in 1943, with a swastika; hers, as she was born in Yugoslavia in 1946, with a five-pointed star.

In *Talking About Similarity* (1976), there was a form of exchange of roles: after Ulay had sewn his lips shut with a needle and thread, Abramović responded to questions from the audience as if she were him; the performance ended when she made a mistake by answering for herself. In *Breathing In Breathing Out* (1977) they were locked for nineteen minutes in a tight mouth-to-mouth kiss, their noses blocked with filter tips so that no fresh air could be inhaled, breathing out carbon dioxide into each other's mouths. In *Incision* (1978) Ulay was restrained against the back wall of the gallery by a stretched rubber cord at waist height and kept running forward as far as the elasticity of the rubber permitted before being forced back, while Abramović stood motionless in line with the point of maximum expansion. One member of the audience was so outraged by Ulay's discomfort and Abramović's apparent callousness that he attacked her; after the interruption, she re-took her position. In *Three* (1978) they each tried to attract the attention of a snake by making a sound blowing into a bottle. 'As in the Bible,' Abramović has said, 'it came to me first.'

If it appeared in *Talking About Similarity* and in *Incision* that Ulay had drawn the short straw, in *Rest/Energy* (1980), one of the most intensely erotic of all Abramović's and Ulay's work together, there was a real threat to her life. Here they held a large bow and arrow, she holding the wooden part

11. Marina Abramović and Ulay, *Rest/Energy* (1980).

and he the stretched string, with an arrow pointing directly at Abramović's heart. Between them they needed to retain exactly the right equilibrium and to slacken off exactly in synchronisation, so that the arrow was not loosed. With clear references to the effortless control of Zen archery, this performance was also a shockingly literal, indeed potentially lethal, staging of Cupid's bow and arrow. It lasted four minutes and ten seconds. Their final piece of work together was *The Lovers*, which involved each of them walking from opposite ends of the Great Wall of China to meet each other in the middle. The journey took ninety days, between 30 March and 27 June 1988. Walking towards each other was suggestive to both of them of the powerful magnetic force attracting them. However, during the long time it took from the initial planning of the project to its execution, their relationship was progressively breaking down. What was originally intended as a celebration of their union became a meeting to say farewell. Abramović's subsequent description of the moment of their coming together in later performances of her *Biography*, and the fleeting hope that the relationship could be revived only to realise its impossibility, is almost unbearably poignant.

Sophie Calle's film *No Sex Last Night (Double Blind)* (1996), made with photographer Gregory Shephard, documented their road trip across America, which ended in a wedding chapel in Las Vegas. Filming their journey on camcorders, the two artists each offer their own intimate account of it, often contradicting each other. The result is a touchingly truthful picture of mutual loneliness and ambiguous communication despite their apparently shared experiences. The later work *Exquisite Pain* (2000) is similarly confessional; it documents in text, photographs and ephemera Calle's ninety-two-day journey to meet a lover in a hotel in New Delhi and her devastation when he failed to keep the assignation. Calle's 'countdown to unhappiness' is presented alongside representations of other people's pain, their replies to the question 'When did you most suffer?' Calle's careful documentation of the period before and after her break-up places that event at the heart of her narrative, though its occurrence and her own survival in its wake emerge as inevitable.

For Calle, the hotel, typically a site of romantic and sexual encounter, is refigured in terms of the absence of intercourse. Similarly, in the triple-screen projection *Atlantic* (1997), Sam Taylor-Wood uses the setting of a restaurant, another site with iconic romantic connotations, as the frame for relationship disintegration. It shows a crying woman opposite a man's fidgeting hands, the restaurant backdrop between them; the couple's row is played out against a loud ambient soundtrack which occasionally obscures their words, marking both the difficulty that they are having in communicating and the indifference of the world around them to their inner torment. Taylor-Woods' *Soliloquy* series (1998–2001) presents photographs that restage well-known masterpieces, above multi-scene predellas that may be read in terms of the internal stream of consciousness of the work's title, offering a potential, and often erotic, sub-text to these iconic images. *Soliloquy III* (1998) shows a reclining female nude that reworks Velázquez's *Rokeby Venus*, while the predella beneath depicts

an orgy in a smart loft apartment. Though filled with bodies, there is nevertheless a sense of detachment.

There is more than a slight sense of isolation in Tracey Emin's art, but here treated far less coolly, more expressionistically. Although her tent *Everyone I Have Ever Slept With 1963–95* (1995) contained, appliquéd on the inside, the names of past sexual encounters as well as those alongside whom she had simply slept, the focus throughout her determinedly autobiographical work is more frequently on herself; to the extent that it makes reference to others, these lovers are notable through their continued absence. Emin relates the facts of mostly dysfunctional relationships, many of which address issues of consent and abuse, in terms of the marks that other people have inflicted on her. Her style is raw and frequently confrontational, not only towards her viewers but even on occasion towards herself. In *The Interview* (1999) she splits herself into two personae, Emin as she might normally be seen and an interviewer. Their often quite heated conversation ends:

> You repulse me.
> Just fuck off.
> You repulse me. You disgust me.
> Twat.[11]

Her usually nude drawings of herself often show a sad and vulnerable figure, reflected in discussions of her work in terms of a 'bad-sex aesthetic'.[12] Some, however, such as *Nice smile good cum* (1997) and *Sleeping Wishing* (2005) reveal a happier sensibility that also emerges in the neon work *Kiss me, kiss me, cover my body in love* (1996).

Vito Acconci's works are less autobiographical, concerned instead with the shifting dynamics within relationships, rather than their effects on the individual. He and his then girlfriend Kathy Dillon feature together, though the issues of control and consent that Acconci explores work almost to the point of depersonalising her. In *Applications* (1970) Dillon covered him with lipstick kisses, which he then transferred to Dennis Oppenheim by rubbing their bodies together. Many of Acconci's works investigate issues of dominance, with the sexual implications that this brings. In the video *Pryings* (1971), he repeatedly attempts to pry Dillon's eyes open, while she resists his forceful attempts to penetrate. The video, *Remote Control* (1971) shows them sitting in boxes in different rooms, able to see each other on video monitors. She has with her a fifty-yard-long-rope, with which Acconci tries to make her tie herself up, according to his spoken instructions and physical demonstrations. Such works articulate the conflicts and power imbalances inherent in relationships. Many observers have interpreted this in terms of the power imbalances between men and women in society as a whole. For Amelia Jones, much of the value of Acconci's work resides in its making explicit the previously hidden 'male-subject-in-action'.[13]

Conflicts and power imbalances are also inherent in the way in which relationships are portrayed in Pina Bausch's dance theatre; but although her women frequently appear in

cocktail dresses and high heels and are sometimes mishandled by burly men, no simplistic message is being conveyed suggesting that men are always in the powerful position – not least because the men are apt to appear in cocktail dresses as well. Sexuality pervades her work: the core theme is that of relationships between men and women, with all the hopes, fears and misunderstandings that these entail. In and through these relationships is revealed what it is to be human; and much of the secret of Bausch's power to move audiences to tears lies in her ability to bring out, without sentimentality, the beauty and fragility in every individual.

Her work has a depth and intensity of insight informed by German Romanticism and Expressionism, but also a lightness of touch and a pervasive sense of humour. One of the most influential figures in recent decades not only on dance but also on avant-garde theatre, Bausch has managed, through her highly fragmented postmodernist style, to communicate a vision of human sexuality and human experience generally of remarkable honesty and sophistication.

Sexual relationships never occur in a vacuum: their implications stretch beyond the two people involved, to the family and the home, or to the social networks in the world outside. In much of her work, Bourgeois deals with sexual intercourse in the context of the relationship with parents and family. *Twosome*, as we have seen, also refers to the mother-child binary; but her relationship with both her parents is a crucial reference in Bourgeois' work. 'Everything I do was inspired by my early life', she would state in the work *Child-Abuse*, produced for the December 1982 issue of *Artforum* magazine. Constructed from vintage photographs of the Bourgeois family, the work related the impact on her of her father's mistress, who had initially entered the family as a teacher for the young Louise. More explicitly than most artists, Bourgeois' work articulates the Freudian 'family romance', based around the fundamental father-mother-child triad, complicated by this outside presence of the mistress. Her feelings of hostility towards her father had been expressed in *Destruction of the Father* (1974); she has said too that the half-human, half-animal, sexually ambivalent creature depicted in the highly polished bronze sculpture *Nature Study* (1984) was a mocking portrait of her father, paying him back for the humiliation which, she claims, he visited upon her as a child. It is extremely close, however, to *The She-Fox* (1985), which she came to identify with her mother, and which is endowed with all the ambivalence she felt towards her as a controlling, yet protective figure. Where the earlier sculpture's tail evokes the penis, the genital zone of the later work is occupied by the tiny head of Louise Bourgeois herself.

Many of Bourgeois' works from the 1980s anticipate her 1990s series of *Cells*, a term that has biological connotations and also refers to small, enclosed spaces. Continuing the architectural metaphor for the body that is a feature of much of her work, these small rooms, which the viewer may look into but not enter, are like stage sets for some drama involving long-repressed painful memories. The series culminates in the paired *Red Room (Parents)* and *Red Room (Child)* (1994), which between them powerfully evoke the primal scene, where the child becomes witness to the parents' sexual intercourse. But the sexual act can be seen as combat – the parents '[l]ocked,' as Norman O. Brown puts it, 'in battle, in holy deadlock'.[14]

Furthermore the imagined hostility is not necessarily just between the parents but can be turned against the child. Brown goes on to quote a dream interpretation by Melanie Klein: 'the dangerous tapeworm represented the two parents in a hostile alliance (actually in intercourse) against him'.[15] Yet, while Bourgeois' memories of her own childhood are undoubtedly a key to this and indeed much of her work, other factors are also in play. In *Fantastic Reality: Louise Bourgeois and a Story of Modern Art*, Mignon Nixon, in addition to adopting a primarily Kleinian framework for reading Bourgeois' work, also draws significant parallels between the two women's careers, crucially including their experiences as mothers, and in one respect seeks to go beyond Klein's own thinking. While Klein concentrated on the child's ambivalent, loving yet murderous feelings towards its parents and mother in particular, a full reading of Bourgeois' art, Nixon argues, deepens these insights by simultaneously pointing to the mother's ambivalent feelings towards her child.

Some artists, rather than focusing on the family, have presented sex as part of a nexus of relationships within a wider grouping, inviting a sociological reading more readily than a psychoanalytic one. Eric Fischl has painted many scenes of suburban American life and, especially in the work of the 1980s but also in some more recent work, the central focus is on sex. The narrative element in Fischl's art is so strong that connections have often been made with both novels and films: he is a master of finding the right moment to freeze the narrative – very often before, during or after some sexual act taking place – to involve the viewer's curiosity and hence complicity to the full. Seldom is it suggested that the sex is satisfying: there is a listless sadness, or at least emotional emptiness, about most of the scenes that Fischl depicts, amplified by his crude painting technique.

While Fischl concentrates on suburbia, Nan Goldin focuses on the inner city, in particular the marginal, bohemian culture which the big city makes possible. The work for which she became most famous is *The Ballad of Sexual Dependency* (c. 1980–86), made between her two series on drag queens, which she showed several times as a slide show, with a varied musical accompaniment ranging from Brecht/Weill through Petula Clark and Dionne Warwick to Maria Callas. It was also published in book form but the advantage of the slide show was its potential to be updated as the lives of its subjects, whom she saw as her extended 'family', changed. Highly diaristic, much of the work's effectiveness came from her own close involvement in the scene she was portraying, where sex was accompanied by a good degree of angst. The closeness of this scene to that of Lou Reed and Andy Warhol's Factory is signalled by the use, in 1996, of the title *I'll Be Your Mirror* for an exhibition, a film and a book. Not only New York, however, but also Boston, Berlin, Paris, Tokyo, Manila and Bangkok have provided the settings for Goldin's works. A more recent slide show *Heartbeat* (2003) showed couples both gay and straight making love to a soundtrack by John Taverner based on a Greek Orthodox mass and performed by Björk. Several critics felt that the absence of the alienation which had been so conspicuous a part of the *Ballad* made this series of images far less compelling.[16] It was also suggested that the shift to a more problem-free depiction of sex made Goldin seem less

involved, more of a voyeuristic outsider – a complaint she has countered in her most recent work by including bedroom scenes with her own lover, Jabalowe.[17]

Like all animals, human beings have always engaged in sexual intercourse. It is perhaps because it is in this sense timeless that intercourse has been less the focus of theoretical activity and debate than either female or divergent forms of sexuality. Yet, like every other aspect of human experience, it is also to a greater or lesser extent bound up with history. All art which deals with intercourse must therefore reflect both its continuous and its historically conditioned aspects, but the degree to which it emphasises the one or the other aspect differs widely. Although Bourgeois' art undoubtedly reflects its historical moment, this is less because of its subject matter than her way of approaching it. By contrast, both Fischl and Goldin, by emphasising the particular social context in which the sex they depict is taking place, thereby stress its historically contingent aspect. Some artists have gone further: more than just depicting sex within a given historically contingent milieu, they have explored the way in which the principal features of the modern world, urbanisation and technological advance, have profoundly altered the very nature of sexual experience.

Chapter 5

Sex, Money and Modernity

The development of the modern world has been characterised by a greater emphasis on the economic than ever before. Industrialisation brought about the modern city, which grew into an increasingly sprawling metropolis; with it came the promise of fortune, in the guise of money and of experience. The city offered the potential for alienation but also for anonymity, fuelled by promised encounters with a multitude of strangers, accompanied, for some, by a sense of erotic opportunity. In recent times, globalisation has taken sexual experience beyond the realm of the city to other man-made environments, real and virtual.

One of the first writers to acknowledge the nature of the modern city was Charles Baudelaire. In his collection of poems *Les Fleurs du Mal* (1857), and most explicitly in the poems grouped as 'Tableaux Parisiens', Baudelaire revels in and draws inspiration from the ambiguous delights of the darker side of Parisian life.[1] In 'The Painter of Modern Life' (1863) he sings the praises of a painter who, roaming unnoticed around Paris 'in search of that indefinable something we may be allowed to call "modernity"', is able to extract the 'mysterious beauty' to be found within the constantly changing everyday urban scene.[2] Baudelaire's concept of the *flâneur*, later developed by Walter Benjamin, is much invoked by academic cultural theorists. Benjamin's attitude towards the *flâneur* was both nostalgic and informed by Marxism, seeing him as a figure doomed by the forces of mechanistic capitalism. The title of his *Arcades Project* (1927–40) refers to the increasingly outmoded glass-roofed shopping arcades that had characterised the city as a space of *flânerie*, and that had featured in the first truly Surrealist novel, Louis Aragon's *Paris Peasant* (1926), otherwise known as *The Nightwalker*. The sexual desire and sense of erotic opportunity that played a large part in the Surrealists' walks through Paris was made more explicit in probably the most famous Surrealist novel, André Breton's *Nadja* (1928).

John Rechy's 1964 novel *City of Night* sets highly promiscuous gay sex against the backdrop of the nocturnal city. The sexuality of urban spaces, with their potential for the exhilarating thrill of the nocturnal hunt, has been the subject of a number of more recent artworks. Gilbert and George's suggestively titled *Street Meet* (1982) shows a black-and-white urban background, against which the pair of artists appear in yellow watching a boy – perhaps a rent boy? – posing with his arms over his head, picked out in green. In Jean-Marc Prouveur's *Strip* (1979) a photograph of a youth in jeans taking a leather jacket off his otherwise naked torso is set against a nocturnal view of Piccadilly Circus, then London's main meeting place for rent boys. Jane Dickson's *Life Under Neon* (1981–88) documents in paintings and drawings the area around New York's Times Square, a place known for strip joints and peepshows. Shadowy figures are depicted against bright glowing colours and darker backgrounds, vividly evoking the sense of excitement and potential for danger, aligning promiscuity with the threat of crime and drug addiction. Another series with the collective title *Peep Land* makes even more explicit Dickson's fascination with the New York sex scene, and inspired the title of her 1988 exhibition 'Peep Show'.

Nobuyoshi Araki mixes pictures of people, especially naked or near-naked women and girls, with images of Tokyo's skyscrapers and the clutter and mess of the city's streets. Though sometimes staged, his photographs all have a snapshot quality; indeed he frequently uses Polaroids. Araki's working method is to produce images in enormous quantity, building up meaning through the presentation of vast groups of images. This may be seen to reflect the saturation of images and signs in the busy metropolis, simultaneous fragments of a shifting

cityscape where capitalism goes hand in hand with vitality. He has published the photographs in numerous books. Typical of these collections are *Tokyo ereji* ('*Tokyo elegy*'; 1981), *Shojo sekai* ('*World of girls*'; 1984) and *Tokyo wa aki* ('*Autumn in Tokyo*'; 1984), their titles indicative of the integral role that the metropolis plays in his work, almost as if the city itself can be considered the object of his love. *Tokyo Lucky Hole* focuses on Tokyo's sex business, including images of strippers, masseuses and sex-workers and their clients. This collection consists largely of indoor pictures and most of the outdoor shots show the red-light area of Kabukicho in the Shinjuku district of Tokyo, with its strip joints and neon signs.

The figure of the prostitute had, as Alyce Mahon has noted, assumed a special relevance for artists in Europe in the nineteenth and

12. Nobuyoshi Araki, *Untitled* from *Tokyo Lucky Hole* (1997).

early twentieth centuries, even 'becoming a cipher for modernity itself'.[3] In his book *Psychogeography*, Merlin Coverley writes:

> If the *flâneur* celebrated by Baudelaire and Benjamin is merely a passive observer detached from his surroundings, then his female counterpart, the *flâneuse*, is ascribed a quite different role, that of the prostitute.[4]

Baudelaire, Benjamin and the Surrealists were favourably disposed towards this figure, in theoretical as well as practical terms. For Benjamin, prostitutes were a prime example of the 'dialectical images' he valued as revealing the truth behind the false promises of consumerism.[5] Indeed, it is remarkable the extent to which prostitution has provided the subject matter of several key modern artworks, most notably Manet's *Olympia* (1865) – which caused a scandal at the Salon and was defended by Baudelaire – and Picasso's *Demoiselles d'Avignon* (1907). The *Walpurgisnacht* section of James Joyce's paradigmatically modern novel *Ulysses* is set in a brothel. The prostitute was a source of fascination too for Degas, Toulouse-Lautrec, Giacometti and Kirchner. Arriving in Berlin in 1911, Kirchner had been influenced by Georg Simmel's texts, *Philosophy of Money* (1900) and 'The Metropolis and Mental Life' (1903).[6]

In 1975, Marina Abramović took on the role of prostitute herself in the performance *Role Exchange*, in which she swapped places with a professional working in Amsterdam's red light district. As Abramović took up position in the window, her counterpart attended a private view at the De Appel Gallery in place of the artist. The concept of exchange explored in this scenario was especially pertinent in Amsterdam, a city whose historical development epitomised the central role of trade led by the burgher class, and which today is well-known for the shop windows in which its prostitutes display their wares. In contrast to Abramović's four-hour experience of prostitution – during which, as a matter of fact, she never got any clients – Cosey

13. Cosey Fanni Tutti, *'Journal of Sex'* *Magazine Action* (1978).

Fanni Tutti worked over a considerable period of time in the sex business as a stripper and porn star, always as an artist with the secret intention of documenting the experience, using the industry as a site for her art in the form of research. The results of her work included sequences of images of her published in pornographic magazines, which she referred to as 'magazine actions'. These, together with a textual account of her experiences, were shown in COUM's 'Prostitution' exhibition at the ICA, London in 1976. In her solo performances, alongside the more personal objects, Cosey drew on the visual vocabulary of pornography. Writing retrospectively in 2002 about a 1976 magazine action called *Confessions of a Shop*

Assistant, Cosey pointed to her need to assimilate herself into the industry, to become like the professional women who surrounded her, working on one level against her sense of artistic distance. Her interest in the coping strategies of the sometimes vulnerable girls whom she encountered – their objectification of uncomfortable situations as a means of feeling in control – is informed by her inside knowledge of the emotional experience behind the projected images of pornography.

Before she became an artist, Annie Sprinkle had worked as a prostitute, as well as a porn star, starting work in a massage parlour in Tucson, Arizona. As she later said:

> For eight years I did quite a lot of prostitution, mostly in massage parlours. There were times when I loved it, and times when it was terrible. It could be a rough job at times, and I've never denied it. ... Prostitution can also be a wonderful, satisfying job. I always felt like a nurse, helping people, making them feel much, much better. Or a teacher, marriage counsellor or therapist. For me, it was a much better job than being a lawyer, an accountant or an engineer, and it could pay just as well. I don't like it when people say that it's better than working at Macdonald's or being a secretary. To me there's no comparison.[7]

Just before she got into prostitution, Sprinkle had worked as a cashier and popcorn girl at a cinema where the notorious 1972 film *Deep Throat* was playing. Almost a year later, when the state of Arizona tried to prosecute the makers of *Deep Throat* and Sprinkle was called as a witness, she met Gerry Damiano, the film's director, and became his mistress for a year and a half. Through him she worked at Kirt Films, eventually accepting the owner Leonard's requests to act in the porn movies they were making. The first, she recalls, was *Teenage Masseuse* (1975), 'the bizarre and shocking story of three girls in a big town'. In her first year in porn, Sprinkle made over fifty feature films. In 1981, she directed a film of her own, called *Deep Inside Annie Sprinkle*, which fast became the second best-selling porn video in the United States, but was suppressed by the FBI. These experiences, together with her involvement with the political group P.O.N.Y. (Prostitutes of New York), an offshoot of the Californian group C.O.Y.O.T.E. (Call Off Your Old Tired Ethics), were to be a major source on which she drew in her later work as an artist. 'If art is meant to evoke or provoke something in its viewer,' she observed, 'pornography certainly does.'[8]

In Nadine Norman's performance *Call Girl 01 44 43 21 65* (2000), she issued an advertisement in Paris inviting people to telephone the given number in order to arrange a thirty-minute meeting with a 'call girl'. It was stipulated that the meeting would involve conversation only, it would take place at the Canadian Cultural Centre, and no fee would be charged. The call girls were in fact impersonated by actresses in stylishly smart dresses, their business-like aesthetic making visual the exchange central to the project. It lasted ten weeks and the telephone rang up to three hundred times a day. Demand well exceeded supply, reflecting perhaps the modern desire for a secular form of confession. When the 'clients' – predominantly though not exclusively men – arrived they were confronted by surveillance

footage of the encounter taking place at that moment. Retaining the English idiom of the work's title, Norman placed significant emphasis on the telephone as a means of sexual encounter, playing on the distancing features employed in many such situations. In documenting the project, she presented the answerphone messages left by 'clients' intrigued as to the status of the girls offered and the nature of the proposed encounter as well as the actual encounters. Here topics of conversation included relationships between men and women, the nature of fantasy and the concept of the 'availability' of women, a theme that would be taken up in Norman's later work *Je suis disponible. Et vous?/I'm Available. Are You?* (2002).

Cui Xiuwen explored the world of commercial sex in China in her video work *Lady's* (2000), which comprises surveillance footage filmed by a hidden camera in the toilets of a Beijing escort club. Young women enter and adjust their appearance, changing their outfits and applying make-up in front of the mirror. Their occupation, hinted at throughout as they return time and time again to perfect their image, is only confirmed towards the end of the video, when we witness their telephone negotiations with clients and counting of the evening's takings, making explicit the link between constructed female glamour and economic exchange.

This link had already been pointed to in British Pop Art. Richard Hamilton's works, including *Hers Is a Lush Situation* (1957) and *$he* (1959–60), emphasise the importance of sex within capitalist production and marketing, stressing the glamorous commodification of women in particular. Another British artist, Peter Phillips – in such paintings as *For Men Only Starring BB and MM* (1961) – celebrated the girls-and-gadgets tradition of male fantasy in a relatively straightforward way. Rather more edgy were Allen Jones' paintings, largely derived from fetish magazines, which endowed slim young women with a smooth, hard, plastic quality, in many ways typical of the aesthetic of the 1960s in general; at the time, any opposition to these works came from cultural conservatives rather than from feminists, as would happen later.

A more explicit link between sexual imagery and that of consumerism is made by Sylvie Fleury in *Wild Pair* (1994), which consists of a collection of pornographic magazine pages depicting muscled male nudes. Placed on top of them are six stiletto shoes which she sprayed with silver paint, their delicate spikiness contrasting with the bulky torsos of the men beneath them. Fleury's *Dark & Deep* series (2003) consists of feather boas in different colours displayed in tall thin Plexiglas boxes that frustrate the instinct to touch and stroke these traditional tools of seduction, making them instead rigid and inaccessible. Milovan Marković's series of *Lipstick Portraits* (1995) depict iconic women like Catherine Deneuve and Vivienne Westwood in monochromatic paintings in lipstick on silk velvet, each in a different shade chosen to suit the individual subject. The artistic project of Jeff Koons enacts the seductive power of consumerism and advertising in a manner highly reminiscent of Andy Warhol's pronouncements on the erotic attractions of making and spending money. Koons' series of glossy *Art Magazine Ads* (1988–89) included one for *Art in America* which showed the artist flanked by two bikini-clad beauties in a highly kitsch setting of extreme artificiality. The

sickly pink and white iced cake which the girl on the right proffers Koons acts as a metonym for the picture as a whole, which exudes sugary sexiness.

Oral metaphor in the sexual sense is inherent in discussions of capitalist consumption. James Hillman's 1995 essay 'Pink Madness' outlines the seduction of consumerism as the revenge of Aphrodite, who, banished to the margins of society, embarks on a quest for retribution and return: 'Aphrodite's pink madness runs the world *sub rosa* in the guise of consumerist economy.'[9] The tempting images of consumerism that permeate everyday life are broadcast as soft-core pornography, arousing and seducing the psyche. 'Remember,' cries Aphrodite, 'what you call advertising, I call fantasy.'[10] Essential to Hillman's conception of the allure of consumerism is the figure of *pothos*, who embodies the mythic yearning for the lascivious sweetness of the unattainable.

According to Yuko Hasegawa, the prevalence of 'an almost plastic and fuzzy pink' in 1990s Japanese culture symbolised the politics of infanticisation and an aesthetic of cuteness:

> the swiftness with which the unique characterization of gender in the *kawaii* characters, originally found in *manga*, animation or toys, dominated almost every aspect of consumer culture, including the sex industry's advertising campaigns, is astounding.[11]

Typical of this phenomenon is Minako Nishiyama's *The Pinkú House* (1991), a full-sized version of the bedroom in the toy house of *Rika-chan* (the Japanese equivalent of Barbie dolls), remodelling it to draw parallels between the saccharin imagery of girls' toys and the colours and forms widely used in the sex (or 'pink') industry. The bedroom, covered in love hearts, frills and Rococo swirls, has a sickly sugariness reminiscent of Koons' cake. *Moshi Moshi Pink* (1995), in which Nishiyama printed pink stickers with telephone numbers and manga images and distributed them in public phone booths, makes a similar connection between childhood imagery, the colour pink and telephone sex. Callers dialling the telephone number reached a pink telephone placed in the gallery, which exhibition visitors were encouraged to answer.

The link between consumerism and the sex industry is made explicit in Takahiro Fujiwara's *Immunity Dolls* (1992): a row of plastic hanging sex dolls evokes the mass production of the assembly line or the rows of new consumer products on the shop floor. The ritual of shopping as the principal route to sensuous enjoyment seems to be particularly strong in Japan. The phenomenon is embodied in the decorative women of Miwa Yanagi's series *Elevator Girls* (1997), whose decorous appearance and exaggerated politeness usually inhabit advertising campaigns and the consumer space of the department store. The girls are depicted almost as statues, dummies or clones, posed in display cases or lying in a heap on the floor, stretching into the distance along a moving walkway. In her first solo exhibition, 'Eternal City I', Yanagi placed an elevator in the middle of the gallery space, flanked by two such girls. Their role has been compared by Hasegawa to that of intricate and excessive packaging in a society structured by luxury consumerism, as well as that of the guardians of the potential to rise to a higher spiritual (and sexual) plane. She thus sees the work as tempering the emptiness

of consumerism by linking it with 'the spiritual sense of emptiness which leads beyond the material world'.[12]

There is an obvious parallel between considerations in art of sex and consumerism and the genre of high fashion photography. Indeed, several fashion photographers became known for the way in which they moved beyond the conventions of that genre to produce highly stylised images that have appeared both in the context of the fashion magazine and that of the art gallery. Conspicuous among these are Guy Bourdin and Helmut Newton. Bourdin's work first appeared in the pages of French *Vogue* in 1955, though he was at the height of his career in the 1970s and 1980s. Luxurious textures and rich saturated colours predominate, but the tone of Bourdin's pictures is for the most part hard, glossy and somewhat detached. His models are often shown only in part, lending a darkly fetishistic element infused with the implication of stylised violence. Newton's largely black-and-white photographs, also widely present in the pages of *Vogue* in the 1970s, are similarly provocative. Inspired by the collision between the exclusive world of the privileged elite and the seedier underside of life, his photographs depict statuesque models in kinky poses, their strength sometimes appearing damaged by crutches or leg braces.

If fashion photography can often contain a sexual element, the world of pornographic magazines has provided an abundant source of visual – and of course highly sexual – material for contemporary artists. Working as a couple, Ida Tursic and Wilfried Mille produce paintings that draw directly on pornographic imagery. Their paintings are characterised by rich colours and thick creamy paint, its viscous nature evoking physically the sticky messiness of the bodily fluids depicted. Semen splatters the faces and is exhibited on the tongues or dribbled from the mouths of delighted women in a number of post-ejaculatory paintings like *La grande éjac* (2002) and women are shown squirting (urine, female ejaculate?) in paintings like the joyous *Garden Party* of the same year. Tursic and Mille concentrate far more on the female than on the male body, and the male presence is often only announced by a penis being sucked or the result of an orgasm. When men's whole bodies are shown, they are often either alone or coupling homosexually, although *Elizabeth* (2003) does feature a man sitting on a sofa, fingering the anus and vagina of a girl lying face down across his knees. Chantal Joffe is another painter, also working in a richly creamy style, who has employed similar imagery, especially in a series of paintings made in 1999, though this largely features lesbian, especially oral sex or sexual activities in which more than two people are taking part.

Other artists have been less interested in pornographic imagery as such than in the processes involved in its production. To make her documentary-style video *Ovidie* (2000) Clarisse Hahn shared her flat for a year with a porn actress and her husband. When this is shown in a two-screen installation together with her *Hospital* (1999) – to make which she had spent five months in a geriatric ward – remarkable parallels become apparent between the movements of the porn actors and actresses and those of the elderly patients being assisted and coaxed by their nurses. Hahn's exploration of the real lives of those involved in the sex

industry continued with her video *Karima* (2002) which follows, with affection, and not without an element of humour, the life and work of a young dominatrix.

For J.G. Ballard 'a widespread taste for pornography means that nature is alerting us to some threat of extinction'.[13] Ballard's *Crash* (1973), 'the first pornographic novel based on technology', centres on a group of suburban car-crash survivors whose sexual desires become focused on the car and the violence of the crash, in a potentially fatal conflation of desire and destruction.[14] The narrator of the novel, James Ballard, enters into a sexual relationship with the female survivor of the crash that he has caused, and which killed her husband, while another character dreams of the ultimate crash that will end in death. In a controversial interpretation of Ballard's novel, Baudrillard hailed the 'hyper-reality' it embodied:

> This mutating and commutating world of simulation and death, this violently sexualised world totally lacking in desire, full of violent and violated bodies but curiously neutered, this chromatic and intensely metallic world empty of the sensorial, a world of hyper-technology without finality.[15]

Ballard himself saw the novel in cautionary terms: 'a warning against that brutal, erotic and overlit realm that beckons more and more persuasively to us from the margins of the technological landscape'.[16]

The Futurists, in particular, had recognised the erotic potential of the mechanised world, in which the car played a vital role. Marinetti's account in *The First Futurist Manifesto* (1910) of his and his friends' relationship with their automobiles – 'we went up to the three snorting beasts, to lay amorous hands on their torrid breasts' – set the tone for most Futurist pronouncements on the human–mechanical interface.[17] In the 1960s, the sexual symbolism of the car was also central to the work of Pop artist Evelyne Axell. Her thoroughly sexy and feisty *Erotomobiles* paintings fetishistically combine automobile parts with parts of the female form. In an especially remarkable painting *Axell-ération* (1965), we are looking down in close-up at a car's pedals and what, especially given the punning title, must be read as the artist's own feet, clad in red high-heeled shoes, the right-hand shoe coming slightly off the heel in a gesture of provocative casualness, as the toes press down on the accelerator.

The alienation of the modern city, with its attendant sense of loneliness, has been the focus for many. The fractured environment of the postmodern era was embodied in Reyner Banham's study of urbanism *Los Angeles, the Architecture of Four Ecologies* (1971), in which he crystallised this sprawling new type of city, characterised by the state of 'Autopia', in which the private car is central. Marc Augé, in *Non-Places: Introduction to an Anthropology of Supermodernity* (1995), draws attention to those depersonalised spaces that characterise the modern city: airports, petrol station forecourts, motorways and motels.[18] These 'in-between' spaces had appeared in Cindy Sherman's photographic series *Untitled Film Stills* (1977–80), which drew on the visual vocabulary of the B-movie genre. More overtly sexual is the photographic series *Chambre Close* (1994) by Bettina Rheims.

Her female models appear naked or partially exposed in anonymous rooms and corridors that are faded and made grubby by the presence of their previous occupants. The bodies of the young women pose against a backdrop of dusty carpets, peeling walls and bare mattresses. The title carries connotations of secrecy, the realm 'behind closed doors', while also suggesting the French *maison close*, or brothel, the private place where many others have been before. Chas Ray Krider's collection of photographs *Motel Fetish: A Hideaway for Dreams and Desire* (2002) eroticises the motel interior, imbuing the room and its furniture with the libidinous presence of those fetish models posed within it and promises of secretive and anonymous sexual encounter.

The realm of the anonymous suburban space has in recent years been increasingly replaced by a new and even more remote aesthetic, that of accessing sex via the computer. Here, where absent bodies partake in virtual sex, the technology of the webcam becomes not only a tool for image dissemination but a libidinal object in itself. Thomas Ruff's series *Nudes* (1999–2002) takes its inspiration from internet pornography, illustrating an explicit catalogue of sexual practices. The blurred aesthetic of the photographs, indicating the influence of Gerhard Richter, embodies the sensibility of distant reverie found in pornography, the visual embodiment of modern sexual consumption, just as Andy Warhol's silkscreens had summed up the aesthetic of a culture of consumerism. Ruff's series of photographs was appropriately accompanied in its published version by a short fictional extract by Michel Houellebecq – one of the most perceptive present-day writers about sex, at least from a male point of view – which describes the experience of a man visiting a swingers' club with his wife. The text exposes the hierarchy (of age and attractiveness) which defines this supposed free-for-all, revealing an enormous sense of nihilistic despair alongside the sexual gratification.

Natacha Merritt's intimate *Digital Diaries* appeared in part on her website *Digitalgirly*, which further extended her use of the digital camera to create an erotic 'ambient visual archive' that functions as a new media artwork in its own right. Merritt herself has allied these new technologies to her own sexual being, declaring: 'my photo needs and my sexual needs are one and the same'.[19] Technological prowess is allied with sexual power, with Merritt's explicit pose becoming an articulation of the merging of the two. The act of photographing becomes integral to the sexual act rather than a mode of documenting it, a far cry from Carolee Schneemann's concern with avoiding camera interference in the authenticity of the experience. The digital camera and internet forum in which the resulting pictures are displayed present the appearance of instantaneity that first appeared with the Polaroid, the promise of direct access to the most intimate experiences. Indeed, on the most basic level, the potential for more explicit sexual imagery to be produced and circulated without censorship is in part due to increasingly widespread access to digital technology.

The world of science fiction offers the erotic fantasy of cyborgs, sexbots and teledildonics, their fetish potential attested to by the members of numerous online 'technosexual' communities and chat forums. 'Robotdoll', the founder in 1996 of the website

14. Thomas Ruff, *ma27* (2001).

alt.sex.fetish.robot, explains the sexual attraction of, 'the look, the stiff motion, the blank stare, the monotone voice' that robots embody.[20] Such visual motifs have provided the inspiration for artists keen to explore the peculiar utopian fantasy underlying much of the erotic fascination with the artificial and technological. Yoichi Tsuzuki introduces the futuristic half of his book of photographs *Sperm Palace* (2001) with a parodic reference to the well-known science-fiction narrative conceit: 'Long long ago, in a town far far away, there was a vagina that swallowed time and space.'[21] The photographs of posed mannequins that follow illustrate Tsuzuki's vision of a post-apocalyptic world of tubes and machines where sexy females are grown in glass vessels. Chris Cunningham's *All is Full of Love*, the video for Björk's 1999 single, depicts two robots as they are created on an assembly line, kiss and fall in love. Shu Lea Chang's digital sci-fi film *I.K.U.* (2002) extrapolates the sexbot scenario to imagine a sinister world where sex may soon be rendered obsolete by a machine capable of sexually satisfying the user by connecting a computer directly to the brain.

Many such works may be seen to enact a futuristic Pygmalion myth, the bringing to life of the man-made model. They render fluid the border between animate and inanimate, situating robotic desire in an ambiguous middle position. The notion of the automaton as an erotic being has a long trajectory that finds literary expression in figures such as the female mechanical doll of E.T.A. Hoffmann's *The Sandman* (1817), or in Villiers de L'Isle-Adam's novel *L'Ève future* (1886), in which he coined the term 'android'. The Surrealists were fascinated by the erotic potential of dolls and mannequins, while the simultaneous excitement and cynicism with which both Marcel Duchamp and Francis Picabia depicted mechanised sexual imagery reflected a distinct ambivalence. The robotic gynoid that inhabits the futuristic urban dystopia of Fritz Lang's 1927 film *Metropolis* offers a remarkably early vision of the god-like powers that accompany this futuristic technology and the destructive potential of replacing humans with machines.

Technology, whether real or fantastic, is bound up with many conceptions of social and sexual utopia. As well as providing endless opportunity, technophilia may in some way express a desire to transcend the limitations of the human body, to escape from nature's biological insistence. In *Technology as Symptom & Dream* (1989), Robert D. Romanyshyn argues that the mechanistic view that has dominated Western civilisation since the Renaissance is inherently anti-corporeal. He links the vanishing point of linear perspective, the mechanisation of the world vision, and the Cartesian separation of the mind from the body, with a logical outcome of departure from nature and, ultimately, from the earth, of which the space rocket is a

perfect symbol.[22] It has often been argued too that there is a link between technology and masculinity. Robert Longo's triptych *Sword of the Pig* (1983), which comprises a dark form that resembles a sword hilt or a church steeple, the nude torso of a muscled-up bodybuilder and an image of disused nuclear missile silos – with their obvious phallic connotations – can be read not only as the critique of macho aggression it undoubtedly is, but also as a pointer to a male urge to transcendence of the material, and maternal, world. There is a sense in which boys, more than girls, are banished from the maternal bosom, need to go out and explore, and prove themselves as men – even if the ultimate aim is one of return. While it is true that the missile silos in *Sword of the Pig* are marked 'inert', suggesting impotence, the fact remains that not all missiles are inert. In a trajectory which may conceivably be linked with masculine, and technological, destiny, those that do blast off return, in the main, to earth.

Whatever the underlying psychological causes and metaphysical implications of the technological adventure may be, there can be no doubt about the profound social and psychological changes which the mechanisation and urbanisation that characterise the modern world have brought about. Of these, one of the most crucial was already identified by Baudelaire. In his dedication 'To the Reader' at the front of *Les Fleurs du Mal,* having described a litany of vices in the darkest of purple terms, he finally identifies one vice as 'uglier, wickeder, fouler than all': *ennui*, only roughly translatable as 'boredom'. Ballard too expresses a fear of 'the most terrifying casualty of [the twentieth] century: the death of affect'. He tempers this warning, however, with the paradoxical contention that, 'this demise of feeling and emotion has paved the way for all our most real and tender pleasures'.[23] It is indeed remarkable the extent to which the human psyche, and human sexuality in particular, has been able to adapt itself to the changed and constantly changing urban and technological landscape. Erotic desire, based in our animal nature, remains very much alive – however much, in an apparently sanitised and desexualised world, it has had to change its form. Perhaps this is a reason for hope, even as those other main characteristics of the id, selfishness and aggression, combine with technological sophistication in potentially deadly destruction. Certainly, nowhere more than in art can the protean quality of modern desire be expressed and brought into consciousness; and artists have risen well to the challenge. Yet, adaptable as human sexuality may be, there is no understanding of it which does not, in the end, bring us back to nature.

Chapter 6

Sex and Nature

The body, especially the female body, has long been associated with the landscape. Notions of rebirth and fecundity reflected the cycle of the seasons, the impregnation of the earth by rain and the ripening of crops (expressed as early myths of 'Mother Earth' and 'Father Sky'). Even if not consciously, this association remains today. Freud made explicit the primal link between nature and sexuality in his *General Introduction to Psychoanalysis*:

> If you have chanced to wonder at the frequency with which landscapes are used in dreams to symbolise the female sexual organs, you may learn from mythologists how large a part has been played in the ideas and cults of ancient times by 'Mother Earth' and how the whole conception of agriculture was determined by this symbolism.[1]

The Renaissance tradition of Venetian visual *poesia*, embodied in works such as Giorgione's *Venus* (1509–10, Dresden), linked woman to the landscape. Depictions of the rural idyll of the countryside, however, could contain too the suggestion of menace, the darkening storm clouds of his *Tempest*. Nature offered not only a peaceful retreat but also the threat of brutality.

Formal echoes of the human body may be found in representations of landscape in works by more recent artists, from Samuel Palmer's breast-like depictions of the hills near Shoreham, to Barbara Hepworth's sculptures, which contain figurative elements as well as relating to the physicality of the landscape. Louise Bourgeois' series of landscape sculptures – such as *Soft Landscape I* (1967) – evoke natural forms from undulating hills to clusters of mushrooms as well as body parts, hinting at the psychical significance of the natural world.

The sexual significance of Georgia O'Keefe's flower paintings has been much discussed; her images play on the morphological similarity between flowers and human – particularly female – sexual organs, underpinned by the status of flowers as the sexual organs of plants. This

biological analogy is made still more explicit in Nina Zaretskaya's erotic images of flowers. The connection between flowers and the feminine are part of the meaning too of Chen Lingyang's *Twelve Flower Months*. Gilbert and George, known for their almost exclusive masculine imagery, remarked that while their pictures of adolescent boys were not about sex, their pictures of plants were.[2] Fruit and vegetables jostle together lasciviously in a humorous section of their film *The World of Gilbert and George* (1980). Tanya Lieberman's series of photographs *Fruit and Vegetables* (1997) also maximises the sexual potential of, among other vegetables, the ripe red flesh of a pepper. Rather more sinister is Matt Collishaw's *Flesh Eaters* (1999), a series of lushly superimposed photographs that depict mainly plant forms with female faces hidden among them.

With the increasing incorporation of the artist's body within the artwork, new possibilities for exploring the relationship between the body and the natural world opened up. Ana Mendieta's work, in performances and photographs that place her naked body in the wild landscape, explores this relationship in an erotic mode that is strongly infused with an awareness of death.[3] The 1975 performance *On Giving Life*, in which the naked Mendieta arranged a skeleton on the grass and lay on top of it, embraced and kissed it, makes a connection between the natural world, death and the erotic. *Flowers on the Body* (1973), in which Mendieta's naked supine body is covered with masses of flowers, links the natural cycle of plant regeneration with the human body, reinforced by the grave-like setting in which she lies. Images in the 1976–77 *Tree of Life* series depict the assimilation of the artist's body into her natural surroundings in a manner similar to the iconic photographs taken around the same time by Holger Trülzsch of Vera Lehndorff (Veruschka) that show her merging into the landscape. In the majority of Mendieta's works, organic materials – red flowers, fire, ice – are substituted for the artist's body. They mark out her trace in the landscape in materials that invoke the metamorphosis of physical transformation, but also evoke the intense passion of this fusion. Both present and absent, she becomes, as Donald Kuspit has remarked, 'simultaneously substance and elusive shadow.'[4]

For Mendieta, earth represents both her mother and herself as mother. She has explained her work in these terms:

> I have been carrying out a dialogue between the landscape and the female body... I am overwhelmed by a feeling of being cast from the womb (nature). My art... is a return to the maternal source. Through my earth/body sculptures I become one with the earth... I become an extension of nature and nature becomes an extension of my body.[5]

Charles Merewether's assertion that the *Siluetas* function, 'as much a shallow grave as an image of a nurturing womb', conveys Mendieta's underlying concern with death and absence, though may underestimate the positive potential with which she imbues it.[6] Helaine Posner is certainly right to supplement Merewether's words with an emphasis on Mendieta's 'belief in the potential for renewal or transcendence'.[7]

The sacrificial element hinted at in the work of Ana Mendieta is perhaps more explicitly present in certain performance works by Jill Orr. In *Bleeding Trees* (1979) the artist's body is identified with the material forms of the natural environment. The violent force to which her body is subjected – strung up from a tree's branch, rent into painful contortions, semi-buried in the earth, her arms splayed and her mouth a gasping hole – allies the violation of the female body with the destruction of the environment. If associated with ecological and feminist concerns of the late 1970s, Orr's work considers such politicised concerns within a highly poetic visual framework.

In regard to her incorporation of crystals into her performance and photographic works of the 1980s and 1990s, Marina Abramović has made explicit her identification of her body with the earth in its mineral materiality and its telluric energies.[8] Her video work *Balkan Erotic Epic* (2005) offers a humorous celebration of Balkan folklore

15. Ana Mendieta, *Imagen de Yagul* (1973) Courtesy Galerie Lelong, New York.

rooted in nature. Male and female genitals play a central role in fertility and agricultural rites, and, as Abramović explains in her filmic persona of Professor, 'as tools against sickness [and] the evil forces of nature'. In one scene, women lift their skirts to the sky, exposing themselves to be impregnated by the rain; in another men masturbate into holes in the ground, fertilising the ground with their semen.

Much of Ulrike Rosenbach's earlier performance work from the 1970s and early 1980s is explicitly concerned with nature as a source of positive energy, reflecting a sense of connection to the earth, as part of it, in which the female has a particular role to play. In a series of performances titled *Naturkreisaktion* (1972) this idea was represented by the circular form – echoing that of the Earth – with the tree as its central point, as in *Dance Around the Tree*.

The dancer Shakti was born in 1957 in Kyoto of a Japanese mother and an Indian father. Her mother, who was founder of the VasantaMala Dance Company and the first person to introduce Indian dance to Japan, taught her to dance from the age of three; and her father, founder of the Gandhi Institute in Kyoto, taught her yoga. When she went, at her father's request, to study Indian philosophy at Columbia University, New York, she did so alongside her study of modern dance with Martha Graham and Alvin Ailey. She created her own intensely energetic and erotic style of dancing out of a blend of Eastern and Western dance forms,

yoga, jazz and contemporary rock. Shakti's *Trilogy: A Tribute to Nature* (2006–07) shows her dancing erotically in the wilderness of Western Australia, by the side of a watering hole in Pilbara, then at the Honeycombe Gorge at Kennedy Ranges and in the Gascoyne Region. The impressive natural surroundings become charged with the erotic energy of the artist's naked body, while she in turn draws sexual energy from the natural forms with which she interacts.

Annie Sprinkle's declaration that she 'can also make love with waterfalls, winds, rivers, trees, mud, buildings, rocks, sidewalks, spirits, the sky, and yes, even animals...', indicates the universality of a sexual communion with nature.[9] Sprinkle's late work reveals a sensibility more concerned with the natural than her earlier work related to the sex industry, though it is still infused with a highly sexual feeling. She became increasingly interested in New Age ideas, as can be seen from the last step of 'Annie Sprinkle's Sex Guidelines for the 1990s or You Can Heal Your Sex Life: a 13 Step Program', which reads:

> MAKE LOVE TO THE EARTH AND SKY AND ALL THINGS, AND THEY WILL MAKE LOVE TO YOU
> Open yourself to the ecstasy that's available just for the asking, and it will affect everything in your life. You are guaranteed many, many benefits. For one thing, you will find that perfect, ideal lover that you have been searching for for so long.
> That lover is yourself.[10]

It is noteworthy that nearly all artists who identify closely with nature are women. There emerges a strongly female bias in considerations of the erotic in nature, in line with the traditional symbolic identification of the female body, much more than the male, with the earth and with nature in general. This gendering is of course highly problematic for those feminist approaches that privilege social construction. To Camille Paglia, on the other hand, it makes perfect sense. The close link between women and nature is especially evident in menstruation, relating directly to the moon and the tides; but in many other ways too the anatomical and consequent psychological difference between the sexes leads to radically different feelings towards nature on the part of women and men. Paglia is not alone among female writers in thinking this. What makes her thinking different, however, is her strident criticism of what she sees as the thoroughly sentimental view, stemming from Rousseau, that nature is essentially benign. Rather, she asserts, nature is always double-edged, destructive as well as creative.

> We say that nature is beautiful. But this aesthetic judgement, which not all peoples have shared, is another defense formation, woefully inadequate for encompassing nature's totality. What is pretty in nature is confined to the thin skin of the globe upon which we huddle. Scratch that skin, and nature's daemonic ugliness will erupt.[11]

For Paglia, nature's destructiveness is felt especially keenly by men, whose primary psychological need is to free themselves from the ensnaring mother-figure. This, in her

somewhat controversial view, is the reason that men and not women have created nearly everything that we would call culture, in the process benefiting women as well. Nature in the end is vastly more powerful; and culture, especially Western culture, is delusional to the extent that it supposes nature can ever be overcome. Yet, to some extent, she argues, such a delusion – which women, closer to nature and thus probably more realistic, are unlikely to share – may have been necessary if any progress beyond a primitive stage of humanity was to be achieved.

Sex lies at the intersection of nature and culture and is our closest link with the natural and animal world; it retains, according to Paglia, nature's dark, chthonian, underworld qualities. She distances herself from the majority of feminist theory in her belief that cruelty, amorality and criminality in sex are not the fault of society but rather of its failure to tame our unruly instincts. Thus, however much we may legislate to ensure more ethical sexual conduct, this will not affect the underlying fantasies which fuel the sexual imagination. It is important, if we are truly to understand sex, that we do not censor these, though clearly we need to guard against their becoming reality.

> We may have to accept an ethical cleavage between imagination and reality, tolerating horrors, rapes, and mutilations in art that we could not tolerate in society. For art is our message from the beyond, telling us what nature is up to.[12]

Furthermore, if there is indeed danger and violence lurking in sex, as in nature, this is inextricably bound up with the value to be found in their potential energy and transformative power.

If one of the principal images relating woman, and especially the mother, to nature is that of earth, then another is that of the ocean, Wordsworth's 'immortal sea that bore us hither'. The linguistic similarity in French between the sea (mer) and mother (mère) has frequently been noted.[13] In 1938, the psychoanalyst Sandor Ferenczi made explicit the connection between the sea and sex. In *Thalassa : A Theory of Genitality* he outlined the act of sexual intercourse in terms of the theory of 'thalassal regression', the desire to return to the sea – from which all life originally emerged – as analogous to the desire to return to the mother's womb. The compelling nature of such a metaphor is enhanced perhaps by the simultaneous attraction and anxiety that both embody. While the element of self-loss potentially involved in sex may be experienced as something analogous to the fear of drowning, it can also be experienced as a blissful return to the immense and all-encompassing place, before birth and after death, where all struggles cease and all conflicts are resolved. Perhaps no one has expressed this more powerfully than the Victorian poet Algernon Charles Swinburne:

> I will go back to the great sweet mother,
> Mother and lover of men, the sea.
> I will go down to her, I and none other,

Close with her, kiss her and mix her with me;
Cling to her, strive with her, hold her fast:
O fair white mother, in days long past
Born without sister, born without brother,
Set free my soul as thy soul is free.
[...]
O tender-hearted, O perfect lover,
Thy lips are bitter, and sweet thine heart.
The hopes that hurt and the dreams that hover,
Shall they not vanish away and apart?
But thou, thou art sure, thou art older than earth;
Thou art strong for death and fruitful of birth;
Thy depths conceal and thy gulfs discover;
From the first thou wert; in the end thou art.[14]

For Freud, it was this 'sensation of "eternity", a feeling as of something limitless, unbounded – as it were, "oceanic"', that lay at the core of the religious instinct.[15]

Further sexual symbolic connotations are found in the image of the seashore as the liminal place where the solidity of the land meets the uncertain state of the sea. The seashore is often imbued with the dreamlike sense of the edge of the unconscious, a questioning of reality such as is suggested in the final coastal sequence of Fellini's *La Dolce Vita* (1960). Shakti's *Woman in the Dunes* shows her dancing at the sea's edge, its title recalling the 1964 film by Hiroshi Teshigawara, *Woman of the Dunes*.[16] Similarly, Malerie Marder's photograph *Because I Was Flesh* (2000) shows the artist reclining naked on a wet and overcast beach, like a washed-up mermaid or modern-day Venus, the goddess of Love born from a seashell.

In contrast with the possibly masochistic sense of identification with nature found in her *Bleeding Trees*, Jill Orr's *Love Songs* (1989) functions as an 'analysis of sexuality [...] set against the panoramic backdrop of the ocean'.[17] Clichéd lyrics from popular love songs were accompanied by projected images which depicted the artist, in both male and female clothing, sitting in a chair and lying in a bed in the sea. Strikingly similar imagery appears in Derek Jarman's film *The Garden* (1991), in which sequences show the artist lying in a bed in the shallow waves of the sea. The film draws a comparison between social persecution of homosexual love and the persecution of Christ, set in and around the garden of Jarman's bleak coastal home in Dungeness in Kent. Jarman has described it as 'a parable about the cruel and unnecessary perversion of innocence'.[18] He invokes the perfection and peace of both the Garden of Eden and the garden at Gethsemane.

Another traditional symbolic element of the garden is to be found in the image of the lady – often the Virgin Mary – in the rose bower. This is an instance of the symbolic association of the female body with the *hortus conclusus*, the closed or walled garden. Thus, in Ulrike Rosenbach's *Glauben Sie nicht, daß ich eine Amazone bin* (1975), the piercing with

arrows of a tondo image of the Virgin in a garden takes on an obvious sexual meaning. A related image of the garden as the realm of secret desire was used as the title of one of the first books to explore women's sexual fantasies, Nancy Friday's best-selling *My Secret Garden* (1973).

In Paganism, Priapus, the god of gardens, offers a specifically masculine slant as a phallic figure who is simultaneously a figure of fertility and the protector of male genitalia. Pan, the goat-like Greek god of Nature, was similarly famous for his seductive and sexual powers (indeed he is often depicted with an erect phallus) – and in some accounts is the half-brother of Priapus. Both gods represent an element of sexual aggression that is to be found in nature, but may also act against it. Much of Paul McCarthy's work harnesses this notion of a vulgar and aggressive engagement with the natural world. In the hyper-realist sculptural installation *The Garden* (1991–92) the figures of a father and son are placed in a natural setting which the title instructs us to consider a garden; the elder man is humping a tree, his trousers around his ankles, while the younger is humping the ground. In its follow-on *Cultural Gothic* (1992), the father looks on approvingly as his son fucks a goat. The focus of both these works on the father–son relationship has been seen, rightly, as a comment on American society and on the family in particular – the bestiality in *Cultural Gothic* has indeed been called a 'metaphor for hidden family violence'[19] – but it is also more than that. Kathleen Quillian has pointed out that in *The Garden* it is 'Mother Earth [who] makes up the trinity of this unnatural family'; and the choice of a goat, in *Cultural Gothic*, raises once again the presence of Pan, in real goat fur and horns.

Nor should the specifically sexual way in which the relationship with the non-human world is portrayed in these works be interpreted away. It may be that the image of white American males, down the generations, fucking nature can be seen partly as a pejorative comment in the manner of a hard-hitting political cartoon, using the slang sense of 'fucking' as 'destroying'. But it would be wrong to reduce them to mere allegories, or to avoid the disturbing sense of ambiguity that they contain. If there is an ecologically and politically valuable moral to be drawn from these works, it is that if we are really to understand our relationship with nature – including, if we believe it has gone drastically wrong, how it has done so – then we need both to acknowledge and to come to terms with a specifically sexual component of it.

16. Paul McCarthy, *The Garden* (1991–92) Photo: Tom Powel Imaging. Courtesy Deitch Projects

Like McCarthy's *Cultural Gothic*, Matt Collishaw's *In the Old Fashioned Way* (1992) makes use of the imagery of bestiality; and, like McCarthy's work, it is mechanised. Collishaw appropriated a pornographic photograph, dating from around 1900, of a zebra mounting and penetrating a woman. The view is from their left: the animal's left fore leg is draped over her shoulder and with her left hand she is holding its hoof, the same arrangement presumably obtaining on the right-hand side; its large erect penis is clearly visible entering her from behind. Collishaw blew this image up to an extremely large size and added a small motor behind the lower part of the zebra, so as to simulate its humping motion. In an article entitled 'Animal Sex Machines', a writer using the name 'Supervert' analyses the role of bestiality within contemporary art, with special reference to *Cultural Gothic* and *In the Old Fashioned Way*. The article argues that both works 'suggest that there's something anachronistic, something unfashionable about interspecific intercourse'.[20]

Oleg Kulik's ongoing work in various media often depicts the artist naked with a range of animals, as part of his broad 'Zoophrenia' project. Often interpreted in terms of political allegory, Kulik's work clearly also displays a raw sexual content that gives primacy to the experiential over the cerebral. The 1993 performance *Deep into Russia*, for example, saw Kulik's head penetrate the vagina of a cow in the presence of eight witnesses. His frequent adoption of canine behaviour in his well-known early performances functions as an expression of the animal element within him, with obvious sexual implications. Later photographic images of human couples having sex superimposed with animals function not only to compare their sexual rituals and experiences but also to suggest the possibility of inter-species relations. Kulik's *Family of the Future* (1997) has similar sexual implications, as a vision of a society based on the coming together of animals and humans. The apartment that he designed as part of this project reflected the unusual nature of the 'family' in its odd scale, while its wallpaper comprising drawings of a man and dog in the style of the Kama Sutra point to the sexual possibilities of the scenario.

The sense of metamorphosis evident in Kulik's works also informs Rona Lee's performance *Eros/Ares* (1990), though here there is no suggestion of bestiality. Lee performed almost naked and painted green, in a ram's head mask, surrounded by the small cut-out figures of couples. The work invoked not only the mythological figures of Love and War but also Adam and Eve to explore the nature of control and mastery in erotic relationships. In *Avid Metamorphosis I* (1995), wearing a large prosthetic beak, Lee painstakingly unpicked a man's suit. In *Avid Metamorphosis II*, of the same year, she wore a high purple feather hat; during the course of the four-day performance, she hung up a dead goose, traced its outline on the floor, and cut its feathers off.

The fusion of human and animal forms in a manner that is strongly infused with a sexual sensibility is treated in broader morphological terms in the work of Louise Bourgeois. Just as Bourgeois' sculptures hint at landscape forms, they also contain forms that are distinctly animal. Indeed, *Nature Study* (1984) appears almost as if in a permanent state of metamorphosis.

The headless hybrid figure seems to crouch on haunches that appear animal (sphinx-like), though its curved back is distinctly human; so too are the breasts that are attached to its front, though their grouping complicates this. Marie-Laure Bernadac's reading of this work highlights the sexual relevance of this ambiguity, by drawing on one historical meaning of the French word 'nature' as being 'the genital parts, especially of female animals'.[21] The prevalence of the image of the spider as a representation of the mother in Bourgeois' work embodies the female archetype of the spider as protective creator and devouring mother, as well as suggesting the myth of Arachne, the young woman overly proud of her weaving skills, turned into an eight-legged creature by the goddess Athena, as told in Ovid's *Metamorphoses*.

In Rebecca Horn's work, as in Bourgeois', the boundaries between human and animal, and between animate and inanimate, are constantly transgressed, though the feel is decidedly different. In *Einhorn (Unicorn*, 1971), a young girl with a prosthetic horn walks through a field of ripening wheat. The unicorn as a symbol of purity is echoed in the image of the beautiful innocence of the young girl and the freshness of nature. Horn's *White Body Fan* (1972) invokes the language of the fan as a complex lexicon of sexual attraction, one in which the oscillation between concealment and revelation is key. The potential for flirtation offered by the fan is apparent once again in *The Feathered Prison Fan*, which appeared in her film *Der Eintänzer* (1978): as two huge ostrich feather fans slowly open and close, they repeatedly expose and hide the girl who stands between them. As with so many of the prosthetic devices that appear in Horn's films, it would become a sculptural object in its own right.

In his book *The Mating Mind* (2000), evolutionary biologist Geoffrey Miller stresses the importance of sexual selection in Darwin's account of evolution, too often neglected in popular accounts of Darwinism, which concentrate almost exclusively on survival.[22] Miller contends that the driving force of evolution is successful reproduction, and the selection of a mate is performed primarily by the female. This phenomenon is epitomised in the peacock, whose magnificently impractical tail remains as a display of sexual attractiveness central to the courtship ritual. Elements of display and delight are inherent in sexual selection in humans – dancing, flirting and play all articulate sexual attraction, and this sense of charming abundance is one that informs much of Horn's work, in which the image of the peacock is indeed a central motif. The white feathered 'mechanical peacock fan' appears in her film *La Ferdinanda* (1981), in which the sinister doctor Marchetti takes potshots at a white peacock in the garden. The following year, in 1982, Horn's mechanical *Peacock Machine* was installed at Documenta 7; the bird's feathers are replaced by a fan of spiked metal armatures that rise and fall with the action of a peacock's tail.

Horn has asserted that the figure of the bird in her work is not an expression of flight but is important because of its feathered form. She has produced a number of feathered prosthetic structures, including the white *Cockatoo Mask* and black *Cockfeather Mask* (both 1973). Horn's writing on these works links the function of the feathers to the acts of looking and caressing. If the black feathered column *Paradise Widow* (1975) is a mask, it is a whole body mask and is

sexually ambivalent and extremely unsettling. A human-sized free-standing sculpture, it can also be entered and there are several photographs of Horn, nude, enclosed in it. Another feather work, *Praying Mantis* (1986), alludes to the cannibalistic sexual act (the female insect is well-known to devour her mate); the silver crane feathers take on a sinister feeling, while a shiny metal shape at its bottom suggests a guillotine, carrying the threat of castration. *Black Widow* (1988), comprising black feathered wings that fan out and retract, evokes a similar danger.

The image of the bird carries with it the association of the egg, also a common motif in Horn's work. The egg both has implications of fertilisation and reproduction and acts as a symbol of the cosmos. The promise of the newborn emerging from its concealment within the egg suggests a form of birth that is embodied too in the figure of the butterfly emerging from the chrysalis. The butterfly's delicate wings are suggested in the shape and movement of Horn's fans, as well as more literally in works such as *The Lovers' Bed* (1990), which incorporates real blue butterflies. The poetic title of a note that Horn wrote in 1988, à propos of her film *Buster's Bedroom*, points to the more cosmic association of much of this sexual imagery in her work: 'Reflections from the Innermost-Earth to the Outermost Constellations. From Soul to Butterfly: Champagne to Big Dipper.'

'Nature' can mean many different things; one important sense refers to nature as the object of the natural sciences and of naturalistic art, and implies the belief that 'matter', which exists 'out there' independently of mind, is the ultimate ground of reality. This materialist conception of nature, which has increasingly dominated Western thinking since the seventeenth-century scientific revolution and the eighteenth-century Enlightenment, can now fairly be called the 'commonsense' view. However, it runs counter to the world's main spiritual and mystical traditions and it was challenged head-on by Romantic writers and artists, none more so than William Blake. Blake personified nature as Vala, whose name,

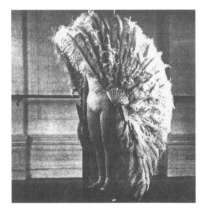

17. Rebecca Horn, *Feathered Prison Fan* from *Der Eintänzer* (1978) © DACS.

in Kathleen Raine's words 'is taken from her veil, symbol of the illusory and ever-varying appearances of the natural world'.[23] There is a remarkable parallel between Vala and the traditional Indian conception of *maya*, likewise personified as a goddess, one of whose principal meanings is 'illusion'. Blake called the firmament of our present world the 'Mundane Shell', something which needs to be broken through if we are to be re-born into our full human potential. Northrop Frye has written:

The bird is not a higher form of imagination than we are, but its ability to fly symbolises one, and

men usually assign wings to what they visualise as superior forms of human existence. In this symbolism the corresponding image of nature would be [...] the egg, which has been used as a symbol of the physical universe from the most ancient times. We think of cosmic eggs chiefly in Gnostic and Orphic imagery, but the account of creation in Genesis as a watery chaos surrounded by a shell or 'firmament', which the spirit of God, later visualised as a dove, broods upon and brings to life, also has oviparous overtones. In Blake the firmament is the Mundane Shell, the indefinite circumference of the physical world through which the mind crashes on its winged ascent to reality.[24]

Whether or not there is something typically male and transcendental in such approaches to nature is an open question. What is certain is that some of the most resonant images which link sex with nature point beyond nature in the sense in which it is most usually meant, to considerations of a cosmic and ultimately sacred dimension.

Chapter 7

Sex and
the Sacred

It is usual to see sex and the sacred, except in so far as sex is necessary for procreation, as essentially opposed: the struggle of spirit versus flesh. Yet the presence of an erotic sub-text in the ritual and imagery of Catholicism is widely recognised. One of the most famous instances of what, at least to modern eyes, is a flagrantly erotic quality in Catholic mystical experience is the vision of St Teresa of Ávila, canonically portrayed by Bernini in *The Ecstasy of St Teresa* (1645–52), while Leo Steinberg has famously analysed the sexualised body of Christ in traditional iconography.[1]

It is in traditional Indian religion, and most notably in the ecstatic cult of Tantra, that a positive relationship between sex and the sacred has been most openly avowed and celebrated. The Tantric vision is of a cosmic sexuality. In Philip Rawson's words, 'Tantra proclaims everything, the crimes and miseries as well as the joys, to be the active play of a female creative principle, the Goddess of many forms, sexually penetrated by an invisible, seminal male. [...] the Tantrika must learn to identify himself with that cosmic pleasure-in-play.'[2] This is a matter not of faith or intellectual understanding, but of direct experience which can be gained only through ritualistically repeated and disciplined activity, including meditation and sex. Tantra advocates sensual enjoyment, not as an end in itself, but as a means to enlightenment and communion with the divine. Tantra, or at least the idea of it, has proved very attractive to many people, including artists, in the modern West. A 'way' rather than a doctrine, its precepts are in principle applicable in radically different cultural contexts; although doubtless only a very small number of Westerners have appreciated anything approaching the subtlety of discipline required truly to qualify as a follower.

With its positive attitude towards the world of the senses – even while agreeing with more orthodox Indian philosophy that this is ultimately illusory – it is not surprising that Tantra has given rise to a rich array of images. These encompass, on the one hand, relatively abstract,

diagrammatic images, especially mandalas, relating the macrocosm of the universe to the microcosm of the individual; and, on the other, figurative depictions of male and female figures, mostly manifestations of the multiple deities and sometimes engaging in sexual intercourse. Both types of image reappear in the work of Francesco Clemente, who first travelled to India in 1973 and subsequently bought a house in Chennai (Madras). One of his most abstract works is *Mother-Father* (1980) which shows, in the middle of a large golden-green background, a vertically placed dark elongated oval – or rather, tall thin rectangle with rounded top and bottom – in outline only; inside it are three circles. More figurative, but still with an abstract element, is *Geometrical Lust* (1985), in the background of which is a large hexagon with concentric stripes, while in the right foreground a tiger-headed woman who, for the critic Waldemar Januszczak, represented 'the mysterious Western equivalent of an Indian deity,'[3] raises her left arm to reveal a hairy armpit inside which is a vulva.

Not only has Clemente been fascinated by the forms of traditional Indian painting but also by its materials and techniques; he has frequently collaborated with Indian artists who, to a greater or lesser extent, continue to work in traditional styles and media. In Jaipur in 1980–81, he made a series of twenty-four gouache miniatures on antique handmade Indian rag-paper. One of these shows a figure squatting near the top of the picture, presumably the source of some golden-brown roughly circular objects that can be read as turds, although they

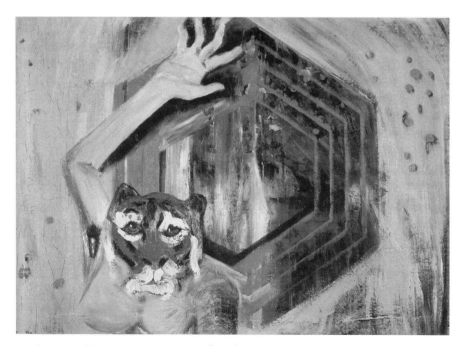

18. Francesco Clemente, *Geometrical Lust* (1985).

actually more resemble fruits as they rain down past flowering trees in a paradise garden into the appreciative mouths of two figures towards the bottom of the picture. These are of uncertain sex, in so far as their top parts look male while their buttocks appear more female. The upper figure is of similarly uncertain gender; and one is reminded of one of a series of pastels that Clemente made in 1980 with the title *Circùito* in which a squatting male-looking figure produces an egg from his rectum.

Though the *Circùito* series is not particularly Indian in style, its title and content could be seen to point to a relationship between human sexuality and the cyclical nature of the universe, which has something in common with the Tantric world-view, though here it is far more perverse. In another work from the series, a man looks out at us anxiously as he takes into his mouth the penis of a figure with a classically beautiful female torso; in a third a woman is giving birth to a baby who is already sucking the erect penis of a man lying beneath the woman. Another pastel work, *Caduceo* (1981), again shows a squatting figure at the top, while most of the picture is taken up with his (or her?) pink tail intertwining with the grey tail of a mouse who, at the bottom of the picture, is nibbling the end of the pink human tail: the intertwining of the tails exactly resembles that of the snakes in the caduceus carried by Hermes/Mercury, still used as a symbol of medicine.

These snakes, an archetypal motif intriguingly comparable to the double helix of DNA, point both to ambisexuality and to the conjunction of male and female, crucially of mother and father, in the sexual act. As Norman O. Brown has written:

> The parents in coitus, the two snakes copulating that Teiresias saw. The two snakes are one snake, a phallic snake which also bites and swallows like a vagina: the uroboric snake, which is both a pole and a hole.[4]

Clemente's *Hunger* (1980) shows the cosmic snake Ouroboros eating his own tail, in an almost perfect circle that extends almost to the limits of the square picture space, while at the bottom a small man tries to gnaw his way through the snake's body, as if to break out of the magic circle of fate.

Tantra has been a source of inspiration for many artists on the West Coast of America, where naturally it has been reinterpreted to suit that particular cultural context. The Californian performance artist Barbara Smith was one of the first to acknowledge and proclaim this influence. Throughout her all-night performance *Feed Me* (1973), part of the San Francisco Museum of Conceptual Art series of *All Night Sculptures*, she was naked and inhabited a warm, comfortable room with incense, music and flowers, as well as food and wine with which the audience were invited to feed her, and body oils and perfume with which they could 'feed' her in an extended sense.

The three-hour performance *Birthdaze* (1981), marking Smith's fiftieth birthday, presented a number of intertwining narratives focusing on her relations with men, both positive and negative. It was punctuated with a number of scripted sexual acts and culminated in a

Tantric ritual which she and her lover Victor Henderson, both of whom had fasted for five days before the performance, carried out to the accompaniment of chanting women. They ate symbolic foods together and engaged in sexual intercourse with the intent of experiencing high states of ecstasy, through an energy-centred but nonorgasmic union.[5]

Annie Sprinkle discovered Tantric sex in around 1984; she was living with the writer Marco Vassi[6] when he was diagnosed with AIDS. The couple stopped having intercourse and oral sex, and studied Tantric, as well as Taoist and Native North American sex techniques. Without abandoning the name or persona of Annie Sprinkle, she reinvented herself, adopting a new persona, Anya. Contrasting the two, she writes:

Annie Sprinkle loves everybody. Anya loves herself.
Annie Sprinkle seeks attention. Anya seeks awareness.
Annie Sprinkle is a feminist. Anya is a goddess.[7]

There is a doctored photograph of a smiling Sprinkle, crowned, sitting in the lotus position, with many arms in the manner of a Hindu deity, holding various sex toys. However much she has come to identify with a spiritual view of sex, the humour and playfulness remain central – though now combined with a more didactic purpose.

Having attended a number of sex workshops, including the Tantric workshops given by the Californian-born Jwala and the Tantric/Taoist ones given by the former Jesuit monk Joseph Kramer, Sprinkle has run a number herself, for women only, including the Sluts and Goddesses Workshop, along with the resultant *The Sluts and Goddesses Video Workshop, Or How to be a Sex Goddess in 101 Easy Steps*. A later video, made with Kramer, was *Zen Pussy: A Meditation on Eleven Vulvas* (1999). Breathing is the key to most Eastern meditation techniques, and it was Kramer who first taught Sprinkle the power of breath in sex. An important part of her *Post-Porn Modernist* show was the Masturbatorium Ritual, in which she would 'breathe, undulate and masturbate [her]self with a vibrator into an erotic trance'.[8] This ritual was, she said, 'inspired by the legends of the Ancient Sacred Prostitutes'.[9]

The dancer Shakti's name refers to the Tantric principle of Cosmic Energy, personified as the Great Goddess, female sexuality incarnate. The Kali-like title of one of her pieces, *Eros of Love and Destruction*, is key to her work as a whole. Her dance evocation of *The Kama Sutra* (1996) concentrated on seven elements: self-love, the male/female principle, love of the same sexes, bondage, orgy, animal instinct and the ultimate orgasm. In *The Pillow Book*, based on the works of the eleventh-century Japanese poet Sei Shonagon and performed at the Edinburgh Festival in 2003, she danced wildly in a flowing red robe before her naked body was painted all over by the artist Mieko Nishimura. Then, in the words of one critic:

Once the painting is completed, the dance is stunning... Shakti dances to seduce her lover (the audience). She knows that the face is a very important part of dance. She

can be seductive, innocent, predatory, sexy, dominant, animalistic, submissive and free-spirited, all in the time span it took to read this sentence. She can devastate with a single look.[10]

Shakti has also danced in more than fifty Buddhist temples in Japan. One of her remaining ambitions is to revive the tradition of the *devadasi*, or Hindu temple dancer, in Japan, knowing it is impossible in India.

Traditionally, temple dancers and sacred prostitutes were often seen as priestesses of the Goddess of Love or, in earlier matriarchal societies, of the Great Goddess in her sexual aspect. For many female artists in the modern West, the image of the Goddess has been a crucial inspiration, both because it is a way of integrating sexuality into a wider natural, cosmic and sacred order and because the artist herself could take on the role of priestess, prophet or even Goddess incarnation.

Frida Kahlo's painting *The Love Embrace of the Universe, the Earth (Mexico), Me, Diego and Mr Xolotl* (1949) depicts her cradling her husband Diego Rivera in the manner of a Pietà; behind her is a green sculptural goddess figure embracing them both and behind her in turn is a more shadowy ethereal goddess figure embracing them all, so that a direct chain is established between Kahlo as an individual woman and the spirit of the whole universe conceived as female. While all Ana Mendieta's works linking her own body to the earth to some extent imply a sacred dimension, the sacred is most explicitly evoked in her series of *Rupestrian Sculptures* (1981), carved into a rock wall in a park in Havana and closely recalling prehistoric fertility goddesses, with titles such as *Guanaroca (First Woman), Atabey (Mother of the Waters), Guanbancex (Goddess of the Wind), Guacar (Our Menstruation) and Maroya (Moon)*, and in *Labyrinth of Venus* (1982), also a sculpted rock wall, this time in Canada.

The image of the Goddess was of central importance for the numerous artists who aligned themselves with that wing of the women's movement which sought to reawaken and celebrate female sexuality through a rediscovery of pre-patriarchal myths and rituals. Mary Beth Edelson's *Woman Rising/Sexual Energies* (1974) and *See for Yourself: Pilgrimage to a Neolithic Cave* (1977), both private rituals documented in photographs, were key works in this genre. Vijali Hamilton studied with Native American shamans. For the collaborative event 'Western Gateway' which took place in the Santa Monica Mountains, California, in 1987, she created a large Medicine Wheel and enacted a ritual performance as the Earth Mother, 'her body covered with earth, her hair wildly tangled'.[11] The first place settings in Judy Chicago's *Dinner Party* (1974–79) were not for historical women but for goddesses: Primordial Goddess, Fertile Goddess, Ishtar, Kali, Snake Goddess, Sophia. Around 1974, Chicago created a work with china paint and pen on porcelain, in which her usual vulvic imagery was surrounded with the words 'The Cunt as Temple, Tomb, Cave and Flower'. Her *Birth Project* (1980–85), created according to the same collaborative principle as the *Dinner Party*, contained an image of the Earth Mother giving birth to herself.

The linking of feminism to esoteric magico-religious concerns was also important for Ulrike Rosenbach, for example in her performance *In the Garden of the Goddess* (1986). Rosenbach has investigated many female archetypes, sometimes using slide projections of famous paintings or sculptures, including images of the Virgin Mary, Venus/Aphrodite and Diana/ Artemis. One of the images projected in her 'Videoaktion' *Maifrau* (1977) was a statue of the many-breasted Artemis; a motif to which Louise Bourgeois also paid direct homage when she wore a many-breasted costume in her 1980 performance *A Banquet/Fashion Show of Body Parts*.

Although the symbolism of the snake is ambisexual, the Cretan Snake Goddess has been of special significance to many female artists in the light of Minoan Crete's position as the last matriarchal culture in Europe before the rise to dominance of phallocratic ancient Greece. Probably the most striking use of that image is Marina Abramović's appearance, bare-breasted and holding a live snake in each hand, as she is lowered out of the 'gods' at the beginning of each of her series of theatre performances *The Biography* (starting 1992). More generally, her use of snakes, both in her relational work with Ulay and in her subsequent solo work, can be seen in the context of her overriding concern with releasing and harnessing powerful sources of energy as well as a belief in their telluric energies. Her work manifests an extraordinary vitality, which in yogic terms could be linked with the awakening of the serpent-like Kundalini force.

Carolee Schneemann has often spoken of the 'sacred-erotic' quality of her work as a whole; one of the performances in which she employed her Vulva personification was entitled *Ask the Goddess* (1991). Schneemann has a special personal and artistic affinity with cats, animals long associated with divine female power. She had a cat who was extremely special for her, named Cluny, which would kiss her fully on the lips each morning; Schneemann recorded these actions in polaroid photographs which she then arranged in a grid, to make the work *Infinity Kisses*. Some time after Cluny's death, she had a vivid dream in which she opened her notebook and inside it was Cluny's arm, from his paw to his elbow, recognisable by his distinctive markings. Overcome with emotion, she had a short conversation with this ghostly apparition, who instructed her to make a particular gesture – one which was later to be the starting point of her performance *Cat Scan*. Schneemann's conviction that there was something Egyptian about the dream led her to furiously research ancient Egyptian religion and symbolism. In the course of her study, she came across an image of a Fourth Dynasty painted limestone relief depicting the Goddess, in the form of a lioness, breathing life into the mouth of her priestess, in a gesture almost exactly resembling that of Cluny kissing her – an image, quite literally, of inspiration.[12]

That artists should fulfil a priestly or prophetic role, what August Wiedmann has termed 'the hierophantic conception of art' was, as he points out, one of the crucial elements of Romanticism.[13] It arose in the context of a declining belief, among advanced thinkers in the West, in the validity of traditional Christian religion, at the same time as a growing sense of the inadequacy of the Enlightenment and the positivist faith in science as a tool to answer the

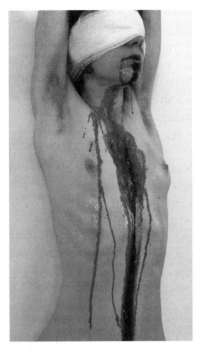

19. Hermann Nitsch, *107. Aktion*
(2001).

fundamental questions. As well as pronouncing the 'death of God' and mounting a withering attack on Christian morality, Nietzsche revived the Classical Greek dialectic of Apollo and Dionysus, increasingly identifying, towards the end of his life, with the latter. Partly reflecting the influence of Nietzsche, the spirit of Dionysus has been crucial in much avant-garde art since the beginning of the twentieth century.

Performance Art in the 1960s was shot through with an orgiastic fever which was unmistakably Dionysian. Hermann Nitsch's Aktions combined (and continue to combine) this Dionysian imagery with that of the Catholic mass, enacting the common themes of sacrifice, brutal death and rebirth, infused with a violent sexuality. Other references within his work include ancient Egyptian mythology, and neolithic religious imagery, for which his principal guide was James Frazer's *The Golden Bough* (1922). Nitsch evokes the richness of religious symbolism and at once undermines its metaphorial qualities by making it literal and forcing the spectator to experience its physical actuality. There has been a slow shift in his work from an initial emphasis on catharsis, the purging of negative and violent impulses, towards an increasing sense of celebration.

A sense of celebration was clearly paramount in Schneemann's *Meat Joy*. Where Nitsch has expressed the tragic loss inherent in sacrifice, *Meat Joy* expressed the joy of the flesh, the carnal. The orgiastic mass of writhing naked bodies broke down the barriers of individual separateness in an ecstatic communion. Much radical theatre of the 1960s too was infused with the same spirit. At the culmination of the 1960s, Richard Schechner's Performance Group staged *Dionysus in 69*, a free adaptation of Euripides' *Bacchae*, closing the decade, in that happily numbered year, with a conscious homage to the god.[14]

For Georges Bataille, the dissolution of the finite boundaries inside which individuals are necessarily imprisoned and the opening out to a oneness with other beings, and indeed with the infinite, is the essence of eroticism as it is of the sacred. In his book *Eroticism*,[15] he opposes the sacred and erotic, characterised by excess, to the everyday world of work, characterised by economic rationality. Religion is only one mode of access to the sacred and he treats it virtually as a sub-category of the erotic, inasmuch as he distinguishes three types

of eroticism: physical, emotional and religious. But the overcoming of separateness and the entering into a state of 'continuity' with all things can only be fully achieved in death. A fascination with death is indeed the 'dominant element in eroticism', a specifically human phenomenon different from basic animal sexuality even though it is based in that. Yet this fascination with death is ultimately, in a thoroughly Nietzschean spirit, an extreme form of 'assenting to life'. While fully admitting the differences between his three types of eroticism, Bataille insists that, from the point of view of inner experience, physical sex, romantic love and religion, both in the sense of sacrifice and mysticism, all share the same essential psychological significance.

Central to Bataille's thinking is the paradox of transgression. The profane world is hedged with prohibitions and taboos, necessary for society to function. Access to the sacred, which is also the realm of violence and death, involves transgressing these; but far from simply denying them, this transgression both relies on them for its meaning and actually reinforces them. Since it is premised on a knowledge of and assent to taboos even as it is breaking them, transgression is necessarily accompanied by anguish. This sense is well conveyed in Max Ernst's painting *One Night of Love* (1927), which depicts an act that could be sexual intercourse or giving birth or an archaic religious sacrifice, taking place on a surface that could be a bed or an operating table or an altar. Still more explicitly, his *Robing of the Bride* (1939) links a deeply troubled sexuality with disturbing pagan and archaic religious ritual.

Much of the later work produced within the Surrealist orbit, or by artists and writers with links to Surrealism, had explored the connection between sex and the sacred, amounting at times to a virtual identification of the two, together with the placing of a supremely high value on that sacred-erotic dimension. In particular, Antonin Artaud exhibited an extreme hostility towards religion that was nevertheless based on an awareness of the profound power of religious ritual, which he took as a basis for his theatrical model. His little-known play *A Spurt of Blood* (1920) enacts the collision between sex (in the figure of the Whore) and religion (in the figure of God), whose hand she bites, resulting in the spurt of blood of the title. Artaud's vision was perhaps most fully realised by Jean Genet, for whom the Catholic mass was the most perfect theatrical prototype.

While rejecting Catholicism, several artists influenced by the Surrealists drew heavily on its imagery, emphasising its unacknowledged erotic substratum. Pierre Molinier's painting *Oh! Marie...Mère de Dieu* (1965) combines the conventional Christian iconography of the haloed figure on the cross with more diabolical Bosch-like motifs: the crucified figure is hermaphroditic, sporting an erect phallus while seeming to be penetrated from behind by a largely hidden figure whose claws maul its breasts, drawing blood. *Le réveil de l'ange* (1960) and *La communion d'amour* (1971) show figures in ecstatic union to such an extent that they almost fuse into one, surrounded by a halo of light. Similarly, Michel Journiac's sculpture *Le Saint-V[i]erge* (1972) has attributes of both sexes: breasts and phallus. Its title plays on the pun between *vierge* (virgin) and *verge* (a rod or penis), in much the same way as Apollinaire's

pornographic novel *Les Onze Milles Verges*. Journiac's earlier performance *Messe pour un corps* (1969) had drawn on the artist's training as a Catholic priest, abandoned in 1962. Journiac celebrated a Catholic mass in a Paris gallery, substituting the communion wafer with a pudding made from his own blood.

In the work of Ron Athey, the interaction between sex and the sacred sprang from a more populist form in the the kitsch world of contemporary American fanatical religion. Athey was raised by Pentecostalist religious fanatics to believe he was a very special sort of evangelist: he described his family as 'poor people using fantastic religion to elevate their self.'[16] Athey was speaking in tongues by the age of ten. At fifteen, he rebelled against his family's wish that he become a fundamentalist minister, experimenting with sadomasochistic sex and drugs. Yet, although he had turned entirely against the credo of his religious background, he retained its fanatical intensity in his work: 'I have trouble living on Earth. My brain wants to live in this psychic mumbo-jumbo. That's how I was raised.'[17] Athey's life and work have been the subject of the film *Hallelujah! Ron Athey: A Story of Deliverance* (1998), directed by Catherine Gund Saalfield.

The Romantic conception that poets and artists can fulfil a priestly or prophetic role may be one of the reasons for the surprising survival in modern literature and art of the image of the angel. As messengers from the divine – and by extension from the unconscious or just in some sense from 'beyond' – angels can symbolise a crucial part in the creative process in which artists themselves are engaged. Intermediate between the human and the divine, archetypal figures which have allowed monotheistic religions to express some of the paradoxes and complexities automatically present in polytheistic systems, angels, however perverse, are widely associated with beauty and the imagination.[18]

For Joseph Beuys, it was as essential that human beings rediscover a fuller relationship with spirits and angels as that they did so with animals, plants and nature. Ulrike Rosenbach, who was one of Beuys' students, made considerable use of angel imagery in her work: the photo-installation *Die Engelparade* (1982) contained images of angels from Old Master paintings. For her performance *Die Eulenspieglerin* (1984), the readymade image she used was of the winged, angel-like figure brandishing a whip in the frescoes depicting a Dionysian initiation rite in the Villa of Mysteries in Pompeii, except that Rosenbach replaced the whip with a branch. She has used the same image, with minor variations, a number of times, including on a kite for the exhibition 'Art Dragons: Pictures for the Sky' (1988–92): she called her contribution to the show *Angel Dragon* and has referred to this archetypal motif as her 'dark angel'.

In the Pompeian frescoes, the figure with the whip, who has been identified with the demon of shame, is about to flagellate the naked back of the female initiate. The Lacanian psychoanalyst Bice Benvenuto likens these depictions of Dionysian rites to the 'rites' of psychoanalysis, arguing that, in both, the experience of shame plays a crucial role. She draws a comparison between the demon of shame and the angel with a flaming sword who barred the return of Adam and Eve to Paradise, a comparison supported by the visual evidence of a

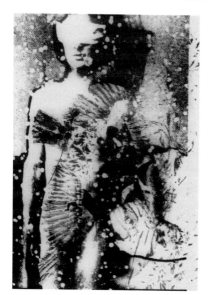

20. Maria Klonaris and Katerina Thomadaki, *Angélophanies (The Angel Cycle)* (1987–88).

number of depictions. 'This whipping,' she writes, 'this painful expulsion, this loss is part of the analytical progression...' – indeed, a very important part, towards the end of an analysis.[19] For, according to Benvenuto, psychoanalysis cannot in itself bring about, any more than the ancient Bacchanalia could, an ecstatic mystical union with God or the Other; rather, it is a specifically human quest into which the analysand is initiated, one which involves precisely the acceptance of separation.

The 1997 exhibition ':Engel :Engel' (':Angel :Angel'), held in Vienna and Prague, highlighted the proliferation of the figure of the angel in modern and contemporary art, including work by, among others, Christian Boltanski and Nancy Spero.[20] One overtly sexual work which was also included was Anette Messager's *The Angel* (1984, from the series *Chimeras*). It shows, beneath a pair of wings, a pair of female breasts and a downward-pointing penis, the breasts placed so that they can be read as testicles, a provocatively blunt reference to the androgynous nature of angels' sexuality.

By contrast, the work of Maria Klonaris and Katerina Thomadaki linking androgyny with angels is characterised by its intense delicacy. The central figure of their *Angels and Archangels* cycle (1985–2003) is transformed from clinical hermaphrodite to Angel by the addition of wings, and is surrounded with astronomical motifs: stars, nebulae, constellations, solar eclipses. Increasingly, this imagery was superimposed on the figure itself, even as this was sometimes doubled. Layer was placed upon layer, creating a palimpsest; transparency, always an element of these artists' aesthetic, became increasingly marked.

The theme of Vivien Lisle's *Legitimate Journey* (1982) is androgyny in its symbolic as well as its literal aspects. Lisle juxtaposes biographical details with traditional mythological symbols – such as the caduceus, the staff of Hermes/Mercury. She retains the polyvalent richness of esoteric symbolism but combines it with a demystificatory stress on medical and historical fact. Rosenbach's performance *Meeting with Adam and Eve* (1982–83) locates the coming together of masculine and feminine more directly within herself. She finds these two opposite forces damaged by their separateness, and seeks a way to reconcile them. As well as drawing on biblical iconography, she evokes other highly symbolic imagery, including angels and the planet Mercury.

The sexual symbolism of snakes in the work of Marina Abramović also hints at a coming together of masculine and feminine sexual energies. More definitely, Abramović's relational work with Ulay can be read as a balancing and dynamic synthesis of masculine and feminine, Yin and Yang, physically incarnated in a male-female coupling that was to culminate in their Great Wall Walk, *The Lovers*. Their penultimate work was *The Sun and the Moon*, which took place in three versions. In the first Ulay sat on top of three chairs which were balancing on top of each other, while Abramović approached him in slow motion, the performance ending when Ulay lost his balance; in the second, done just once, an even more minimal performance, reminiscent of *Nightsea Crossing* (1981–87), the artists sat motionless opposite each other until one of them left, exposing the one who remained to the reactions of the audience; and the third, an installation, featured two black vases the size of the artists' bodies and thus standing in for them, which were given the names the Sun and the Moon, the one reflecting light and the other absorbing it, a pairing somewhat reminiscent of Joseph Beuys' pairing of felt and fat.

Many artists in the twentieth century were attracted to the highly sexualised symbolism of alchemy. On the theoretical plane, alchemy was reinterpreted by writers such as C.G. Jung, Mircea Eliade and Gaston Bachelard not as a literal attempt to turn base metals into gold but as a sophisticated metaphor for psychological transformation and spiritual refinement. Central to the alchemical symbolic system is the division into gendered opposites, such as the solar king and the lunar queen, and their coming together in the 'chymical wedding'. The union of male and female to make something new can be manifested in the physical union of two human beings but the same principle, the *mysterium coniunctionis*, is seen in the alchemical system as operative at every level of reality.

Despite Marcel Duchamp's statement that if he did use alchemical imagery it was in the only way possible in the twentieth century, namely unconsciously, convincing interpretations have been made of many of his works in alchemical terms. *The Bride Stripped Bare by her Bachelors, Even*, known also as the *Large Glass*, has been interpreted in alchemical terms by, among others, Arturo Schwarz in 'The Alchemist Stripped Bare in the Bachelor, Even'.[21] If the sexual as well as the alchemical symbolism is prominent enough in the *Large Glass*, it is even more so in *Etant donnés: 1. La chute d'eau 2. Le gaz d'éclairage* ('*Given: 1 The Waterfall, 2 The Illuminating Gas*') (1946–66). Its hyper-realistic sculpture of a nude woman is set in a kitsch landscape; behind her is a mechanised waterfall, the falling of Water to Earth, both elements traditionally symbolic of Nature, while in one of her hands she holds a torch, the illuminating gas of the title, Fire rising into Air, elements symbolising Culture.

Much of Rebecca Horn's work is infused both explicity, as in *Blue Bath (The Chymical Wedding)* (1981), and elsewhere more implicitly, with a sense of the sexual connotations of alchemy, with its potential for the explosive coming together and chemical fusion of substances. The funnels that appear in many of her work suggest the apparatus of the alchemist as well as the female sexual parts; in *The Hybrid* (1987) she places coal – the pure

element that has the potential to become diamond – and sulphur – gendered masculine in alchemy – into these distinctly female glass vessels. Horn incorporates sulphur in several of her works, alongside the fluid element mercury, which is traditionally associated with the feminine in alchemy, in a way that evokes the material union of the sexes.

The sexual element, not only in relatively esoteric symbolism but also in historic mainstream religious imagery, is one important reason for contemporary artists to engage with traditions which might, from a purely modernist perspective, seem outdated. In Adrien Sina's series of diptyches *Dark Angels/Bright Devils* (2004), part of his continuing investigation into the 'archaeology of desire', mediaeval Catholic imagery – a page from an illuminated manuscript, a painting or sculpture – is juxtaposed with images of contemporary youth culture – most typically, a girl in exotic clubbing gear sporting tattooed flesh. Visually, the halves of the diptych are joined by a simple Latin cross, sometimes right way up, sometimes inverted. In Sina's words:

> Feathers tattooed on a girl's shoulder: a memory of angel's wings. Gothic lives, not as broken treasures accumulated within museum vaults, but as a universal youth culture where a dark language speaks love, rebellion and romantic desire cloaked in black. The crucifix has acquired other rituals, a semantic field in which it speaks to its inverted other; the monks who calligraphed and decorated coloured manuscripts were tormented by the devil with sexual visions; his work and theirs lives today on the skin.[22]

Recent decades have seen in the work of some contemporary artists a return to a visual language that has remarkable affinities with traditional sacred hieratic art, the post-Enlightenment reinsertion into art of the language of meaningful sacred symmetry. Formally, the shape of the mandala, which traditionally maps man's place in relation to the ordered cosmos, has appeared in the work of several artists, drawing comparisons with the imagery of ancient sacred systems. The mandala-like shapes of Helen Chadwick's *Piss Flowers*, for example, resemble those of Hindu temples or Buddhist stupas.

Perhaps the most consistent use of mandala-like imagery occurs in much of the work of Gilbert and George, appearing as hieratic and symmetrical, sometimes stressing a central point but more usually a vertical axis. Forming that axis in *Angry* (1977) is a photograph of an obscene figure scrawled on a brick wall, with an outsized penis and holding detached penises in both hands for good measure, with arms outstretched in the pose of Leonardo's Cosmic Man. The cartoon-like *Buggery Faith* (1983) has a cruciform structure in which four red-tipped circumcised penises converge on a brown form which can only be interpreted as an anus. *Bloom* (1984) recalls the traditional Paradise imagery of Islamic gardens and carpets but features four faces of thuggish youths arranged as if they were petals of the central flower. The diptych *Life* and *Death* (both 1984), as well as resembling stained glass windows in the way that most of Gilbert and George's works do, relate specifically to those windows depicting the Tree of Jesse: Christ's lineage but also an archetypal symbol of ascent and descent. Flanked

by pictures of youths, the central axes of these pictures consist of seven images of the artists, alternating, seven being the number most associated in sacred symbolism with ascent, as in the Mountain of Purgatory, as well as the number of the chakras in the Hindu tradition, thus relating it to the axis of the human body. Perhaps the strongest association of these pictures, especially given the titles, is with the Tree of Life, most archetypal of all vertical symbols, connecting Heaven, the Earth and the Underworld, and its double, the Tree of Death, from which derives the knowledge of good and evil. This is fitting indeed for work which connects the highest human aspirations with the basest forms of lust.

There is a surprising paradox in the juxtaposition of the obscene subject matter of many contemporary artworks with an interpretation of their sacred elements. Paul Ricoeur begins his book *Freud and Philosophy: An Essay on Interpretation* (1965) by suggesting that 'there is an area today where all philosophical investigations cut across one another – that of language'.[23] The language studied by psychoanalysis is that of the unconscious, which is a symbolic one in the sense that embedded in an immediate meaning is at least one further or deeper meaning: that is why interpretation is called for. The great contribution that Ricoeur has made here and elsewhere is to distinguish two fundamentally opposed approaches to interpretation. One, which he calls the 'hermeneutics of suspicion', consists in the unmasking of false consciousness and the revelation of less than creditable motives hidden behind it. As the principal exemplars of this tradition of demystification Ricoeur cites Marx, Nietzsche and Freud. Each studied a somewhat different sphere of human activity and each found a different concealed motivation: behind cultural values and political, legal and social institutions, Marx found class economic interests; behind morality, Nietzsche found the drive for power; behind dreams and other products of the unconscious, Freud found repressed sexual desire. Yet each believed that the motivation they uncovered was the primary key to understanding human behaviour and consciousness as a whole. Since the time Ricoeur was writing, the idea of demystification, the claim to have uncovered a fundamental underlying reality has been increasingly replaced by that of deconstruction – perhaps more modest, certainly more open-ended – but still premised on suspicion.

The other approach to interpretation that Ricoeur identifies is that which is concerned with the 'restoration of meaning'. Writers in this tradition lay stress on the inherent truth in symbolic languages to which, with the rise of an excessively literal-minded and supposedly objective ways of thinking, we no longer have access. What is required, according to them, is the ability to listen to symbols, to sense the 'something' to which they refer and to be open to their power of revelation. Among the exemplars of this form of restorative hermeneutics, Ricoeur cites Mircea Eliade. Many people would also point to C.G. Jung, Freud's renegade disciple, but Ricoeur personally is somewhat dismissive of Jung. Rather, his main purpose in writing *Freud and Philosophy* is to show that Freud himself, although one of the great demystifiers, was intellectually subtle and honest enough to be open to the restorative approach as well.

In his essay 'Obsessive Actions and Religious Practices' (1907), Freud first compared religious practices to the actions of obsessive neurotics – both ritualised, and both, according to his analysis, motivated by the perceived need to ward off some terrible ill which would be the consequence of their not being performed, ultimately punishment by a vengeful father-figure. Not surprisingly, the primary effect of such a comparison was for Freud, and remains for others, to disparage religion. If correct, it punctures religious dogma, along with neurotic rationalisation, and offers further proof of the 'illusionary' quality of religious belief. But, even while accepting this, we must go beyond the initial disillusionment. Whatever the original *cause* of religion – or neurosis – may be, this need not pre-judge the value which religion – or neurotic symptoms – may have in terms of providing insights into areas inaccessible, as yet anyhow, to rational thought. Freud was aware, in fact, of the possibility that a symptom, as well as harking backwards, could also contain within itself the seeds of a potential healing process; and, by the same token, we can say that much of the value of sacred symbolism lies in its mapping out of our relationship to the world in a way that seeks not only to explain where we have come from but also to provide a beacon towards which we might aspire. For Ricoeur, symbolism is, indeed, 'the area of identity between progression and regression'.[24] Furthermore: 'By probing our infancy and making it live again in the oneiric mode, symbols represent the projection of our human possibilities into the area of imagination.'[25]

One of the great advantages of art is that it does not need to choose between a demystificatory and a restorative form of interpretation. Not only can it live with ambiguity, but precisely the tension between what appear as contradictory opposites is a massive source of potential power. Nowhere is this more true than in the case of art that links sex and the sacred. The closeness of these two domains, even if largely explicable in the terms set out by Bataille, remains a paradox – the often painful nature of which Bataille was all too well aware of – and the art which deals best with it, far from seeking some compromise, allows the paradoxical nature of this closeness to be heightened. For it is not necessarily in the form of sexuality which religion sanctions, namely marriage, but often in the more varied or perverse forms of sexuality, those which seem to the pious to be most drastically opposed to the sacred, that profound links with the sacred are to be found.

Chapter 8

The Theatre of Cruelty

In a classic 1919 essay, Freud noted the frequency with which patients of both sexes reported the fantasy of a child being beaten as an auto-erotic source of pleasure.[1] In the female cases, they were seldom taking part in this scenario themselves but rather witnessing unknown boys being beaten by some male authority figure. In the male cases, they were far more likely to identify with the child being beaten, while the person administering the beating was imagined as a woman. The origins of this sexually stimulating fantasy, which Freud traced back to before the age of five or six, were different for girls and boys; but he postulated a wholly unconscious intermediate phase, arising out of the Oedipus Complex, in which both girls and boys fantasised about being beaten by their father.

> This being beaten is now a convergence of the sense of guilt and sexual love. *It is not only the punishment for the forbidden genital relation, but also the regressive substitute for that relation* [...] Here for the first time we have the essence of masochism.[2] [Freud's italics]

Whereas, in repressing and remodelling this fantasy into its final form, the boy avoids his homosexuality through a heterosexual object-choice (even while retaining a 'feminine' passivity), the girl 'escapes from the demands of the erotic side of her life altogether', becoming a 'spectator at the event which takes the place of the sexual act'.[3] Perhaps the most striking feature of Freud's account of the twists and turns by which these highly theatrical scenarios are developed is the extent to which roles and identities are shown to be interchangeable.

Freud introduced the concept of a 'death instinct' in *Beyond the Pleasure Principle* (1920), replacing his earlier binary model of the pleasure principle versus the reality principle with the more over-arching and frankly mythical one of Eros versus Thanatos, Love or Life versus Death. He further developed the idea of the death instinct in *The Ego and the Id* (1923), in which he

elaborated the topographical division of the self into ego, superego and id.[4] In this scheme, it might be assumed that the ego – as that part of oneself with which one identifies – always performs the function of mediator between the instinctual demands of the id and the moral commands of the superego (as well as between the self and external reality); however, this is not necessarily the case. Although Freud believed that the superego has its origins in the authority of the parents, it drew its energy from the repressed forces of the id: 'the superego is always close to the id and can act as its representative vis-à-vis the ego'.[5] This paradoxical affinity left open the possibility of an unholy alliance between superego and id, the former at the service of the latter, as a means of giving expression to covert sadism, while feeling morally justified. Conspicuous examples of this would include, historically, the enjoyment of public executions and, more recently, the enthusiasm shown in the popular press for harsh treatment of offenders. It may, however, provide a crucial key to a much wider range of social and political phenomena.

Freud had adopted the term 'sadism' from the psychiatrist Richard Freiherr von Krafft-Ebing, who in his 1886 *Psychopathia Sexualis* named the perversion after the Marquis de Sade. De Sade's unusual level of explicitness is perhaps part of the reason for the modern fascination with him; indeed, he has provided a figure for numerous investigations into the sexual element of political power and society, elevated from the position of virtually unpublished pornographer to that of cultural reference point. Various thinkers have drawn comparisons with other major cultural figures: Lacan compared him to Kant;[6] Barthes identified a structural similarity between sadomasochism, politics and religion in the figures of de Sade, Fourier and Loyola;[7] Paglia placed him in opposition to Rousseau in terms of their view of human nature.[8]

De Sade was a major figure in the Surrealist pantheon of literary and revolutionary heroes. Surrealist art contains countless examples of sadism, both in direct reference to de Sade – André Masson produced drawings in illustration of de Sade's *Justine* (1928), Roberto Matta *The 120 Days of Sodom* (1944) – and in the cruel erotic sensibility pervading many of their works. The violently contorted sexual scenarios depicted in much of Hans Bellmer's work, in particular, are highly infused with sadomasochistic feeling, as are many of Salvador Dalí's drawings and paintings from the 1920s. In his erotic text *The Visible Woman* (1930), Dalí claimed that perversion and vice were the most revolutionary forms of thought and activity. Pierre Klossowski wrote extensively on de Sade, also producing large-format drawings that depict awkwardly posed figures in ambiguous, highly sexualised and potentially sinister situations.

In his linking of eroticism and death in *Eroticism*, Bataille laid claim to an affinity with de Sade, citing, among numerous references, Sade's statement that 'there is no better way to know death than to link it with some licentious image'.[9] Bataille draws an analogy between sacrifice and intercourse, in which the act of killing sanctioned by sacrifice is allied to sexual penetration in its breaking down of the barrier of separateness and individual will. The continuity of all things is revealed through violence and death as through sexual reproduction: 'the external violence of the sacrifice reveals the internal violence of the creature, seen as loss

of blood and ejaculations'.[10] Whereas Bataille appears to be celebrating the violence in sex and sacrifice (even while stressing its element of anguish), much of Artaud's writing casts sex as the tool of his own violent persecution. Artaud's 1932 text 'The Theatre of Cruelty' demanded the enactment of violent spectacle: 'there can be no spectacle without an element of cruelty as the basis of every show. In our present degenerative state, metaphysics must be made to enter the mind through the body.'[11]

Hermann Nitsch's Sadean and ritualistic performance works constitute just such an assault on the senses; indeed Nitsch has declared Bataille and Artaud to be his 'brothers'.[12] The 'passive actors' of his Aktions are bound to crosses or cross-like wooden structures and saturated with the blood and offal that is poured over them. Audiences are overpowered by the sight and smell of blood and animal intestines, which Nitsch obtains from slaughterhouses (indeed the slaughter of animals has occasionally become part of the performance itself). It is the violence of the Dionysiac cult that Nitsch stresses, focusing on the rending of the animal carcass. The sexuality that pervades all of his work is made shockingly visual in the ripping open of the bull's carcass to create an extremely vulvic form into which bloodied hands are thrust.

If Nitsch's work relates more evidently to sadism than to masochism, the same is true of Otto Muehl. Their fellow Viennese Aktionist Günther Brus, however, demonstrates a more masochistic aesthetic. *Action Number 33*, performed at Vienna University in 1968, comprised Brus urinating into a glass and shitting on the floor, then smearing his body with the excrement and drinking the urine. In *Körper-Analyse 1* (1969), in contrast to Nitsch's use of actors, Brus himself is naked, trussed up and smeared with dirt, a rope around his neck, another tying his ankles, so that his legs are splayed exhibiting his scrotum. This submissive sexual position echoes Freud's insistence that there is always a feminine component in masochism. The work of Rudolf Schwarzkogler exhibits an even more extreme masochism. Gauze bandages often encase the body, sometimes including the head, which is exhibited in a state of utter abjection, suggestive of a horrific form of death. Images of scissors and razors abound. In *2.Aktion* (1965) a fish's head with a razor blade in its mouth is taped to the artist's genitals. Perhaps unsurprisingly, a rumour gained currency in the art world that Schwarzkogler had amputated his penis bit by bit (lent credence by the artist's early death), though this proved mercifully false.

In Gina Pane's work *Sentimental Action* (1973), performed in front of an all-female audience, she sliced her open palm with a razor-blade and punctured the skin of her left forearm with a row of rose thorns. Bunches of red roses, with their traditional romantic associations, provided a visual analogue to her blood, and bunches of white roses echoed the artist's white clothing. Photographs of the performance, taken by Françoise Masson, were later incorporated into 'constats' – art objects and images that relate to the action and constitute its documentation. The carefully arranged sequence of images makes explicit the erotic beauty of the masochistic act: Pane is depicted bending lovingly over the blade and thorns, while the positioning of bunches of roses held against her thigh suggests the work's inherent sexual metaphor. Working in France at the same time, Michel Journiac frequently enacted the

wounding of his own body as a means to express the suffering of the sexual and social body. In his words:

> The body is the place of all markings, of all wounds, of all traces. In the flesh are inscribed the tortures, the prohibitions of social classes, the acts of violence perpetrated by the powers-that be, scattered but never abolished.[13]

Rachel Rosenthal's *Performance and the Masochist Tradition* (1981), originally conceived as part of a panel discussion exploring *Taboo Subjects*, investigated Performance Art's frequent use of masochistic imagery. The piece was delivered as a performance lecture, in which Rosenthal assumed a masochistic persona. There are obvious reasons why physical pain or risk must be directed towards the artist rather than the audience, though Rosenthal's stated aim of eliciting an uncomfortable reaction in her audience as a way of matching the discomfort of her subject highlights the extent to which (psychological) pain is inflicted on the audience as well.[14] In her book *Contract with the Skin*, Kathy O'Dell analyses the work of such artists as Pane, Chris Burden, Vito Acconci and Marina Abramović in terms of the particular importance of a masochistic contractual bond 'sometimes between performers themselves [...] and always between the performer and audience members'.[15] It is her contention that 1970s Performance Art involving pain functioned as a critique of two fundamental and

21. Rachel Rosenthal, *Performance and the Masochist Tradition* (1981).

interconnected social institutions: the home, in which people are brought up; and the law, governing their adult lives. Both institutions are founded on the notion of contract, similar to that which is a typical feature of masochistic sex.

The notion of the contract is made literal in the 1870 novel *Venus in Furs* by Leopold von Sacher-Masoch, whose name was used to designate the perversion.[16] Gilles Deleuze, in a close commentary on Masoch's text entitled 'Coldness and Cruelty' (1969), both stresses the central importance of the contract for Masoch, and shows how in this and several other ways the sexuality which he expresses differs radically from that expressed by de Sade. While Deleuze is probably right to separate the sexual universes of the two writers, his attempt to cast doubt on the whole psychoanalytical conception of sadomasochism as a dialectical entity is less convincing. Nevertheless, the imagery of coldness in Masoch's writing on which Deleuze places special emphasis – behind the descriptions of cruelty he sees 'the more secret theme of the coldness of Nature, of the steppe, of the icy image of the mother'[17] – undoubtedly does represent a significant strand within masochism and to some extent justifies his approach. Closely related to the fascination with coldness is another typical feature of the masochist sensibility, the love of suspense:

> In Masoch's novels it is the moments of suspense that are the climactic moments [...] This is partly because the masochistic rites of torture and suffering imply actual physical suspension (the hero is hung up, crucified or suspended), but also because the woman torturer freezes into postures that identify her with a statue, a painting, or a photograph.[18]

This concept of suspended motion is beautifully brought out in Cleo Uebelmann's film *Mano Destra* (1985), in which the lesbian sadomasochistic relationship between its protagonists, a leather-clad dominatrix and her willing victim, bound with silk cords, is expressed not through activity, but through seemingly endless waiting, where extreme violence is an ever-present possibility but never actually takes place.

Morse Peckham, writing on the relationship between eroticism and politics, discusses the helplessness and powerlessness of the human infant – as, in a different way, did Lacan – developing from this notion the fact that the child is constantly attempting to achieve a form of control over an overwhelmingly powerful environment. Through life, says Peckham, there is the need to assert power over the natural environment. Sadism is thus interpreted as a literal albeit flawed attempt to do so with the aim of eliciting an acknowledgement of this power. Masochism can take two forms, either that of giving in to the pleasure of surrender, at least momentarily letting nature win (allied with being taken into the arms of the mother); or controlling one's own body as a way of mastering the objective world of which it is part.[19]

A key issue is the relationship between unwanted and uncontrollable pain, on the one hand, and pain deliberately invited, on the other. This is the central focus of Stephen Dwoskin's documentary-style film *Pain Is* (1997), in which explicitly sexual scenes include a woman in bondage and another telling the artist, who is off-screen, how much she is enjoying herself

as she brings a whip down on him. In contrast, another interview is with a sufferer from chronic pain and many scenes are in a hospital setting. Dwoskin, however, does not labour the contrast: his thought-provoking voice-over shows rather the extremely complex interconnections between different forms of pain. Taking little notice of previously accepted ideas, Dwoskin's approach is highly personal, informed both by his handicap resulting from polio when he was aged nine and by his frankly avowed sadomasochistic and voyeuristic sexual tastes.

The LA-based performance artist Bob Flanagan, a sufferer from cystic fibrosis, made a series of performance works with his long-term partner, the dominatrix Sheree Rose.[20] The posthumous film *Sick: the Life and Death of Bob Flanagan, Supermasochist* (Kirby Dick; 1997) would later chronicle his life and work. Many of Flanagan's performances explored the relationship between the pain of his illness and acts of controlled sadomasochism, as in the 'ascension' in which he was lifted from his rope-tied ankles from a hospital bed situated in the gallery space as part of his exhibition 'Visiting Hours'.[21] Many works centred on his penis, which he notoriously nailed to a plank of wood. He also pierced it with hypodermic needles, appropriating the paraphernalia of medical treatment and diverting it into the realm of sexual gratification. Flanagan's incantatory text 'Why:' breathlessly catalogues the multifarious factors which may have contributed to his unconventional practices. Among these, the innocuous and wholesome things of the everyday are invested with a highly perverse potential:

[...] because hardware stores give me hard-ons; because of hammers, nails, clothespins, wood, padlocks, pullies, eyebolts, thumbtacks, staple-guns, sewing needles, wooden spoons, fishing tackle, chains, metal rulers, rubber tubing, spatulas, rope, twine [...];[22]

Flanagan's vision of masochism brings out both its passivity and its inherent heroism:

[...] because surrender is sweet; because I'm addicted to it; because endorphins in the brain are like a natural kind of heroin; because I learned to take my medicine; because I was a big boy for taking it; because I can take it like a man; [...][23]

Ron Athey's performances also frequently contain a strong element of sadomasochistic ritual. In *Martyrs and Saints* (1991), the first part of his 'torture' trilogy, three drag-queen nurses, their lips sewn closed, lead three mummified bodies into an operating theatre, where they are subjected to enemas, speculum probes and genital piercing. In *Four Scenes in a Harsh Life* (1994), which Athey once described as the most sadistic piece that he ever made and formed the second part of his 'torture' trilogy, he cut the back of a fellow performer and dabbed the bleeding wounds with strips of paper towel which he then hung up on clothes lines. *The Judas Cradle* (2005), conceived and performed with the opera singer Juliana Snapper, is named after a torture device used by the Spanish Inquisition. This consisted of a pyramidical block which came up to a sharp point onto which the prisoner was lowered so that it entered his anus. Athey climbing onto a replica

of this device was, literally, the still point at the centre of this highly operatic, baroque and complex piece.

For psychoanalysis, sadomasochism is to be distinguished from fetishism, which Freud analysed as being the simultaneous denial and affirmation of a maternal penis. Nevertheless, both share the characteristic of converting a threatening and destructive situation into an occasion of pleasure. Indeed, it could be argued that male heterosexual masochism (and perhaps lesbian masochism) resembles fetishism especially closely in the sense of endowing the mother-figure with her missing phallus. In any event, socially speaking, there is such a degree of overlap between the s/m scene and the fetish scene that they are virtually indistinguishable; similarly, many of the artists who deal with one necessarily cross over into the other.

There is an especially large amount of sadomasochistic fetish imagery in the form of photography – much of which, as in the work of Grace Lau, starts out as documentation of the scene. Indeed so large is the amount of such work that it would be unhelpful to attempt a survey. One photographer in this area, however, whose work is particularly interesting from an art perspective is Gilles Berquet. A great admirer of Pierre Molinier, he creates images of startling strangeness and originality. Like many fetish photographers, he favours the use of black-and-white or monochrome but often colours the prints by hand, giving them the air of nostalgic erotica. The most frequent subject matter features women in bondage – all enthusiast friends of his – and women urinating in a variety of ways, including into a wine glass or a man's mouth. The images point to the paradox of finding liberation through restraint.

In Japan, bondage occupies a central place in the sexual imagination, in the form of *Kinbaku*. This involves tying a person up with thin rope, tightly constricting their body or suspending them, usually in highly assymetrical positions in order to increase the aesthetic impact. It has its origins in *Hojojutsu*, a military means of restraint and a form of martial art. In the eighteenth century, four kinds of torture were officially introduced for criminals and suspects, including constriction and hanging by rope. In the early twentieth century, it began to be sexualised. Nobuyoshi Araki has taken countless photographs of women, and less frequently men, bound and sometimes suspended in a vast array of poses; these are among his most controversial images. Bondage also plays a major role in the fetish photography of Masaaki Toyoura. Much of the effect of the images collected together in Toyoura's 1993 book *Elysion* depend on the use of black-and-white photography and derelict interior settings. Some of the female figures depicted are pregnant; some have their heads or whole bodies encased in rubber; some are bound with barbed wire. There is a palpable sense of death and decay, together with an almost religious sense of stillness and an eerie beauty.

Fascinated, like Araki, with the sexual energy of Tokyo but coming to it as an outsider, Romain Slocombe has made photographs of young Japanese women thoroughly bandaged, often with slings, plaster casts, eye patches or cervical collars. The girls appear to be the victims of serious accidents, revealing an obsession not so far removed from Ballard's *Crash*.

Many of these photographs were collected in the book *City of the Broken Dolls* (1997). More recently, Slocombe has turned his photographic attention to attractive young upper middle-class French women, again depicted as bandaged accident victims. Both groups of pictures were shown in his 2006 exhibition 'Medical Love'.

Franko B has also made considerable use of medical imagery in performances in which he allows blood to run from him, dripping down his arms and body. Here it is the artist himself who is the apparent victim; that it is his own blood that is spilled is crucial. Medical motifs range from assistants dressed as doctors in several performances to splints, bandages and the catheters in his arms to keep his veins open while he bleeds. In *Aktion 398* (1998), named as a homage to the Viennese Aktionists, audience members who entered a small space one at a time for a one-to-one encounter with the artist were invited to feel a large wound that had been cut in his side, its redness contrasting with his white body make-up. His comment that 'everyone is bleeding inside' suggests an especially poignant sensibility, as well as a desire to reach out to touch others, in his form of masochistic imagery.[24]

Of all forms of sadomasochistic and fetish imagery, it is perhaps the medical which makes most explicit the connection between erotic pleasure and real physical and psychological pain. It was Jean-Martin Charcot's work on traumatic hysteria at the Salpêtrière in Paris that so impressed the young Freud and led to his work on hysteria with Josef Breuer. If the traumatic events which, in developing the full-blown theory of psychoanalysis, Freud believed to lie at the root of his early patients' neuroses, were largely in their own minds, the origins of the traumata suffered by combatants in the First World War, which led to his postulation of the death wish, were overt and plain to see. One of his most important observations was that the fact that an experience was unpleasurable did not necessarily render it unsuitable for play but, on the contrary, could make it the basis of a compulsion to repeat the experience over and over again.

The dismemberment that recurs in the work of Louise Bourgeois is overtly sadistic, enacted against the parents, though it is, according to Bourgeois, universal: 'well, the body is always dismembered, of course, what a child does to a toy'.[25] On the few occasions that whole bodies, as opposed to body parts, feature in her later work, it is more often than not in relation to both suffering and sexuality, as in the drawings of 'Sainte Sebastienne'[26] and the sculptural 'arch of hysteria', which first appeared in a small female version in *Cell III* (1991) but had become male in *Cell (Arch of Hysteria)* (1992).[27] The reversal of gender roles is noteworthy, as Bourgeois has indicated:

> It is a remark about the hysterical, and in the time of Jean-Martin Charcot, any ill, any disease, was attributed to hysteria, to be precise, and hysteria was attributed to women, which was absurd. This is all it means.[28]

Asked about cutting up the male body in *Arch of Hysteria*, Bourgeois famously replied 'Don't you cut your lunch up when you're ready to eat it?'[29] Another confirmation of the cannibalistic

and thoroughly Kleinian oral sadism that pervades Bourgeois' work is the fact that an alternative title for *Destruction of the Father* had been *The Evening Meal*. As always, however, the meaning is thoroughly ambiguous. If the connection between food and sex is closer for women than it is for men, in the sense that both involve ingestion, it is clear that while desiring to eat the father is undoubtedly murderous, it is also symbolically incestuous.

Much of the work of Rebecca Horn is pervaded by a sense both of eroticism and of the threat of potential violence. An element of spikiness is evident in much of her imagery, as in the ubiquitous sharp-pointed metal rods. In *High Moon* (1991) two rifles are suspended on the end of rods; above them are two glass funnels filled with red liquid and beneath them a trough, also filled with red liquid, some of which has spilled out onto the floor, reminiscent of an abattoir. *The Seventy-Seven Branches of Destiny* (1993) consists of seven kitchen knives, again on the end of motorised metal rods, that rhythmically thrust up into the soft bristles of seven paint-brushes suspended above them. A knife on the end of a rod also features in her installation *Broken Landscape* (1997), which she developed in a performance piece entitled *Dialogue of Injury between Knife and Feather*. Many of her drawings are similar stylistically to those of Artaud, to whom explicit homage is paid in *Artauds Traum* (*Artaud's Dream*, 1990).

Horn's *Les Délices des Evêques* (1997)[30] was installed opposite the cathedral in Münster, the town in which she had ten years previously converted a tower used by the Nazis as a place of torture and execution.[31] The new work drew a comparison between the Nazis and the Holy Inquisition, pointing to the persistence of human cruelty down the ages. It contained two chairs identified as prayer stools, one fixed to the wall and the other swinging from the ceiling. From the former 'passive' chair extended two motorised metal rods, which Horn called 'fear tentacles'. As these opened out, the 'active' chair swung viciously towards it, then gradually lost momentum, before swinging again in an endlessly repeated cycle. Also motorised was a rope which cracked like a whip; blood was spattered on the floor and walls. The space was pervaded with the strong sense of a murderous crime being committed, with judicial sanction; while criminal and judge, aggressor and victim, partially merged and exchanged roles. Horn's own accompanying text to this piece is decidely sexual in tone:

> The victim is ready to receive its aggressor. In waiting expectation it submits to the lethal penetration. By acquiescently spreading open the aura of its inner circle the victim weakens its adversary so much that the swinging action thereafter becomes a farce. The whipping snake rope disrupts the rhythm of the act.[32]

The relationship between sadism, pathology and crime was also explored by Roberta Graham in her performance *Campo Santo* (1982). Rather than institutionally sanctioned violence, it focused on the case of Peter Sutcliffe, the 'Yorkshire Ripper' responsible for murdering a number of women, several of them prostitutes, by methods involving slashing and cutting.[33] A Catholic, Sutcliffe claimed to have been instructed to kill his victims by the

voice of God. In *Campo Santo*, photographs of the murder sites were mounted on tombstones, around which were piles of urban detritus, including old newspapers, one bearing the headline THE MAKING OF A MONSTER. Part of Graham's message was the all-too-usual wrongheadedness of this reaction to the case, projecting all the evil outwards onto one individual, rather than using the particularly dramatic circumstances of the case in order to help us recognise within all of us the psychology of both the perpetrator and the victim.

However, *Campo Santo* gained added resonance from the way in which it drew attention to the industrial setting as a backdrop for psychopathic crime. 'Camposanto' is the Italian for 'cemetery'; but written as two words it translates as 'sacred field', which referred to a geographical triangle delineating Sutcliffe's area of operation. Covering West Yorkshire and Greater Manchester, it is an area marked by the contrast of bleak upland moors and densely populated towns whose growth was the direct product of the Industrial Revolution. Graham had long been fascinated by Emily Brontë's *Wuthering Heights* in which the harsh landscape of the West Yorkshire moors parallels the violent emotions of the protagonists; similarly, in her lightbox piece *Whether the Storm?* (1982) forked lightning echoes the veins and arteries within her own body.

That there is something sinister about the landscapes of the Industrial Revolution is something felt by many, but it may go deeper than that. William Blake was doing more than using a picturesque turn of phrase when he spoke of 'those dark, Satanic mills'. According

22. Roberta Graham, *Whether the Storm?* (1982).

to the psychoanalyst Donald Meltzer, a follower of Melanie Klein, a motivating force at the core of capitalism is a desire for revenge against the Mother.[34] If the idea of tearing into Mother Earth seems far-fetched in relation to capitalist activity as a whole, it is perhaps easier to accept in relation to an activity that was crucial to the development of the Industrial Revolution: mining, in which the body of Mother Earth is cut and torn into. Indeed, one speaks of landscapes which have been heavily mined as being 'scarred'. Sutcliffe's crimes may have been a terrible literalisation not only of the universal perpetrator–victim duality but also of a deeply unconscious psychosexual motivation behind major economic processes. A related line of thought, focusing on a later stage in the development of capitalism, is pursued in Bret Easton Ellis' novel *American Psycho* (1991).

Psychosexual motivation may also play a much larger part than is generally understood in political processes. According to Norman O. Brown: 'Without an understanding of the seamy side of sexuality there is no understanding of politics.'[35] In *Love's Body*, he stresses the masculine nature of almost all politics to date, but points out that the expression 'patriarchy' obscures the importance of the part played by inter-generational struggle, the sons revolting against the father. A crucial key is provided by Freud's myth of the tyrannical father of the 'primal horde' being murdered and eaten by his sons.[36] Patriarchy in its pure sense is embodied in the notion of the king as father of the nation and in orderly dynastic succession. However, most progressive forms of politics are based much more on the fraternal model: the 'band of brothers', the 'liberté, egalité, fraternité' of the French Revolution, the frequently evoked fraternity between Socialist and Communist parties. Though it may be true that this fraternal politics merely creates a new father figure – Robespierre, Napoleon, Lenin, Mao – their revolutionary, anti-patriarchal beginnings remain crucial to an understanding of the historical dynamic.

Brown applauds Ortega y Gasset's statement that 'it was not the worker, the intellectual, the priest [...] or the businessman who started the great political process, but youth, preoccupied with women and resolved to fight', and comments:

> [...] politics as juvenile delinquency [...] The band of brothers feel the incest taboo and the lure of strange women; and adopt military organization (gang organization) for purposes of rape. Politics as gang bang.[37]

Gilbert and George's photographic series *The Dirty Words* (1977) takes as its common component the inclusion of images of found graffiti from walls around the city. As well as directly sexual messages, one of the most frequent uses of graffiti is as a territorial marker, embodied most famously in the message that a given person, group, club or gang 'rules', somewhat similar to a male animal's act of marking out territory through scent. Indeed, the pair once remarked that the only really interesting drawings today are to be found on lavatory walls, since they are expressions of real desire.[38] Permeating the works is the sense of the aggression of the rough world of London's East End, embodied in images of broken windows and grimy bricks.

One work from the series, *Prick Ass*, has as
its central section the image of a battleship. One
is tempted to read in it the unconscious mood
of Britain several years before the Falklands War,
and is reminded also of the remark famously
attributed to Churchill that the three traditions
of the British Navy were 'rum, sodomy and the
lash'. At least the second of these is hinted at by
the picture's verbal component. Another of the
series, *Cunt*, includes photographs of the Houses
of Parliament and of toy soldiers, perhaps inviting
the interpretation that adult political leaders
could be seen as still psychologically playing
with 'boys' toys'. The word of the title, whose
connotations are simultaneously sexual and
aggressive, is placed across the top of the picture;

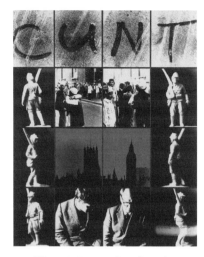

23. Gilbert & George, *Cunt* (1977).

the elevated position of this obscene form of the feminine can be compared with that of
the 'cinematic blossoming' at the top of Duchamp's *Large Glass*.

Possibly the most archetypally masculine expression of political power is to be found in
Fascism, typically headed by a clear and charismatic leader supported by gangs or squads of
violent followers. Wilhelm Reich's 1933 account of the mass psychology of Fascism links it
explicitly to sadomasochism and the repression of free sexual expression: 'sadism...is the
offspring of suppressed nature and is the only important trait differentiating man's structure
from that of the animal'.[39] While the standard left–right political spectrum was based on the
dialectic of economic ownership, a perhaps more crucial axis is that based on power, with
authoritarianism and anarchism at its extremes. Naive and self-contradictory as the tendency
of the Punk movement to combine the anarchist 'A' with the Nazi swastika may have been, it
may also have shown an intuitive understanding of the importance of this axis based around
the concentration or diffusion of power as such. Kenneth Anger's *Scorpio Rising* (1963)
intercuts its primary biker narrative with shots of Hitler and helmeted Nazi parade troops, as
well as the figure of a youthful Puck cheering on the racing bikers. The lyrics of the sweetly
sung pop song *I Will Follow Him* that accompanies part of this penultimate section of the film,
take on a more sinister meaning in this context, making explicit the link between the political
and erotic objects of desire.

Pier Paolo Pasolini's film *Salò, or the 120 Days of Sodom* (1975) is based on de Sade's novel
but it also incorporates elements from Dante's *Inferno* and is set in the tiny Fascist republic of
Salò which existed briefly at the close of the Second World War when the rest of Italy had been
taken by the Allies. As in de Sade, a succession of fantasies, recounted and enacted, lead from
the titillating to the ever more horrific and brutal. In contrast to the hypocritical and

irresponsible depictions of violence typical of commercial cinema, Pasolini both honestly acknowledges his own implication in sadistic sexual desire and, as a deeply moral person, is horrified at the suffering to which, in non-consensual situations, such desire can lead. The almost unbearable tension between these positions helps make the film one of the most profound explorations of the relationship between sexuality and political power ever made.

The final, most extreme cruelties in *Salò* are enacted in a courtyard, while the libertine anti-heroes take turns to watch through binoculars from an upstairs window. Some of the footage is shot as though we too are watching through the same device; at one point the binoculars are turned around. Similarly, in Horn's *Les Délices des Evêques*, a pair of binoculars trained on the cathedral periodically swivels so that the viewer becomes the one implicitly observed. Both works strongly suggest that if we are to solve the enigma of human cruelty we cannot just project it onto others but must acknowledge its place in our own libidinal make-up as well as understanding the sadomasochistic bonds on which society is based. Both works, too, make clear the intimate link between sadomasochism and voyeurism.

Chapter 9

Stories of
the Eye

Marcel Duchamp's last major work, *Etant Donnés* (1946–66), confronts its viewer with a battered wooden door into which are set two small peepholes. The view through them is directed at the crutch of an open-legged naked female mannequin, playing out a shocking voyeurism that had been suggested by the Oculist Witnesses in the lower (male) sector of Duchamp's *Large Glass*. The setting is an ambiguous one, suggesting both an enchanted secret garden and a crime scene. The act of peering through the peepholes suggests an analogous relationship with the desire to access the unknown interior of the female body. However, the entire scenario frustrates the act of looking: the viewer moves their head from side to side in an attempt to peer into the corners of the kitsch landscape, in order to fully comprehend it, only to be barred by the heavy wooden door that blocks vision. Simultaneously, the work creates a sense of physical unease in its viewer, who is cast into the role of unwitting voyeur: there is the very real possibility that this act of peering is being observed from the rear of the darkened room by other gallery visitors.

Hannah Wilke's *I Object* (1977–78) offers a direct retort to *Etant Donnés*. A false book cover, it depicts Wilke naked on the rocks at Cadaquez, her legs splayed in a pose that clearly evokes Duchamp's mannequin. The 'object' in the work's title functions both as a noun that highlights the objectifying nature of the voyeuristic gaze, and also as a verb that seemingly rails against it, yet is more subtly ambiguous. 'Why *not*,' Wilke asked, 'be an object?'[1] The work's subtitle, *Memoirs of a Sugargiver*, is a direct response to Duchamp's anagrammatic 'marchand du sel', a gesture of generosity that sweetens his salt seller with its feminine polarity. Wilke offers images of her body, freely available without the barrier of Duchamp's wooden door, in a manner that allows the viewer's gaze to roam over it uncontrolled and unfettered, a gesture of sharing that is echoed in the proffering of 'memoirs'. By presenting her body on the cover of a book, Wilke sets up an oscillation between the verbal (that which

is read) and the visual (that which is watched), a play between word and image that is enacted firmly in the realm of voyeurism and exhibitionism.

In 'The Sexual Aberrations', the first of his *Three Essays on Sexuality* (1905), Freud discusses the part played by seeing in libidinal arousal.

> The progressive concealment of the body which goes along with civilisation keeps sexual curiosity awake. This curiosity seeks to complete the sexual object by revealing its hidden parts. It can, however, be diverted ('sublimated') in the direction of art.[2]

Freud does not develop the point in relation to art. Rather, having set out the conditions under which the pleasure in looking can be classed as a perversion, he lays considerable emphasis on the fact that, as with sadism and masochism, voyeurism and exhibitionism exist as a pair. 'Every active perversion is [...] accompanied by its passive counterpart: anyone who is an exhibitionist in his unconscious is at the same time a voyeur [...] and vice versa.'[3]

Nevertheless, neither in this nor in his subsequent writings does he devote anywhere near as much space to this pair of visual perversions as he does to that concerned with cruelty. Much later, in *Civilization and Its Discontents* (1930), Freud speculated that a crucial factor in human development, associated with our adoption of an upright posture, was the replacement of smell by sight as the dominant sense.[4] The intimate link between voyeurism and exhibitionism noted by Freud has not been as widely accepted as that between sadism and masochism. There is no single word, equivalent to sadomasochism, which unites them. Nevertheless, there is evidence of a popular understanding of the two-way function of the eye in describing it both as a 'window on the world' and also as a 'mirror of the soul'.[5]

One of the most remarkable pieces of writing to take the eye as its central motif is Bataille's novella *Story of the Eye*.[6] Its title is precise: it is not the story of its human characters, even the first-person narrator, so much as of the eye as an object of their sexual obsession, and of the transformations in their sexual imagination between it and other objects of similar shape but wholly different function: the egg, the sun, a bull's testicle. Bataille's is a shockingly physical consideration of the eye, in which divorcing it from its function of seeing is connected with the recurrent theme of enucleation, as the innocent erotic game of cracking eggs develops into the gouging of eyes. It is a characteristically violent vision, playing on the dialectic between sight and blindness: it is significant in this respect that the sun, the giver of light, is also an agent of blinding. The book was a key text for that dissident stream of Surrealism which was to prove so influential for later artists; both André Masson and Hans Bellmer made remarkable illustrations for the first two editions.

Story of the Eye was a direct inspiration for Jo-Ann Kaplan's 1997 film *Story of I*, which shows a woman lying in the bath reading Bataille's tale. The film contains a number of direct textual quotations – one of these, 'l'œil de chat' ('the eye of the cat'), the title of Bataille's first chapter, making an interesting parallel, in the context of voyeurism, with Schneemann's

Fuses. Kaplan's work also uses the cinematic devices of montage and superimposition to explore the analogies so crucial in the original, between the eye and other similarly shaped objects. Kaplan brings too, however, a more self-reflective and female perspective to the story: not only does she become the voyeur of her own body, but beautifully effected visual transformations link the eye with the rose and with the vulva. One of the sensations aroused by the film, as raw eggs are sucked down the plug hole, is of inside and outside flipping into each other, an impression reinforced by the interspersed image of the inner anatomy beneath the skin. One of the most powerful images in Bataille's text is of the eye gazing out from inside the vagina; in Kaplan's film, it is as if the vagina is looking at itself in a mirror.

Despite Bataille's evident fascination with the eye, the debasement to which he subjects it plays an important role, according to Martin Jay, in advancing the tradition in French thinking of hostility to 'ocularcentrism', which Jay charts in his book *Downcast Eyes*. That tradition is marked by an extreme suspicion of the visual, even if this suspicion has taken a variety of forms. One of the key concepts to emerge from it is that of the 'gaze', which derives from Jean-Paul Sartre: Sartre used the same term in French, *le regard*, as was later to be used by Lacan and others, a fact that has been somewhat obscured for English readers since, in Sartre's case, it has often been translated as 'look', whereas in that of Jacques Lacan and those subsequent writers who have invoked him, it appears as 'gaze'. In *Being and Nothingness*, Sartre tells the story of walking into a park and being the master of all he surveys; but then another person enters the park and he realises that he has become the object of this intruder's gaze, a realisation which he experiences as a radical disempowerment, a robbing of his own subjectivity, and a source of shame.

Lacan's attitude towards the visual is, if anything, even more negative than Sartre's. His distrust of it is already evident in his first major contribution to psychoanalytical theory, the theory of the 'mirror stage'. According to this, the ego is constituted through a *méconnaisance*, a false identification with the whole and coherent 'other' seen in the mirror, as a compensation for the child's experience of its own body as fragmented and incoherent. Lacan's adoption of Sartre's notion of the gaze dates from the 1950s but in 1964 he radically reworked it. Since seeing can never be unmediated but is always, like language, socially constructed, the subject is caught up in a network of significations over which he has no control and which will survive him, thus implicitly reminding him of his own death. For Lacan, the gaze is no longer personified, as it had been for Sartre, and he explicitly separates the gaze from the eye, identifying it instead with the *objet petit a*. Here is not the place to attempt a summary of Lacan's infinitely complex reformulation of the gaze, dependent as it is on an understanding of his thinking on a wide range of issues, most particularly his theorising of the 'other'. Suffice it to say that, pessimistic as his account of vision's entrapment in the socially constituted symbolic order may be, his fear of collapsing back into the pre-social imaginary order, the realm of intuition, is far greater.[7] More generally, the extent of Lacan's anti-visual bias is evident in his statement in *The Four Fundamental Concepts of Psychoanalysis* that:

The eye may be prophylactic, but it cannot be beneficent – it is maleficent. In the Bible and even in the New Testament, there is no good eye, but there are evil eyes all over the place.[8]

A perhaps significant biographical detail is that Lacan personally owned one of the most famously voyeuristic paintings in the history of Western art, Courbet's *L'origine du monde* ('*The Origin of the World*', 1866). According to Rainer Mack, 'Lacan had put a sliding wooden panel with a hidden trigger over the painting, thus enabling him to control the gaze directed at the woman's sex.'[9]

The 'anti-ocularcentric' rhetoric of the French writers analysed by Jay is directed in the first instance against what he identifies as the 'dominant scopic regime' in Europe since the Renaissance, characterised by linear one-point perspective. (In so far as this way of seeing implies a fundamental split between the viewing subject and the perceived objective world, it can be seen as consonant with the philosophy of Descartes, so that one is justified in calling this scopic regime 'Cartesian perspectivalism'.) However, their attack does not stop there; rather, Jay convincingly shows, writers such as Foucault, Debord, Derrida and Irigaray as well as Sartre and Lacan, mount a series of assaults on the visual *per se*. There is more than a little irony in the fact that precisely these writers are among those most frequently cited and drawn on for intellectual authority by contemporary visual artists and art historians.

One of the principal metaphors through which Alberti propounded the method of one-point perspective in painting was that of the window, the canvas of the picture functioning as a window onto the scene being depicted. This monocular vision – embodied by the window (or indeed the single peephole), but removed from the binocular construction of actual sight (as reinstated by Duchamp's double peephole) – carries clear implications of voyeurism. The potential for gendering the subject–object separation was brought out in the famous Dürer woodcut of a male artist looking through a peephole in a perspective device at a naked female model, from his *Treatise on Measurement* (1525). Susan Felleman has written of this work that it 'might be titled "where objectivity meets objectification", so clearly does it explicate the sexualized dynamics of the perspectival gaze'.[10]

In the twentieth century, the window remained a significant motif, not least for the Surrealists. Despite the Cubist destruction of one-point perspectival space, André Breton continued to view paintings as essentially windows, but he also sensed something uncanny in the window motif. Indeed, his championing of automatic writing as a means of liberating the unconscious in the first *Manifesto of Surrealism* was prompted by a daydream in which a phrase was, as he put it, *'knocking at the window'* (his italics) and this phrase 'was something like: "There is a man cut in two by the window"'.[11] Magritte in particular played with the analogy between painting and the window in such works as *La condition humaine* ('*The Human Condition*', 1933) and, more sinisterly, *La clef des champs* ('*The Key to the Fields*', 1935), where the glass of the window is smashed.

The subject of voyeurism in contemporary art, then, has grown out of a vast historical discourse that surrounds the notion of sight, of objectification and the function of the window as a visual device. Merry Alpern's series *Dirty Windows* (1994) draws on this tradition but utilises the function of the window as something to peer into, as well as a means by which to look out onto the world; as such, it could be said to combine the paradigms of both the window and the peephole. Alpern's series comprises photographs taken from one window giving onto an air shaft through another window, of the bathroom of an illegal sex club in New York's financial district. The grainy aesthetic of the black-and-white photographs, combined with the dirtiness of the windows, serves both to render the subjects anonymous and to produce the effect of illicit capturing. The bodies of Alpern's scantily dressed subjects are truncated by the window frame, through which we glimpse their actions: undressing, having sex, fixing up, and exchanging money. The arduous nature of Alpern's nightly vigil over the cold winter of 1993–94 reveals the mundane frustration of this kind of voyeurism, and the lack of control that she had over the appearance and actions of those she had set out to watch. Also key is the possibility of being discovered – Alpern has spoken of her anxiety of being caught – with the result that these images tread the boundary between the caution of the hidden and the eroticism of the lustful or at any rate inquisitive gaze.

In contrast to Alpern's adoption of the role of covert voyeur, Noritoshi Hirakawa's photographic practice includes an element of complicity that confuses and challenges conventional perceptions of the male voyeur and his female victim. The series *Dreams of Tokyo* (1991) depicts women crouching, their skirts raised to reveal their lack of underwear. Their direct yet inscrutable gaze and obvious posing in the streets of Tokyo raises questions as to the motivation of both parties. The photographs from *A Flower and the Root* (1993) harness dramatic cropping to produce narrow vertical images that suggest a door left slightly ajar to reveal a naked and reclining woman in extreme contraposto, her buttocks and anus displayed alongside her startlingly direct stare. As voyeuristic images, these incorporate an element of surprise, both in their frustration of the expected sight of her sex, and in the confrontational nature of her returned gaze. *The Reason of Life* series (1998) similarly investigates the complex relationship of desire between the male voyeur and his female subject. Hirakawa states:

This is the view of what men dream of but can never be at the point to see. Many men have

24. Merry Alpern, *Untitled #2*, from *Dirty Windows Series* (1994).

a lot of desire to see the underwear beneath a woman's skirt. At the same time, many women think about having their underwear looked at by men. This desire is never spoken of in public. The woman is photographed by the artist at the same moment as the woman photographs herself. The camera can be a very good excuse to connect men's and women's desires.[12]

In *The Pandora that is Pandora's Box* (1993), Hirakawa forces the spectator to take positive action to fulfil his (or it could be her) voyeuristic desire. A projector projects onto a screen a photographic slide of a naked girl, her back propped up against a tree and her legs open in a manner deliberately reminiscent of Duchamp's *Etant Donnés*, but with the significant difference that not only is the girl's face fully visible but she is looking directly at the viewer. The lighting within the image gives the impression that the camera (or the projector) is illuminating the figure within an otherwise dark, nocturnal scene. Teasingly, however, a second projector projects a small circle of pure white light directly onto the girl's genital zone, thereby rendering it invisible in a way which recalls the censoring of images in newspapers and magazines. The only way for the spectator to overcome this frustration is to block the beam of the second projector; when that is done, the girl's genitals are revealed.

No doubt highly influential on this generation of contemporary artists' investigation of the dynamics of voyeurism is the work of Cindy Sherman, for whom notions of looking and being looked at are crucial. Adopting the role of the voyeur's subject, Sherman has constructed images in which there is often a strong feeling of intrusion on private reverie. The grainy black-and-white *Untitled Film Still #39* (1979), in which she stands in the bathroom in her underwear gazing down at her own body (so that we look at her looking at herself), is one of the most explicitly voyeuristic, finding clear visual echoes in both Alpern and Hirakawa. That these scenarios are deliberately constructed by Sherman herself gives a different twist to the traditional notion of voyeurism as an illicit act.

Sherman's work makes specific reference to the representational conventions of film, often drawing on the visual vocabulary of the B-movie genre. Laura Mulvey's pioneering and much-quoted essay 'Visual Pleasure and Narrative Cinema' analyses the structures of the pleasure of cinematic looking within the framework of the male symbolic order of desire.[13] Mulvey identifies two types of pleasurable gaze for the (male) viewer: the first is scopophilic, the erotic pleasure that is derived from looking at another; the second type is developed through narcissism and the constitution of the ego, and springs from identification with the hero. The former implies a separation from the image on screen, articulated in the iconic female close-up; the latter an identification that is set in the recessional space of filmic (male) action. Mulvey frames this dynamic in psychoanalytic terms, identifying the female icon with the threat of castration and characterising the cinematic look as the means by which the male unconscious seeks to escape this castration anxiety. This may be achieved through the demystification and devaluation of woman or, alternatively, through the 'complete disavowal

of castration' by means of the fetish.[14] This 'fetishistic scopophilia' is enacted either in the form of a substituted object or by means of turning the represented figure itself into a fetish in order to render it reassuring rather than dangerous.

The figure of the stripper occupies a position that contains elements of both fetishisation and demystification. Striptease's sexual implications are more overt than in the films that Mulvey considers, relying on the agreed interchange between a voyeuristic audience and an exhibitionist performer. It constitutes, in the analysis of Linda Williams, 'a continued oscillation between exposure and concealment – the satisfaction of seeing all and the frustration of having that sight cut off in a "premature climax"'.[15] For Camille Paglia it is the possibility for women to retain the final mystery, even when naked, that accounts for the effectiveness of striptease. It has provided fertile ground for artists as a means of exploring the nature of this arrangement and the implications for looking that it carries.

Hannah Wilke's performance and photographic work makes frequent reference to the striptease, most famously perhaps in her 1976 performance of a stylised strip behind Duchamp's *Large Glass* at the Philadelphia Museum of Art, another overtly erotic riposte to the gendered, yet cooly ironic eroticism of Duchamp. Wilke incorporated the striptease into several other works, including *Super-T-Art* (1974), *Intercourse With...*(1977), and a number of performances arising out of the photographic series *So Help Me Hannah* (1979;1982;1985). Accused of excessive exhibitionism, she defended her use of her own (extremely attractive) body: 'exhibiting oneself is difficult for other people who don't feel good about their bodies. I could have been more humble – but if I'd been more humble I wouldn't have been an artist.'[16] Wilke's striptease is highly stylised, performed slowly and deliberately; she adopts static poses that heighten the erotic tension, exaggerating the frustrated climax that Williams identifies, and recalling Mulvey's frozen screen icon. Wilke's strip reveals not only herself, through her own naked body, but also her viewer's libidinal investment, refusing the detachment of more conceptual Duchampian contemporaries. For Joanna Frueh, Wilke

[...] is her own voyeur, her own seer, who comes to realise that to seduce is to lead astray, to lure herself and others away from the habitual negations of the erotic. Wilke calls the gaze 'a sparkle'. The gaze is sparkling eyes, the spark of desire, an 'assertion of life'.[17]

Sophie Calle's *Autobiographie – Le strip-tease* (1989) is presented in the context of personal biography. It comprises a photograph of a bespectacled man looking up – in awe, admiration? – at the half-naked Calle who poses stiffly in front of a make-shift curtain. The image is displayed alongside a text that describes her childhood routine of undressing in the elevator of an apartment building and the echo of her disrobing twenty years later. The analogous relationship that Calle sets up between her aloof adult self and her mischievous six-year-old self – and whether the work implies a childlike enjoyment in stripping or a more cynical view of the objectification of women – remains deliberately ambiguous.

Marlene Dumas' *Strippinggirls* series of paintings (2000), based on Polaroid photographs of strippers and erotic dancers, presents her subjects in a variety of poses. Titles such as *Caressing the Pole* and *Cracking the Whip* illustrate the range of speciality moves, while *Leather Boots, Satin Gloves* and *Glitter Bra* suggest an arbitrary method to easily identify unknown dancers, whose faces are often obscured by Dumas' expressive use of light and shadow. This, combined with the frequently low viewpoint of the near life-sized images, places the viewer in the position of a strip-club spectator, though Dumas' typically muted palette frustrates the erotic element of the encounter.

The notion of the model carries multiple connotations (artist's model, fashion model, as well as prostitute or porn star). Just as in Wilke's work, the strip becomes a metaphor for the role of the artist, for whom personal psychical exposure is analogous to physical revelation, so art has been compared to prostitution, demanding the exposure of the self by a marginal figure in society for the benefit of the whims of clients. In Jemima Stehli's 1991 *Strip* series, the artist stripped in front of curators, critics and art dealers, in a gesture towards the artworld that is reminiscent of Carolee Schneemann's *Naked Action Lecture*. Stehli's series of

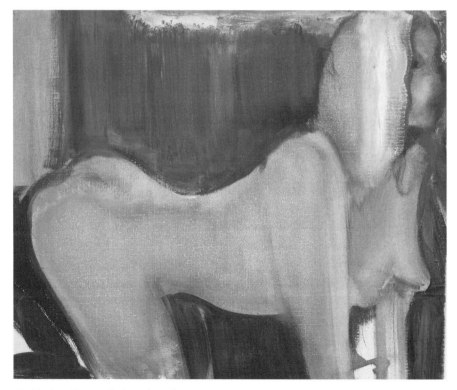

25. Marlene Dumas, *Stripper* (1999).

26. Jemima Stehli, *Flirt* (1999).

Polaroid photographs *Flirt* (1999) repeatedly depict her bare legs and short skirt. In a parody of the kind of imagery frequently found in advertising, Stehli placed the images in a grid pattern on the reverse of the flip-up seats in London taxis, though the work was censored by the Cab Advertising Committee at The Public Carriage Office. The work highlights the abundance of voyeuristic imagery in the public domain; while the title, together with the open-legged pose of many of the images, also introduces issues of complicity.

Skip Arnold has used the display of his own body to question the gendered bias of the striptease, and by extension the representation of the naked body. In the performance *On Display* (1993), he sat hunched naked in a Perspex vitrine for several hours a day in an Austrian gallery space. His declamation refuses the label of exhibitionist:

> It's okay for gays, lesbians and women to display their bodies but not straight men. Straight men are accused of egocentrism, exhibitionism and exploitation. What I am doing is not exposure. I am not showing a spectacle but a body as material.[18]

Atta Kim's *Museum Series* (1994 onwards) similarly presented nude figures in museum vitrines, including a naked couple embracing on a bed of red velvet in a large Perspex box.

To some extent, all artists who choose to use their own body in their artwork could be considered in terms of exhibitionism, particularly when their work is especially biographical, as in the case of Natacha Merritt. The structure of the website upon which Merritt displays her revealing visual diary makes clear the focus of her work on the act of exhibitionism, and its attendant invitation to become a voyeur; thus one navigation category invites the visitor to 'Take a Peek', while in her 'Manifesto' she writes, 'welcome, voyeurs, to the very private sexual journey of a 21st-century girl'.[19]

Annie Sprinkle's *Public Cervix Announcement* used exhibitionism in a lighthearted response to attitudes to the female body.[20] She sat on stage with her legs apart and invited members of the audience to examine her cervix with the aid of a speculum, flashlight and reproductive charts, in an act of demystification that she has explained thus:

> Exposing one's body in public is something I highly recommend...I've been accused of 'relentlessly exposing myself', and I like that sentiment. It is liberating, and it can also be defensive, aggressive, loving, entertaining, plus it can also be about breaking silly taboos. It can create energy, and it can also be a turn-on. It leaves no secrets.[21]

To a certain extent, Sprinkle's invitation to inspect, functions to counter the illicit looking of the would-be voyeur by resituating it in the public arena: 'It's a way of saying to some

men, "You guys want to see pussy? Fuck you, I'll show you more pussy that you ever wanted to see."[22]

James Hillman has drawn an explicit link between exhibitionism and power, interpreting the act of social exhibitionism, that is an exaggerated drawing of attention to oneself, in terms of the genitalised behaviour implied by a more literal interpretation of exhibitionism. He extrapolates the realm of sexual exhibitionism to consider the broader dynamics of social display as an expression of power, 'the blatant generous showmanship of codpiece and cleavage and bustle that plumps the behind'.[23] Though based on the structures of exhibitionism, Hillman's analysis stresses the ability of power to be hidden as well as ostentatious: 'we have to distinguish between the exhibition of power on the one hand and covert operation of power on the other'.[24]

Vito Acconci's concern with the dynamics of power relationships has frequently been situated in the realm of exhibitionism and voyeurism, especially intriguingly in his January 1972 performance *Seed Bed*, at the Sonnabend Gallery in New York. Hidden from view beneath a ramp in the gallery space, Acconci responded to the movement of visitors above him by masturbating, his moans and sexual fantasies relayed to them via a sound projection system. Playing with vision and its absence, Acconci substituted his voice for the controlling gaze. Though invisible, he acted out a paradoxical form of exhibitionism in his aggressively sexual invasion of the psychological space of the gallery visitor, who became a forced participant in the encounter, a blind voyeur of the unseen exhibitionist. The work has been seen to parody the structures of the art world, where the creative act and the sexual one are closely allied and art may be considered a form of exhibitionism aimed at seducing, and thus exerting power over, its public.

Sanja Iveković's performance *Triangle* (1979) – enacted on the occasion of the visit of President Tito to Zagreb in what was then Yugoslavia – explored the implications of exhibitionism on power and its subversion in a more directly political situation. From the private balcony of her apartment, Iveković had noticed a security officer with a walkie-talkie stationed on the roof of an adjacent building overlooking the presidential route, and a policeman on the street below her, also with a radio. Aware that she herself would be visible only through the binoculars of the former, she positioned herself on the balcony and simulated masturbation, until the policeman rang her doorbell and ordered that 'persons and objects should be removed from the balcony'.[25] The triangular scenario upon which the work depends plays on both vision and its absence, sight relayed through radio, an action forbidden by one who has not seen it. Bojana Pejić's analysis of the work in terms of 'the *liaison dangereuse* between sight and power, between *voir* and *pouvoir*', makes explicit not only this link but also the one between both of these and sex as a playful way to subvert power.[26] The framing of the balcony points to notions of private and public. Pejić considers these realms in specifically gendered terms, drawing on the trope of the woman on the balcony as a part of the *mise-en-scène* experienced by the male *flâneur*, a figure that is situated on the boundary

between privacy and display. Thus the police officers are figured as male 'organs of order' who control the public realm of ordered vision and respond to what they deem its disruption.

Elke Krystufek's performance work *Satisfaction* (1996) resituated the very private space of the domestic bathroom in the public arena of the Kunsthalle, Vienna. In front of an audience that watched through a viewing window, she bathed, then lay on the floor and masturbated with a vibrator. The spectacle that she presented offered a confrontational modern take on traditional representations of 'la baigneuse', in which she is recast in the role of active agent of pleasure. The work plays on the implicit sexuality of historical depictions, creating a scenario in which the coy modesty of the bathing girl is refigured as a woman who exerts control over her own sexual experience.

Stephen Dwoskin's twelve-and-a-half minute film *Moment* (1970) comprises a single shot of a girl's face while she is masturbating. Dwoskin has consistently explored voyeurism and exhibitionism, including their relationship with sadomasochism. He has drawn attention to the passive voyeurism of the audience that dominates mainstream cinema, offering in his own films the opportunity for a conscious and self-aware engagement with the dynamics of looking. *Dyn Amo* (1972), based loosely on the stage play *Dynamo* by Chris Wilkinson, presents a sequence of actresses who take on, largely unwillingly, the role of strippers; in the final, longest scene, the actress becomes for a while the passive plaything of a menacing group of men. The film's scenario creates an ellision between the protagonists' stage roles and their real selves. The use of facial close-up, which recurs throughout Dwoskin's work, is combined here with several devices that deprive the actresses of the comfort of their familiar routines, thereby bringing about a 'stripping' in a psychological as well as physical sense. They often look directly into the camera, on the one hand reflecting the crucial interaction (unseen by the viewer of the film) between them and the film-maker and, on the other, forcing the viewer to confront their own implication in the voyeuristic process. More recently, the grainy black-and-white footage in Dwoskin's currently ongoing series of films *Nightshots* (the first three completed in 2007) evokes the act of illicit voyeurism, emphasised by awkward camera angles. The often blank eyes of the protagonists at once confront the viewer and enclose the women in their own sollipsistic world. At times Dwoskin's subjects seem to enact a casual, though unpleasurable, exhibitionism, while his own presence as a sexual participant is also acknowledged. The act of filming at night and the animalistic quality of the film's soundtrack – the low register of the grunts, moans and other breathing sounds being caused by extreme slowing down – give it a predatory air and invoke the chthonian realm where sight is stifled.

The notion that voyeurism can bring with it the potential for sadism, with the implication that the looked-at can become a victim, is the principal reason that voyeuristic images remain controversial. Though many of the works discussed thus far have subverted this concept by reclaiming the position of the voyeur's supposed victim, or by exploring the vulnerability of the looker, the gaze is still widely regarded as potentially dangerous. Where this has become most apparent is in the increasingly extreme reactions that can be provoked by images of adolescents

and children. In the early twentieth century, artists like Kirchner and Mueller could paint adolescent girls in an evidently erotic context without receiving anything like the degree of opprobrium that doing so would today. Salvador Dalí's erotic text *Reverie* (1931) involved an eleven-year-old girl, her mother and a prostitute; while probably the artist most famous, or in some people's eyes infamous, for depicting female adolescent sexuality is Balthus. In recent decades, such work has become increasingly subject to censorship, suggesting that the taboo on depictions of sex in general has been replaced by that forbidding images of children in a sexual context. Graham Ovenden's works featuring female children and adolescents have drawn the attention of law enforcement officers, despite the Tate Gallery owning a number of his prints including the *Five Girls* and *Alice* series (both 1970). So strong has the taboo surrounding the subject of children and sex become that it can more easily be handled by female artists, probably the most notable examples being Sally Mann and Inez van Lamsweerde. Yet even they have encountered problems. Betty Schneider's nude photographs of her daughter at nine months, two years and five years old upset some gallery visitors in London in 2004 and provoked a furore in the British popular press, causing the gallery to withdraw them.

As has often been noted, the question of whether and how images of children point to their subjects' sexuality lies more in the eye of the beholder than anywhere else. Indeed, a certain level of ambiguity in depictions of children in work by artists such as Larry Clark and Matt Collishaw suggests deliberate playing with the violent reactions that they may engender. Collishaw's series of photographs depicting a teenage schoolgirl sleeping in a wood conjure a magical scene behind which lurks the possibility for a sinister voyeuristic motivation. Liina Siib's photographs show playing children and flirting teenagers. *Presumed Innocence* (1997), a series of photographs that depict children in a swimming pool, raises questions both about the children's possible sexuality as well as the adult viewer's own mixed emotions of voyeurism and guilt at sullying a wholesome scene with a potentially paedophilic look. Particularly enigmatic, though undoubtedly poetic and resonant, are Oleg Kulik's series of works on the theme of *Lolita* (2000), which include superimposed images of himself, often in foetal or semi-foetal position, and a young girl, often with a cheeky grin, floating in water as if in amniotic fluid; though to what extent this work, despite its title, is really about sex remains uncertain.

For many contemporary artists, the modes of voyeurism and exhibitionism have functioned in part as a way of enacting just that scenario which has long been at the root of a prevalent suspicion of art – that it may be a licentious and corrupting force. Indeed much of the suspicion of art that has been expressed throughout European history has stemmed from associating it with sexual licence. Thus all images, not just explicitly sexual ones, have been widely sensed to be seductive. As Jonas Barish has demonstrated in his book *The Antitheatrical Prejudice* (1992), of all the arts it is the theatre which has most been the object of puritanical disapproval – significantly, the word 'theatre' is etymologically imbued with the act of vision, derived from the Greek verb *theatron* 'viewing place' – yet the visual arts, as normally defined, have been close behind. Indeed, many Romantic and modern artists in the bohemian tradition – as well

as several of the more recent artists featured in this book – have been more than happy to live up to their detractors' expectations.

The linking of the polytheistic Hellenic, Classical and pagan stream in European culture with a delight in images, and of the monotheistic Judaic, Protestant and biblical stream with a hostility to images and a preference for the Word, is a generalisation that requires many qualifications. Nevertheless it contains enough truth to provide, initially at least, a useful historical framework. It is not coincidental that there is often a link between puritanism and iconoclasm. Undoubtedly, such 'anti-ocular' tendencies as those propounded by so many twentieth-century theorists do to some extent share a heritage with the puritan tradition of image-suspicion. Conversely, for James Hillman, ardent advocate of a return to the pagan polytheistic approach, the image – particularly when appearing in dreams or similar psychic manifestations – is something not to be distrusted, as with Lacan, but to be embraced. Camille Paglia's strongly asserted preference is also for the 'eye-intense' pagan tradition, 'based on cultic exhibitionism'.[27]

Just as there are many kinds of sadism and masochism, so voyeurism and exhibitionism take many forms. It would be unhelpful to consider either set of perversions in too homogenous a manner; rather they cover a broad range of phenomena, and as such have provided infinitely rich material for the visual arts. Voyeurism and exhibitionism are an inherent part of the dynamic of art, if only because of its visual component, but are also present in art writing and criticism. Indeed an element of showmanship is vital to art as a process that places the private in the public realm. A consideration of the sexual implications of such an analogy brings with it associations of curiosity, the desire to uncover and to know, along with the power to veil and to substitute. It also leads necessarily to questions that are closely connected to the enigmatic notions of beauty and its opposite.

Chapter 10

Beauty and Beastliness

No story has a better claim to encapsulate the fundamental dynamic of sex than that of Beauty and the Beast. In its bringing together of the two apparent opposites, it gives expression in archetypal form to the powerful paradoxes that make sex so feared and so sought after, at once despised and idealised, repulsive and attractive. The first published version of the traditional fairytale, by Gabrielle-Suzanne Barbot de Villeneuve in 1740, was somewhat rambling; the countless variations which have followed are closer to Jeanne-Marie Leprince de Beaumont's more succinct, abridged version of 1756. Behind the tale of Beauty and the Beast lies the myth of Eros (Cupid) and Psyche. First told as a story-within-a-story by an old woman in Apuleius' second-century novel *The Golden Ass*, it tells of a mortal woman's search to regain her divine lover Eros, having been cast from him as punishment for looking on him against his instruction. According to Marina Warner in *From the Beast to the Blonde*, 'the first Beast of the West was Eros'.[1] The most striking difference is that not only Psyche but Eros too was intensely beautiful. His was, however, a beauty that needed to remain hidden – it was Psyche's premature looking at him which caused his abandonment of her. Crucially, the god of Love also shared with the later beastly incarnations the quality of wildness.

Wildness has long been considered an essential feature of male sexuality but increasingly it has been recognised as essential to female sexuality as well.[2] Warner notes a major shift of emphasis within stories of Beauty and the Beast from the seventeenth century onwards: at first the Beast is identified with specifically male sexuality, which needs to be tamed and civilised, whereas 'later the Beast is perceived as a principle of nature within every human being, male and female, young and old, and the stories affirm beastliness's intrinsic goodness and necessity to holistic survival'.[3] Nevertheless, even if the tale is taken as intrapsychic, the Beast's codification as in some important sense 'masculine' remains central to his identity.

Both Eros and Psyche and Beauty and the Beast are stories of initiation, most especially that of the female into sexual love. They are also both, the pagan myth more explicitly than the later fairytale, quest stories; but whereas in most quest stories it is the male who sets out to find his princess or equivalent, in Eros and Psyche it is the female who, through many trials and tribulations, must win, or rather win back, her beloved. Warner applauds Apuleius' intuition in putting the tale into the mouth of an old woman, for she sees it as a myth which expresses a fundamentally female perspective, a reason perhaps for its popularity with female fairytale writers. When men tell it, they often, according to Warner, use it to 'introduce special pleading on their own behalf'.[4] In particular, male adaptations of the story make Beauty static. For example:

> Underlying the static serenity of Josette Day's La Belle in Cocteau's film lies the Symbolist fetishisation of impassive femininity, as defined by Baudelaire, of Beauty who speaks of herself as '*un rêve de pierre*' (a dream of stone).[5]

Paradoxically, the female then becomes associated with the material and the male with the spiritual, in his 'enchanted castle', so that there is a return to something very like the traditional symbolic alignment of female/nature and male/culture, whereas the central thrust of Beauty and the Beast is to reverse that alignment.

In the coupling of the beautiful and the beastly, there is a strong implication of defilement – not inconsistent with the 'universal tendency to debasement in the sphere of love' which Freud discussed in his celebrated essay of that name.[6] Bataille, near the beginning of the chapter entitled 'Beauty' in *Eroticism*, writes: 'If transgression is impossible, then profanation takes its place. Degradation, which turns eroticism into something foul and horrible, is better than the neutrality of reasonable and non-destructive sexual behaviour.'[7]

Beauty is what gives this defilement, this profanation its meaning and its worth. But what constitutes beauty? Bataille takes what he admits are very tentative steps towards an answer, and points to a fundamental paradox. On the one hand, a man or a woman – he is really only interested in the case of a woman – is considered more beautiful the further their appearance is from the pre-human, anthropoid, that is to say, from the animal. On the other hand, a purely ethereal beauty would be insipid: essential too is an element of animality, as suggested by the hairiness of the sexual organs. He spells out the principal value of beauty for eroticism, in a passage which makes the analogy with his theory of sacrifice clear:

> Beauty has a cardinal importance, for ugliness cannot be spoiled, and to despoil is the essence of eroticism. Humanity implies the taboos, and in eroticism it and they are transgressed. Humanity is transgressed, profaned and besmirched. The greater the beauty, the more it is befouled.[8]

In these terms, sex may be seen as the realm where the calm of beauty is disturbed – and aroused – by the introduction of the animal – hairy, sweaty, reddened: the idiomatic 'beast with two backs'.

For Camille Paglia, the notion of beauty is a construction to protect human beings from the paralysing fear of nature's beastliness.

> Consciousness has made cowards of us all. Animals do not feel sexual fear, because they are not rational beings [...] We see too much, and so have to stringently limit our seeing. Desire is besieged on all sides by anxiety and doubt. Beauty, an ecstasy of the eye, drugs us and allows us to act. Beauty is our Apollonian revision of the chthonian.[9]

In line with her belief that women are inherently closer to nature and the chthonian than men, it is men who have the greatest need of the fiction of beauty; which is why, in contrast to most animals, beauty in the case of human beings is associated mainly with the female.

The classic account of ideals of beauty in Western art is Kenneth Clark's *The Nude: A Study in Ideal Form*, in which he draws the crucial distinction between 'naked' and 'nude', arguing that the latter was based on the figure of Venus in the more common case of the female nude, and of Apollo in the case of the male. Umberto Eco's *On Beauty* also considers ideals of both the female and the male form: his analysis of the history of the Western conception of beauty substitutes Adonis for Clark's Apollo, suggesting a nuance more closely concerned with the male body as an object of sexual desire.[10] Eco extended the Classical tradition to the mass media in the twentieth century, identifying the iconic Hollywood film star as the modern embodiment of beauty – both male and female, though recognising the distinct preponderance of the latter throughout the modern period.[11] Abigail Solomon-Godeau has identified the decades surrounding the French Revolution as the period that witnessed a 'crisis' in male representation: 'during which the beautiful male body ceded its dominant position in elite visual culture to the degree that the category "nude" became routinely associated with femininity'.[12] Germaine Greer has focused recently on depictions of male beauty in an attempt to unpick what she sees as the prevailing linguistic female bias accorded the term. Greer's assessment is that the word 'beauty' may be associated with the male only in his youthful incarnation, that it is a word that ceases to be appropriate with the transition from 'boy' to 'man'.[13]

In the discourse surrounding modern art at the beginning of the twentieth century, beauty became a controversial notion to invoke, largely expunged, in its traditional form, from critical discourse on art. The Futurist pledge that demanded 'for ten years, the total suppression of the nude in painting', indicated a violent aesthetic rejection of images of the female form, relocating beauty in the image of the machine.[14] André Breton's prescription that beauty must be 'convulsive or it will not be at all', disrupted the notion of beauty with bodily violence.[15]

More recently, the rise of feminist discourse has further problematised the predominance of beauty as the traditional trope within which to represent the female nude. In seeking to

divest the female body of the objectifying male gaze of the grand tradition, many feminist artists and writers claimed the female body as political ground. For some, this has led to a complete eschewal of images of the female body as an object of beauty, a position as critical of modern art as it was of Classicism.

In contrast, Wendy Steiner, in *Venus in Exile*, has argued that modern art's rejection of the nude represented an unfortunate break from Classicism and should be seen as part of its one-sided preference for the sublime, gendered masculine, over the beautiful, gendered feminine and therefore dismissed as trivial. She is strongly critical of the antipathy that modern art has displayed towards the beauty of the female form. According to her, it is the modern pursuit of the anti-beautiful sublime that has led on the one hand towards a tendency to destroy the image and on the other, paradoxical as it may seem, to a fascination with low-life figures such as the prostitute – to the exclusion of representations of the sensual figure of Venus.[16]

Jeremy Gilbert-Rolfe's study on beauty and the notion of the 'contemporary sublime' is also informed by the distinction between the two. He has noted the repeated failure of beauty to reclaim a central position in the aesthetic realm:

In the art world, the idea of the beautiful often threatens to make an appearance or comeback but, in practice, always tends to be deferred. When not deferred it's devalued, so that references to the 'merely' beautiful are common but invocations of beauty unaccompanied by that adjective scarce, to the extent that some might see a Freudian dimension in this deferring and diminishing of what's nominally at the centre of the discourse.[17]

Nonetheless, though the rejection of the notion of beauty has in some cases led to its absence from modern and contemporary art, it has more widely paved the way for its reassessment.

A thoroughly original reinvention of the ideals of Classical beauty is the work of Marc Quinn, whose white marble sculptures (2001–04) that depict disabled subjects refigure the Classical nude. In 2001, Hans Haacke's insertion of Quinn's sculptures into the sculpture galleries of the Victoria and Albert Museum in London, part of the cross-institutional exhibition 'Give and Take', resituated them among such canonical works as Canova's *Three Graces*, the epitome of Neoclassical notions of beauty. The unusual appearance of Quinn's subjects, whose body types would not normally fit standard social ideals, is elevated to the realm of the Classical model; intriguingly, their form finds poetic resonance with the missing limbs of those Classical sculptures that are considered the epitome of beauty. Quinn's portrait of *Selma Mustajbasic* (2000) adopts the traditional pose of the reclining nude, retaining a sense of elegant languor, just as his *The Kiss* (2002) embodies the tenderness of such traditional artists as Rodin.

John Currin's reworking of the traditions of the female nude also refigures traditional art historical frames of beauty in a contemporary context but reflects a sensibility very distinct

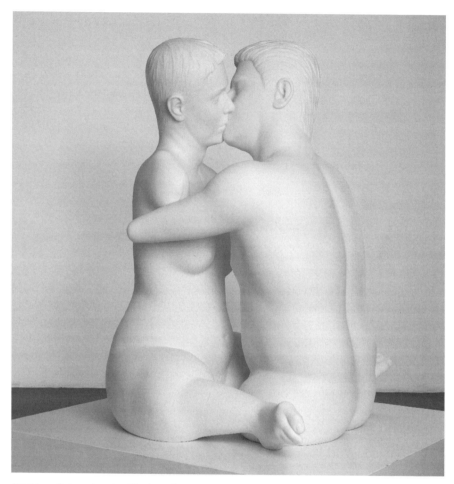

27. Marc Quinn, *Another Kiss* (2006).

from Quinn's in its deliberate visual disturbance of these ideals. This strategy results in unsettling images of women with large, overmade eyes and pendulous breasts; those features usually deemed sexually attractive are extrapolated to the point of the grotesque, while their short skirts and bright make-up contrast with an underlying physical decay. In many works, Currin makes reference to the Northern European ideal of the female nude, emphasising their extended bellies and physical awkwardness. Currin's interrogation of the female body extends, via his adoption of the tradition of figurative painting, to unsettle the traditions of representation as a whole. Lisa Yuskavage's paintings of female nudes are informed by a similar strategy, though her style makes reference to the aesthetic of the pin-up, combined with the somewhat sickly colouring and soft-focus settings of typical illustrations

of fairytales. The pneumatic nymphettes that she depicts exude a wide-eyed, pouting seductiveness that many find disturbing.

For a number of artists, the ironic language of kitsch provides a means by which the tradition of beauty may be invoked in a way that remains ambiguous, simultaneously citing its visual power and negating its potential for embarrassment by flirting with its subversion, countering good taste with bad. Most notable in this respect is the work of Jeff Koons, whose embrace of kitsch is inspired by multiple sources that include, in such sculptures as *Bourgeois Bust* (1991), the language of Classicism. A double bust, in white marble, of Jeff and Ilona embracing – he naked and she adorned with beads – it is more explicitly related to the tradition of Neoclassicism than earlier works from the *Made in Heaven* series. Though the tradition of Classical beauty that it invokes is the same as Quinn's, Koons' kitsch operates with a greater sense of detachment. Hannah Plumb's sculpture busts, which take the form of blow-up sex dolls, are even more clearly situated in the realm of sexualised irony. The headless *Miss World Torso* (2005) is a humorous conflation of the *Venus de Milo*, complete with one missing arm and a truncated one, and a plastic sex doll with visible seams and stiffly hemispherical breasts.

The languorously androgynous boys that feature in the paintings of Carlo Maria Mariani embody a poetic sensibility that nevertheless hovers ambiguously at the boundaries of kitsch. The firm bodies of Mariani's ephebes are things of desire, in many ways the embodiment of the Classical ideals of male sexual beauty. Indeed, ever since its inception with figures like Johann Joachim Winckelmann, Neoclassicism has often been associated with male homosexual desire. Mariani links this Classical conception of beauty with the sublime, placing the two side by side rather than in opposition. He has said, 'I see my work as the swan-song, the last expression of the concept of beauty *and* the sublime'[18] [my italics].

The revival of Classicism was the avowed aim of the St Petersburg New Academy of Fine Art, founded in 1989 by Timur Novikov, who would launch the Neo-Academicist movement in the same year with a series of collages dedicated to Oscar Wilde. One of the Academy's most prominent students was Georgy Gurianov, whose works predominantly feature sailors in uniform or young men with bared torsos in heroic poses that, once again, evoke Classical sculpture. A typical picture, produced on the occasion of the Gay Games in Amsterdam in 1998, depicts a group of muscle-bound hunks sitting two abreast in a boat. Such works combine the Classical aesthetic with an iconic, almost kitsch and stereotypical gay subject matter. Despite his loathing for Communism, Gurianov has recognised the extent to which Socialist Realism kept the tradition of Classical art alive. His work makes explicit the homoerotic subtext in much heroic Communist-backed public art, and by extension all forms of totalitarian art, acknowledging, for example, the influence of Leni Riefenstahl.[19] Rather than presenting a mere rejection of totalitarian imagery, Gurianov's work explores the tension between the desire for freedom of sexual expression and the attraction of potentially repressive structures of authority. For Gurianov, as for Mariani, the aim of rediscovering the harmonious beauty in art

sets him apart somewhat from the more interrogative drive of both Currin and Yuskavage. While their depictions of the female nude have produced only disquietening results, the ambiguity in Mariani and Gurianov lies in how literally to take their pronounced belief in beauty as something to be recuperated. 'The point of my painting,' states Mariani, 'is to rediscover something beautiful, not like a virtuous beautiful painting...rather a painting that is rigorous and difficult in terms of technique.'[20]

Marina Abramović's work *Art Must Be Beautiful – Artist Must Be Beautiful*, performed in 1975, highlights the conflation of the notion of beauty as it is applied to art, to artists and to the female form. The ideal state of beauty outlined in the work's title phrase – which Abramović chants throughout the performance – is allied with her increasingly painful and manic repetition of the act of brushing her hair until she hurts her face and damages her hair, destroying those traditional signifiers of female beauty. It is not coincidental that the conflation of the different senses of beauty should be highlighted in an action involving hair. 'The language of the self would be stripped of one of its richest resources without hair,' writes Marina Warner, 'and like language, or the faculty of laughter, or the use of tools, the dressing of hair in itself constitutes a mark of the human.'[21] Abramović's work allies the act of dressing hair with that of artistic creativity, creating a destructive scenario in which both art and artists must attain beauty.

The varying visual significances attached to hair have provided fertile ground for contemporary artists. Helen Chadwick's *Loop My Loop* (1991) plays on the specific significance of blonde hair, which traditionally carries associations with goodness and the sun. She intertwines golden hair with glistening pink pig's intestine, rendering concrete the coexistence of beauty and the beast, human and animal, in a scenario that is simultaneously attractive and repellent. Her *Glossolalia* (1993) centres on a phallic tower of lambs' tongues cast in bronze, surrounded by the fur of wolfs' skins, the arrangement to some extent echoing that in *Piss Flowers*. Performance artist Giovanna Casetta undertook a change of hair colour for a year, from her natural brunette to blonde, charting how different public attitudes to her were. On her final day as a blonde, Casetta re-enacted in the fountains of Trafalgar Square, London, one of the most famous scenes from *La Dolce Vita*, in which Sylvia (the blonde Swedish actress and 'sex goddess' Anita Ekberg) dances in Rome's Trevi Fountain.

Mona Hatoum's work plays on the dual associations of hair with both beauty and beastliness. In the humorous and punningly titled *Jardin Public* (1993), she has attached a triangle of her own carefully collected pubic hair to the seat of a wrought-iron art nouveau-style chair, refiguring its curvilinear forms as a voluptuous female body while inviting viewers to engage physically with her pubic hair through sitting. The work plays on the dual associations of pubic hair, simultaneously protector of the genitals and barrier to them, enticing and threatening with the potential for entanglement. Hatoum's sculpture *Hair Necklace* (1995) is made from delicate balls of the artist's own hair, combining the dark matted hair of the beast with the adornment of beauty. The white bust upon which Hatoum's necklace

is hung evokes not only the shop-window display dummy (indeed the work was displayed in the window of Cartier), but also the flawless white marble busts of Classicism.

Most directly counter to the Classical ideal of beauty, with its associations of wholeness, youth, health and physical perfection, is the slimy putrefaction of abjection, as outlined by Julia Kristeva in *Powers of Horror* (1980), the first of the trilogy that would also include *Tales of Love* (1983) and *Black Sun: Depression and Melancholia* (1989).[22] For Kristeva, abjection is characterised by the collapsing of the borders between object and subject, embodied in states that call into question the autonomy of the subject as a being separate from the mother and father. Abjection is rooted in the body's margins and those matters and fluids that are issued from its orifices. What causes abjection, in Kristeva's reckoning, is that which 'disturbs identity, system, order. What does not respect borders, positions, rules. The in-between, the ambiguous, the composite.'[23] Borders are threatened by defilement and pollution, both from within and without. In a chapter titled 'From Filth to Defilement', Kristeva categorises polluting objects as either excremental (alongside excrement are decay, infection, disease) or menstrual, the threat that issues from identity's interior.[24] Abject matter figures our descent to the primal state prior to symbolic structures. The notion of abjection, though, is also intrinsically linked to that of *jouissance*, with its implications for violent climax. Indeed, sex is linked closely with abjection in the merging of subject and object and the loss of self-containment through exchange of bodily fluids. For Kristeva, abjection figures crucially in contemporary art. Writing in the catalogue of the exhibition 'Rites of Passage' in 1995, she declared her belief in the role of art to 'accompany' what she sees as the current state of crisis and fragmentation. In these terms, the recuperation of beauty in a straightforward sense is not viable: 'We have reached a kind of degree zero of harmony,' she asserts, 'We are incapable of attaining beauty.'[25]

Kristeva's notion of the abject has frequently been invoked by critics in relation to Cindy Sherman's photographs of the late 1980s and early 1990s. The unidentifiable nature of the glistening and oozing substances of Sherman's images provokes the sensation of disgust, while the merging of inside and outside recalls Kristeva's notion of endangered borders. The frame of *Untitled #190* (1989) is filled with a slimy mass that suggests the innards of the body, almost obscuring the glistening eyeballs, nose and grimacing mouth in the centre of the image, a virtually complete dissolution into putrid matter. The half-creature in a work from 1985, its human features metamorphosing into the snout of a pig, offers another transgression of borders, the threat of return to an earlier animal state – the resurgence, one might say, of the beast. Still more unpleasantly, the grubby greenish waxen flesh in *Untitled #242* and *Untitled #243* (both 1991) is eerily suggestive of the bloated and discoloured extremities of a corpse left lying outdoors.

John Duncan's controversial performance *Blind Date* (1980), in which he purchased a female corpse from Tijuana and filmed himself having sex with it, made literal the link between the sexual act and the abjection of death and putrefaction. Duncan related the act in terms of an 'indescribable intense self-disgust', suggesting that the state of debasement applied equally

to him and to the corpse. After the act, he had a vasectomy operation, 'to make sure that the last potent seed I had was spent in a cadaver'.[26] The dramatic sexual collision of life and death in Duncan's performance recalls Kristeva's invocation of the corpse as a demonstration of that which is 'permanently thrust aside':

> Such wastes [body fluids] drop so that I might live, until, from loss to loss, nothing remains in me and my entire body falls beyond the limit – cadare, cadaver. If dung signifies the other side of the border, the place where I am not and which permits me to be, the corpse, the most sickening of wastes, is a border that has encroached upon everything.[27]

The deliberately messy aesthetic in much of the work of Paul McCarthy harnesses the aesthetic of repulsion, exploring an infantile fascination with filth. Early paintings, executed between 1966 and 1968, appear gestural and visceral, an expression of the excremental pleasures of paint. McCarthy has described as highly sexual and sensual his technique of painting with his hands on canvases laid on the floor, before burning the images. His later performances assault the senses of his audience with environments smeared with dirt, ketchup, mayonnaise and chocolate syrup. In collaboration with Mike Kelly, McCarthy gleefully besmirched the iconically squeaky-clean persona of *Heidi* (1992), making fun of her latent sexuality by means of grotesque buffoonery.[28]

Chiharu Shiota's work is informed by a markedly different sensibility. Her performance *Bathroom* (1999), a ceremonial bathing in mud, is documented in photographs that appear almost scatological. By staging the performance in a bathtub, Shiota makes clear her deliberate transgression of the contemporary emphasis on cleanliness and hygiene; the ritual is posed in opposition to the perceived artificiality of modern life, and posited by the artist as a return to the earth as the material whence her body came. She describes it in terms of harnessing the regenerative qualities of filth, stating, 'when I pour the filth over my head, I feel that my whole body breathes again.'[29]

The defilement of beauty – linked so closely in Bataille's mind with eroticism – may thus be seen to imply more than its straightforward destruction. Shiota's wallowing in mud refutes the conventions of cleanliness and its alliance with physical beauty. In a similar manner, Hannah Wilke's work has been seen to enact the defilement of the social conventions of beauty.

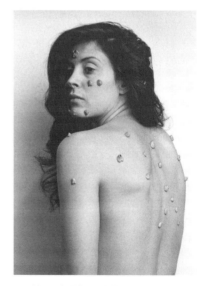

28. Hannah Wilke, *S.O.S. – Starification Object Series* (1974).

Wilke's *S.O.S. – Starification Object Series* (1974) shows the artist in various poses, her face and torso covered in the cuntlike folds of bubblegum for which she became known. On one level this is a protest against the repressive and damaging structures of feminine beauty: the poses that Wilke adopts and the props that she brandishes – sunglasses, hair curlers, a gun and cowboy hat – recall those of fashion models. Thus 'starification' means the process of becoming a star, as well as the decorative wounding implied by the word's similarity to scarification, pointing to the painful beautification rituals of some African tribes. Wilke enacts in *Starification Object Series* her position as 'the victim of [her] own beauty'.[30] Another implication of this series of works, however, is that if beauty may be figured as an oppressive façade (epitomised in the slick flatness of the fashion photograph), it is constructed to act metaphorically for the female sexual organ, which is itself rendered invisible. Thus Wilke's act of plastering her face and body with tiny representations of the cunt – with its wound-like associations – may be considered a reassertion of its physical presence. Such an act not only undermines the sexual lack created by social constructions of beauty, but serves as an erotic empowerment of women.

The representation of the female genitals is more literal in Judy Bamber's hyper-realist painted diptych *My Little Fly, My Little Butterfly* (1992), in which they are juxtaposed with insects. The flies suggest repulsion and the butterflies metamorphosis and beauty, thereby pointing to an emotional ambivalence towards the female sexual organs on the part of both men and women. Zoe Leonard's installation for the 1992 'Documenta' exhibition inserted black-and-white photographs of women's genitals into museum galleries devoted to eighteenth- and nineteenth-century art, from which she had removed all paintings except those of women.[31]

Wilke's frequent references to Venus in her work – with titles like *Venus Basin, Venus Cushion, Venus Envy* and *Venus Pareve* – reveal her concern with the ideal and its relation to her own body. Much of the power and poignancy of her harrowing final series, *Intra-Venus* (1992–93), which documents the effects of her body's succumbing to cancer and of the treatments she was receiving, derives from the contrast with her earlier performative and photographic work, in which her beauty had been a crucial factor. Thus beauty is an inherent part of this last series, implicit through its absence, lost through the 'beasts' of age or illness. Indeed, there is a tradition, from Wilke's *Intra-Venus* to Kozyra Katarzyna's *Olympia* to Annie Sprinkle and her partner's shaving of their heads, of relating the experience of illness to the subject of beauty. Another artist who has made a series of work out of her experiences with cancer is Roberta Graham. In some of her most characteristic work Graham has superimposed photographic images of the outside of her body with x-ray images of the inside. The final piece has often taken the form of a lightbox, an ideal medium for the purpose because of its transparency. The medical connotations of internal views of the body inevitably hint at mortality, and there is in fact a somewhat Jacobean sense of *memento mori* about much of Graham's work.

There is in art a notable history of the Romantic ideal of illness, from the tradition of the tragic pale women of the Pre-Raphaelites to the more recent fashion for 'heroin chic', that springs from the act of consorting with death. This may be considered in terms of the notion of the *Vanitas*, which emphasises the transience of physical beauty, embodied in the traditional accompaniment of symbols of time with the figures of Venus and Cupid. Central to conceptions of beauty is the haunting omnipresence of death, while tragedy is necessarily infused with a sense of beauty. Thus Nietzsche's poignant question, 'what must these people have suffered that they might become thus beautiful?' and the protagonist of Thomas Mann's *Dr Faustus*, who deliberately seeks out ill health.

Franko B's work is infused with a powerful physical and spiritual vulnerability; the artist's body is presented as fragile and wounded, literally and emotionally naked. Franko's avowed aim is beauty, one that he has allied to the beauty of old master paintings and that is reminiscent, in its compelling vision of the beauty of the wounded and compromised body, of the work of Francis Bacon. Franko's approach reflects his belief in beauty as the single most important way in which to touch people on the deepest affective level, a means of connecting with the psychic wounds that he perceives as universal:

> I think beauty functions like a bridge...things that touch you. There are many times you are moved and you don't know why. This is something very, very deep.[32]

For Kristeva, the state of vulnerability is vital to the function of analysis: 'One must keep open the wound where he or she who enters into the analytic adventure is located.'[33] She speaks, in terms that are highly appropriate to Franko B, of the 'unstabilised subject' whose wound remains open as being 'like a crucified person opening up the stigmata of its desiring body', and argues that it is this openness and vulnerability that makes catharsis possible.[34]

Franko B's presentation of his own vulnerable body covered in thick white make-up offers a visual similarity to the lyrical representations of the body presented by the Butoh movement, since its inception in Japan in 1959 with Tatsumi Hijikata's homoerotic performance of *Kinjiki* (*Forbidden Colours*), and during its burgeoning into a worldwide phenomenon. Beauty in Butoh – the 'dance of darkness' – resides not only in its focus on birth, death and shadow, but in the frequently fragile quality of the body depicted. As Sondra Horton Fraleigh has noted, 'Butoh taps the subconscious body by stripping the social body, and its aesthetic dramatises the beauty of emergent form through natural processes of birth and decay.'[35]

29. Franko B, *I Miss You* (2005).

Cathy de Monchaux's work, through its combination of sexually suggestive forms and spiky materials, produces a sense of beauty that is both vulnerable and threatening. In *Dangerous Fragility* (1994), labial folds of pink leather are surrounded by claw-like brass blades, suggesting the softness of intimate flesh encased in harsh rigidity. The splayed shape of the work and the incorporation of leather ribbons and buckles evoke too the boned structure of a corset or chastity belt, simultaneously beautiful and dangerous in its restraint. Monchaux's striking forms reflect a fascination with symmetry, 'the attribute most steadily singled out over the centuries', according to Elaine Scarry, as that which most clearly denotes beauty in human form.[36] Visually similar to Monchaux's works, Nazareth Pacheco's installation *Jóias* ('Jewellery', 1997–2001) consists of rows of elaborate female decorative articles – beads, collars and jewellery – that are intricately constructed from razors, hooks and needles. The work is infused with violence, at once delicate and deadly, attractive yet terrifying.

The works of Rebecca Horn often suggest a similar sense of the symbiosis of beauty and cruelty. Simultaneously frightening and extremely tactile, they embody in a highly poetic manner the dialectic of creation and destruction. The precise movements and delicate spikiness of works like *Kiss of the Rhinoceros,* or the rhythm of deadly penetration of *The Seventy-Seven Branches of Destiny,* evoke the violent beauty of the sexual act. The explosive splattering of fluids in many of her installations connotes not only the messiness of sex, but suggests too that beauty may often be accompanied by abject dissolution. Such works contain an intrinsic beauty that operates on a level more powerful than mere prettiness, invoking both the Apollonian and Dionysian in equal measure.

James Hillman, whose writing has long championed the value of an engagement with beauty, echoes the Classical myth of Eros and Psyche in the emphasis that he places upon the soul's need for beauty. He acknowledges that beauty can be superficial: 'Feeling can also become too aesthetic, love only for the beautiful, or love only for beautiful women, or the inability to enter into that aspect of feeling where it is harsh and savage.'[37]

However, he sees in it too the power to access a more profound experience of the world. Essential to this process of deepening the sense of beauty is the recognition of its intimate connection with death:

> The Box of Beauty which Psyche must fetch as her last task refers to an underworld beauty that can never be seen with the senses. It is the beauty of the knowledge of death and of the effects of death upon all other beauty that does not contain this knowledge.[38]

For Hillman, true beauty is perceived with the heart, sensed in the visual realm of imagination rather than just with the outward eye. Ugliness becomes a symptom of the 'anesthetized heart', the modern desert of the soul, reminiscent of Ballard's 'death of affect'. Fortunately, much as Ballard sees a redeeming value in the widespread taste for pornography, Hillman sees a redemptive possibility in the 'roaring lion', noting the traditional association of the lion with the desert as well as with desire:

> Surprisingly, this desert is not heartless, because the desert is where the lion lives [...]
> The more our desert the more we must rage, which rage is love [...] Our way through
> the desert of life or any moment in life is the awakening to it as a desert, the awakening
> of the beast, that vigil of desire [...] Like cures like: the desert beast is our guardian
> in the desert of modern bureaucracy, ugly urbanism, academic trivialities, professional
> official soullessness...[39]

In these terms, the beast signifies not only a being whose inner beauty needs to be brought
out but also an active, redeeming force in us that can be the rescuer, rather than the despoiler,
of beauty.

Like all the best stories, both Beauty and the Beast and Eros and Psyche function on many
levels and are open to multiple interpretations. The shift in interpretations of the fairytale from
the seventeenth century onwards that Marina Warner observes, towards recognising the
beast as a principle inherent in women as well as men, undoubtedly marks an increase in
sophistication; but, by the same token, beauty needs to be recognised as a principle inherent
in men as well as women. If both the fairytale and the myth can rightly be read at one level as
telling of specifically female quest and initiation, at another they are equally applicable to both
sexes. Indeed the overt theme of the Classical myth is the soul's quest for and eventual reunion
with sexual love, its protagonists personifications of these universal principles. It would not be
exact to call this reading 'intrapsychic', since what is at stake is precisely the *relationship
between* the psyche and sexual love; rather, it points to yet another level of meaning. Both
stories – perhaps most evidently Beauty and the Beast – encapsulate the fundamental dynamic
of sex in human beings. However, both – perhaps most evidently Eros and Psyche – also go
much further and give a poetic account of the fundamental role that sex plays within the
infinitely complex fabric of our inner lives.

Afterword

Sex is about much more than sex. Arguably, it is the single most important key to unlocking the secrets of human motivation. That is certainly the view of psychoanalysis; and there is a strong case for saying that the principal value of psychoanalysis and those schools of thought which derive from it lies less in the sphere of therapy than in what they have to offer intellectually to a much wider understanding not just of the actions of individuals but of collective human action also. History, politics, sociology and all the human sciences have already learned much but have much more yet to learn from focusing on the seemingly irrational patterns of belief and behaviour that can be brought about by the workings of unconscious desire. Art, while lacking the kinds of analytical tools that theoretical disciplines possess, has a correspondingly greater freedom to explore in intuitive and imaginative ways, with the potential to lead to still newer and more unexpected insights. It follows that art about sex has, in principle at least, the potential to lead to radically new insights of particularly crucial human importance.

Probably the biggest historical change affecting art over the last forty years has been the rise in the number of women artists. In the 1960s female artists were still rare and making art about sex was especially problematical for women. Now, there are probably more women artists dealing with sex than men. One of the reasons for this may be the sense of inhibition that some heterosexual male artists have felt in making art expressing their sexual feelings, as a result of their taking to heart the criticisms levelled against patriarchal structures of desire by feminism. However, despite the large number of women making art dealing with sex in one way or another, it is still highly problematical for women to make art openly celebrating their heterosexual feelings, as the fates of Carolee Schneemann's *Fuses* and Anna Thew's *Clingfilm* testify. It is even now still thought by many people, of both sexes, inappropriate – almost in some ill-thought-out sense indecorous – that women should openly express their sexual desire, certainly for men.

Contemporary images of desire and sexual experience thus cannot be assumed to reflect equality in the artistic any more than in the wider social realm. Indeed, there is today a very distinct lack of images of men as objects of heterosexual desire, produced either by female or by heterosexual male artists. In this respect, art has not broken with the mould of popular

culture, in which there is a ubiquity of images of sexually attractive women and, apart from the gay context, almost none of men as explicitly sexual objects. The tendency of women artists to focus on the female body, most often their own, has, to a remarkable extent, excluded an exploration of the desirable male form. Rather, in the work of many female artists, the relatively rare inclusion of the male body functions as much to refuse its sexuality as to affirm it. It is uncertain how much this focus on the female body stems from a belief that the straightforward reversal of the male gaze would only serve to validate patriarchal scopic structures, and how much it reflects a female preference for touch over sight, or for stories over static images, as means to erotic arousal – and, to the extent that is the latter, how much this is due to acculturation and how much it may point to something inherent in the female psyche.

Just as an excess of images of women may be damaging to women, so a paucity of images of men may be damaging to men. If this is so, then there is reason to be grateful for the celebration of the male body that has at least been carried on in the gay media and by gay artists. It is possible that our current cultural phase will develop in such a way that images of the sexualised male form in a heterosexual context will become more frequent; if this happens, it will be interesting to see to what extent art initiates, or merely mirrors, such a development. More importantly, now that male heterosexual desire in its patriarchal form can no longer be taken for granted, it is time for men to re-examine their sexuality afresh. There could be an enormous gain if men, and male artists in particular, were to undertake an investigation into male sexual desire analogous to that which women have been undertaking over several decades into female desire, and in which feminist-inspired art has played a key role. A start has been made but as yet it is on a comparatively small scale.

The more open discussion of sex in recent decades has led to a wider acceptance that sexuality can take a variety of forms; and this has been fully reflected in art, though it has affected groups in slightly different ways. If lesbian artists have benefited from the combined effect of an improved position for women and a greater acceptance of homosexuality, it could be claimed that – because of the inhibitions felt by some heterosexual male artists and the continuing tacit requirement that women should not be too explicitly lustful – it is gay male artists who, at this particular historical juncture, are the freest to be totally upfront about their sexual desire. Arguably more far-reaching than the open celebration of homosexuality is the fact that representations of gender and sexual identity have gone beyond the male–female binary into the realm of inter-sex and trans-gender. However, it must be acknowledged that a true inclusiveness, if this is indeed the aim, must not only embrace in-betweenness but also allow for the acceptance of difference, so that sex may still, if so desired, represent the coming together of opposites.

Despite the radical and largely successful challenge to the notion of the 'norm', paralleled and to some extent brought about by the rise of feminism and queer theory, this does not imply a sexual free-for-all. Taboos still exist and in certain cases have been strengthened. The biggest sexual taboo today is almost certainly paedophilia; a fact that is reflected both in the care

artists need to exercise when addressing the subject and the hostile public reaction liable to greet any art suspected of coming close to it. That the word 'adult' is often used as a euphemism for 'sexual' indicates the fundamental nature of the strict boundary separating sex from children in our society. It is perhaps significant too that Freud's theories about childhood sexuality appear to be those least accepted by popular contemporary commentary. In apparent contradiction to this, however, a large amount of commercial imagery – mostly popular with children themselves – sexualises children, especially girls, to a greater degree than ever before. The confusion and irrationality at the heart of contemporary society's attitude towards the relationship between childhood and sex suggests the need for art to investigate further what unconscious forces might be distorting perceptions.

Another fertile area which invites further exploration is the relationship between sex and violence. This has been considered by some, such as Wilhelm Reich, to be an inverse relationship, in which violence is a product of sexual repression; while for others, including Georges Bataille and Camille Paglia, the relationship is more direct, in which sex itself is figured as a dark and dangerous force. There is truth in both views: the sadism, for example, that cloaks itself in moral justification is almost certainly fuelled by frustrated sexual energy; on the other hand, sex is undoubtedly a disturbing force and the ruthlessness with which sexual aims can be pursued is often, to put it mildly, at variance with the ideal of kindness. We do not need to follow Bataille, as some sections of art criticism have tended rather uncritically to do, in his glorification of destruction and debasement. Nor of course should we fall for the stereotype of men as inherently cruel and women as inherently kind, as may seem to be implied by some more simplistic forms of feminist polemic. Rather, we need to recognise the extreme complexity of sex's relationship with violence; and therein lies art's great opportunity. Violence – both in its propensity to erupt and the contagious manner in which it can spread – has always been a central problem besetting human society and remains so now, potentially with more lethal consequences than ever. Sex, because of its complex relationship with violence, may be an especially valuable tool with which to explore this highly problematical terrain.

Whatever the relationship between sex and violence, that between sex and beauty, as also between beauty and art, might reasonably be expected to be both intimate and positive. Someone coming to contemporary art for the first time could be forgiven for supposing that art about sex was ideally placed to present a vision of beauty and allure. Yet, though some artists have infused their work with a feeling of playfulness or sensual tactility, contemporary art for the most part continues to present sex in terms that are anything but beautiful: more commonly it depicts ugliness, abjection and sexual alienation. Toying with the notion of beauty by framing it in the language of irony or kitsch does suggest possible awareness of a lack but has something of the quality of nervously, not to say self-consciously, dipping a toe in the water. While, given the trivialisation by the mass media of almost every worthwhile ideal, the fear that by wholeheartedly committing oneself to the water one will inevitably be submerged in sentimentality has some justification, this is clearly a situation that needs to be overcome.

Gilbert-Rolfe is right to suggest that the constant deferral or devaluation of the notion of beauty may point to an unconscious block, analogous to the repression of sexual desires analysed by Freud. This is undoubtedly an area in which much remains to be done. Fortunately, the prospect of yielding a little to the seductive powers of beauty promises to be far from unpleasurable.

Possibly the most important quality in art about sex is honesty: openness to all authentic feelings, free from any preconceived moral or ideological restraints. Not only is honesty crucial on the part of the artist but, if the art is to stimulate creative and imaginative self-awareness in the viewer, it is required on both sides. A guilt-free acceptance of one's own sexual desires is in itself an enormous and valid source of pleasure. Whether one chooses to act on all of them is another matter; but a non-judgemental attitude to both one's own and other people's desires is a precondition for developing a mature, responsible sexual morality based on conscious understanding. An acceptance of difference is also necessary: not just some generalised difference between the sexes, or between gay and straight, but between individuals. People's sexual preferences and fantasies differ more widely than is generally recognised; if it was ever thus, it is possible that the degree of diversity has increased with the complexity of our society. This diversity is to be celebrated; it is one of the things reflected in the rich variety of artistic practices that we have considered. Yet even the recognition of the extent to which our idiosyncracies vary can help to promote a new sense of community, a realisation that we are not alone in failing to conform to any 'norm'. Furthermore, despite the individual differences, several new and sometimes revealing common patterns emerge. Indeed, as we have seen, it is in large measure the ability of art to bring the more important of these patterns into focus that constitutes its unique potential value.

At the same time art, like sex, is itself a valid source of pleasure. Art's ability to provoke advances in understanding and to provide occasions for enjoyment are not at variance. Knowledge and pleasure can perfectly well go hand in hand – appropriately, 'knowing' and 'pleasuring' have both been used as delicate ways of referring to the sexual act. The art of the last forty years that has dealt with sex has opened up vast tracts of previously unexplored psychic territory and, in the process, dissolved many unnecessary inhibitions. The gains in terms of both awareness and opportunities for self-fulfilment have been considerable. Certain areas in which further exploration may prove especially fruitful have been indicated; there are doubtless many more.

Notes

Introduction

1. Although he does not specifically propose a spectrum, I am highly indebted in my thinking in this respect to Morse Peckham.
2. Ellen Schwartz, 'Vito Acconci: "I Want to Put the Viewer on Shaky Ground"', *Art News*, Summer 1981, p. 96. In psychoanalytical terms, the body can be equated with the phallus, while the environment can be equated with the womb. Therefore, the movement in this book from body to environment could be seen as one from the phallus to the womb – a movement which could itself possibly be seen as a form of sublimated coitus, or uterine regression.

Chapter 1. The Body

1. Lea Vergine, *Il corpo come linguaggio (La 'body-art' e storie simile)*, Milan: Giampaolo Prearo Editore, 1974 (dual-language, Italian and English). Revised version *Body Art and Performance: The Body as Language*, Milan: Skira, 2000 (English language only).
2. The provocative power of the book comes partly from the way in which it cross-references psychoanalytical insights with ideas gleaned from a dizzyingly wide array of sources: anthropology; political theory, notably Hobbes and Marx; the Bible; mystical writing, including Christian, Hindu and Buddhist; poetry, especially William Blake; and many others.
3. Harold Rosenberg, 'The American Action Painters', *Art News*, December 1952, pp. 22 ff. Reprinted in Harold Rosenberg, *The Tradition of the New*, London: Thames & Hudson, 1959. See also Amelia Jones, *Body Art/Performing the Subject*, Minneapolis: University of Minnesota Press, Chapter 2: 'The "Pollockian Performative" and the Revision of the Modernist Subject', 1998, pp. 53 ff.
4. The publication during the 1990s by Zone Books of the series *Fragments for a History of the Human Body* reflects the incorporation of this sensibility into the arena of theoretical and critical discourse.
5. Quoted in Marie-Laure Bernadac, *Louise Bourgeois*, Paris, New York: Flammarion, 1996, p. 81.
6. See Marie-Laure Bernadac, *Louise Bourgeois*, p. 78.
7. Louise Bourgeois, statement, in Dorothy Seiberling, 'The Female View of Erotica', *New York Magazine*, 11 February 1975, p. 56; cited in Helaine Posner, 'Separation Anxiety', Donald Hall, Thomas Laquier and Helaine Posner, *Corporal Politics*, exhibition catalogue, Cambridge and Boston: MIT List Visual Arts Center, Beacon Press, p. 24.
8. Louise Bourgeois, in Charlotte Kotik, 'The Locus of Memory', *Louise Bourgeois*, New York: Brooklyn Museum, 1994, p. 24; cited in Marie-Laure Bernadac, *Louise Bourgeois*, p. 132.
9. See Adrian Stokes, *Reflections on the Nude*, London: Tavistock Publications, 1967.
10. http://www.fourthplinth.co.uk/marc_quinn.htm
11. Sigmund Freud, *Penguin Freud Library, Vol. 7: On Sexuality*, pp 116–17. The section of the second essay entitled 'The Phases of Development of the Sexual Organization', in which the pre-genital organisations of sexual life are most clearly stated and from which this quotation is taken, was only added by Freud in 1915, ten years after the *Essays'*

first publication. The ideas expressed in the added section are for the most part, however, already implicit in the second essay's original form.

12. Also known as *Flux Film No. 4* or just *No. 4*.

13. Julia Kristeva, 'Motherhood According to Giovanni Bellini', *Desire in Language. A Semiotic Approach to Literature and Art*, Oxford: Basil Blackwell, 1981, pp. 237–70.

14. Norman D. Brown, *Love's Body*, Berkeley. Los Angeles, Oxford: University of California Press, 1966, Schaffhausen: Stemmler, 1993, p. 128.

15. Peter Weierrmair (ed.), *Das Bild des Körpers*, London and New York: Routledge, 1991, p. 70.

16. Freud, S.E. XIX, p. 26. Quoted in Margaret Whitford, *Luce Irigaray: Philosophy in the Feminine*, pp. 63–4.

17. Frances Morris, in Stuart Morgan and Frances Morris, *Rites of Passage: Art for the End of the Century*, London: Tate Gallery, p. 102.

18. For one such challenge to this notion see Christine Battersby, 'Her Body/Her Boundaries. Gender and the Metaphysics of Containment', *Journal of Philosophy and the Visual Arts*, special edition 'The Body', ed. Andrew Benjamin, London: Academy Group, 1993, pp. 30–39.

19. Visually, some of these closely resemble the Surrealists' 'exquisite corpse' drawings.

20. *Nature Study* and *Blind Man's Buff* (both 1984) and *The She-Fox* (1985).

Chapter 2. The Celebration of Female Sexuality

1. Joan Riviere, 'Womanliness as Masquerade', *The International Journal of Psychoanalysis (IJPA)*, vol. 10, 1929. The specific situation to which Riviere was referring was that of women making their way in a traditionally masculine professional environment.

2. Luce Irigaray, *The Sex Which Is Not One*, Ithaca, NY: Cornell University Press, 1985, p. 25. Originally published under the title *Ce sexe qui n'en est pas un*, by Editions de Minuit, 1977.

3. Luce Irigaray, *The Sex Which Is Not One*, 1985, p. 28.

4. Carolee Schneemann, *Imaging Her Erotics*, Cambridge, MA and London: MIT Press, 2001, p. 55.

5. Carolee Schneemann, *More Than Meat Joy: Performance Works and Selected Writings*, New York: McPherson & Co., 1979, p.180.

6. Carolee Schneemann, *More Than Meat Joy: Performance Works and Selected Writings*, p. 238. Though the text referred to 'a happy man/a structuralist filmmaker', Schneemann later said that the scroll was actually a missive to the critic and art historian Annette Michelson 'who couldn't look at my films.' See David Levi Strauss, 'Love Rides Aristotle Through the Audience: Body, Image, and Idea in the Work of Carolee Schneemann', in Carolee Schneemann, *Imaging Her Erotics*, p. 319.

7. Alexandra Munroe, *Japanese Art After 1945: Scream Against the Sky*, New York: Harry N. Abrams, 1994, p. 196.

8. Barbara Schwartz, 'Young New York Artists' *Crafts Horizon*, October 1973, p. 50; quoted in Margo Hobbs Thompson, 'Agreeable Objects and Angry Paintings', *Genders*, no. 43, 2006.

9. Johanna Frueh, in Wilke and Frueh, *Hannah Wilke: A Retrospective* (Columbia, MO: University of Missouri Press, 1989), p. 18.

10. Roswitha Mueller, *Valie Export: Fragments of the Imagination*, Bloomington and Indianapolis: Indiana University Press, 1994, p. 33.

11. Ibid, p. 31.

12. She was 'discovered' while performing at a burlesque theatre on 42nd Street, New York, by Richard Schechner.

13. Annie Sprinkle, *Annie Sprinkle Post-Porn Modemist*, Amsterdam: Art Unlimited, 1991, p. 111.

14. C o-produced and co-directed with videographer Maria Beatty, with music by Pauline Oliveros.

15. http://www.pbs.org/art21/artists/antoni/clip2.html

16. Ibid.

17. Cf the title of Artaud's play, *The Spurt of Blood*.

18. Carolee Schneemann, *Imaging Her Erotics*, p. 237.

19. http://www.susanhiller.org/Info/artworks/artworks-TenMonths.html. Included in the 1996 Hiller exhibition at Tate Liverpool. See Tony Godfrey, *Burlington Magazine*, vol. 138, no. 1117 (April 1996), pp. 269–70.

20. Although shown together in 1990 at Fawbush Gallery in New York City, Smith conceived of the Shields as independent works.

21. Rosemary Betterton, 'Promising Monsters: Pregnant Bodies, Artistic Subjectivity, and Maternal Imagination', *Hypatia*, vol. 21, no. 1, Winter 2006, pp. 80–100.

22. Julia Kristeva, 'Motherhood according to Bellini', in *Desire in Language*, p. 237.

23. For a comprehensive discussion of this work, see Elizabeth Herles, 'Helen Chadwick, One Flesh: Christian Iconography and Motherhood', *Exposure Magazine*, vol. 2, no. 3, April 1997: http://members.lycos.co.uk/exposuremagazine/helen.html

24. Mary Kelly, *Post Partum Document*, with a forward by Lucy R. Lippard, Berkeley, Los Angeles, Oxford: University of University of California Press, 1999, is a republication of the artwork in book form.

25. Sigmund Freud, *New Introductory Lectures*, p. 167.

26. Norman O. Brown, *Love's Body*, pp. 72–74.

27. See Judith Staines, 'Webs and Networks', www.culturebase.net/print_artist.php?844

28. Both were shown at the exhibition 'Stitches in Time' at the Irish Museum of Modern Art (2003–04).

29. Helaine Posner, 'The Self and the World: Negotiating Boundaries in the Art of Yayoi Kusama, Ana Mendieta, and Francesca Woodman', in Whitney Chadwick (ed.) *Mirror Images: Women, Surrealism, and Self-Representation*, Cambridge, MA and London: MIT Press, 1998, p. 158.

30. Maria Klonaris and Katerina Thomadaki, 'L'Insaissable/The Ungraspable', *Performance*, no. 62, November 1990, p. 51.

31. Luce Irigaray, *Ce sexe qui n'est pas un.*. Cited in Maria Klonaris and Katerina Thomadaki, 'The Ungraspable', p. 59.

32. Carolee Schneemann, *Imaging Her Erotics*, pp. 299–100.

Chapter 3. Divergent Sexualities

1. See article by Margery King, 'Public Faces, Private Parts', http://www1.uol.com.br/bienal/23bienal/especial/iewa.htm

2. 'Fifth Independent Film Award.' *Film Culture* 29 (1963). Quoted in Sheldon Renan, *The Underground Film*, London: Studio Vista, 1968, p.183.

3. Julia Kristeva, 'Motherhood According to Giovanni Bellini', in *Desire in Language. A Semiotic Approach to Literature in Art*, p. 243.

4. Georges Bataille, 'The Solar Anus' [1927], in *Visions of Excess: Selected Writings, 1927 – 1939*, trans. and ed. Allan Stoekl, Manchester: Manchester University Press, 1985, pp. 5–9.

5. Isaac Julien, quoted in Molly Shinhat, 'Black History and Desire', *FUSE*, June/July 1990.

6. Painted by Françoise-August Biard.

7. Kobena Mercer, 'Avid Iconographies', in Kobena Mercer and Chris Darke, *Isaac Julien*, London: Ellipsis, 2001, p. 11.

8. Sandra Lahire, 'The Fairies Banquet', *Coil*, no. 7, 1998. Reproduced at www.luxonline.org.uk/articles/fairies-banquet(1).html

9. http://www.cla.purdue.edu/waaw/corinne/Essay5/htm

10. http://www.cla.purdue.edu/waaw/corinne/Cotrell.htm

11. M.K. and K.T. interviewed by Madeleine van Doren, Catalogue of *Le Rêve d'Electra*, Galerie Edouard Manet, Gennevilliers, 1987; quoted in Maria Klonaris and Katerina Thomadaki, 'The Ungraspable', p. 69.

12. Maria Klonaris and Katerina Thomadaki, 'The Ungraspable', p. 65.

13. *Horsexe: Essay on Transsexuality*, Autonomedia,1990. Millot expanded on this concept, applying it to angels, when interviewed by Klonaris and Thomadaki for their *Petit Traité d'Angelologie* (France Culture, 1986): 'The

angel is not both sexes at once, like the hermaphrodite, but neither one sex nor the other. It is another form of omnipotence. An omnipotence by abstraction.' Quoted in M.K. and K.T. ibid.

14. Maria Klonaris and Katerina Thomadaki, 'Intersexuality and Intermedia: A Manifesto', *Festival of Computer Arts*, Maribor, Slovenia, 2000, p. 20.

15. For a detailed discussion of the performance see Gray Watson, 'Legitimate Journey', *Performance*, no. 18, August/September 1982, pp. 15–16.

16. Susan Sontag, 'Notes on "Camp"'.

17. Nan Goldin, *Nan Goldin: The Other Side*, New York: Scalo, 1993.

18. http://www.dellagracevolcano.com/statement.html

19. An item on a recent conference agenda at the University of Manchester may be symptomatic: 'Homophobia and Paedophilia and the Construction of Identity for Males Who Have Been Subjected to Childhood Sexual Abuse', coupling homophobia and paedophilia as though they belong together naturally, even though one is hostility towards a sexual disposition while the other *is* a sexual disposition.

Chapter 4 Intercourse

1. *Fuses* was the first part of an autobiographical trilogy that also included *Plumb Line* (1970) and *Kitch's Last Meal* (1973–75).

2. Interview with Kate Haug, in Carolee Schneemann, *Imaging Her Erotics*, p. 23.

3. In 1961, Iannone had taken on the US government single-handed to get the ban on Henry Miller's *Tropic of Cancer* lifted, and won. She has been a tireless fighter for freedom from censorship throughout her life.

4. See *Dieter Roth and Dorothy Iannone*, Hanover: Sprengel Museum and Berlin: Holzwarth Publications, 2005.

5. http://observer.guardian.co.uk/review/story/0,6903,1504491,00.html

6. http://observer.guardian.co.uk/review/story/0,6903,1504491,00.html

7. Interview for the film *Louise Bourgeois* by Camille Guichard (1993). Quoted in Marie-Laure Bernadac, *Louise Bourgeois*, p. 130 and note 4, p. 153.

8. *Dislocations* catalogue (New York: MOMA, 1991). Quoted in Marie-Laure Bernadac, op.cit., p. 130 and note 5, p. 153.

9. *Rebecca Horn: The Glance of Infinity*, Hanover: Kestner Gesellschaft, 1997, p. 146.

10. *Rebecca Horn: The Glance of Infinity*, p. 152.

11. Tracey Emin, *Tracey Emin: Works 1863–2006*, New York: Rizzoli, 2006, p. 40.

12. See Jennifer Doyle, 'The Effect of Intimacy: Tracey Emin's Bad-Sex Aesthetics', in Mandy Merck and Chris Townsend (eds), *The Art of Tracey Emin*, London: Thames & Hudson, 2002, pp. 102–18.

13. Amelia Jones, *Body Art/Performing the Subject*, p. 123.

14. Norman O. Brown, *Love's Body*, p. 64.

15. Melanie Klein, 'The Psychogenesis of Manic-Depressive States', p. 293; quoted in Norman O. Brown, *Love's Body*, p. 64.

16. See, for example, Frances Richard, review of Nan Goldin at Matthew Marks Gallery, *Artforum*, June 2003.

17. Roberta A. Smith, 'Legends Strike A Pose, With or Without Music', *New York Times*, April 18, 2003.

Chapter 5. Sex, Money and Modernity

1. A particularly good example is 'Le Crépuscule du Soir' ('Evening Twilight'). The association with death is especially evident in 'Les Sept Vieillards' ('The Seven Old Men'). Quoting some lines from the latter poem, Norman O. Brown comments: 'This metropolis is necropolis'. (*Love's Body*, p. 41)

2. Baudelaire refers to the painter in question just as M.G.; he was in fact Constantin Guys. A translator and great admirer of Edgar Allen Poe, Baudelaire compares Guys to the narrator in Poe's *Man of the Crowd*. Baudelaire's seminal essay is not, however, of interest as a piece of eulogistic criticism about an existing artist so much as a call to future artists to re-direct their attention to the urban scene.

3. Alyce Mahon, *Eroticism and Art*, Oxford: Oxford University Press, 2005, p. 65.

4. Merlin Coverley, *Psychogeography*, Harpenden, Herts: Pocket Essentials, 2006, p. 72.

5. 'Ambiguity is the pictorial image of dialectics, the law of dialectics seen at a standstill. This standstill is utopia and the dialectical image therefore a dream image. Such an image is presented by the pure commodity: as fetish. Such an image are the arcades, which are both house and stars. Such an image is the prostitute, who is saleswoman and wares in one.' – Walter Benjamin, *Reflections*, p. 157. See Rebecca Schneider's Foreword in Annie Sprinkle, *Hardcore from the Heart*, London and New York: Continuum, 2001, p. vii.

6. See Sherwin Simmons, 'Ernst Ludwig Kirchner's Streetwalkers: Art, Luxury and Immorality in Berlin 1913–16', *The Art Bulletin*, vol. 82, no. 1, March 2000, pp. 117–48, cited in Mahon op.cit, p. 94.

7. *Annie Sprinkle Post-Porn Modernist*, pp. 13–14.

8. *Annie Sprinkle Post-Porn Modernist*, p. 51.

9. James Hillman, 'Pink Madness, or Why Does Aphrodite Drive Men Crazy with Pornography?', *Spring*, no. 57, special edition 'Archetypal Sex', 1995, p. 61.

10. James Hillman, 'Pink Madness', p. 39.

11. Yuko Hasegawa, 'Post-identity *Kawaii*: Commerce, Gender and Contemporary Japanese Art', in Fran Lloyd (ed.) *Consuming Bodies: Sex and Contemporary Japanese Art*, London: Reaktion, 2002, p. 128.

12. Ibid., p. 132.

13. 'News from the Sun' in *Myths of the Near Future* (1982). This is not dissimilar to Morse Peckham's view that a taste for pornography is an indication of the cultural vigour of a society.

14. J. G. Ballard, 'Introduction to the French Edition of *Crash* (1974)', in *Crash*, Triad/Panther, 1985, p. 9.

15. Jean Baudrillard, 'Ballard's *Crash*', p. 319. See Nicholas Ruddick, 'Ballard/*Crash*/Baudrillard', *Science Fiction Studies*, no. 58, vol. 19, part 3 November 1992 for a detailed analysis of the debate that Baudrillard's reading engendered.

16. J. G. Ballard, 'Introduction to the French Edition of *Crash* (1974)', in *Crash*, Triad/Panther, 1985, p. 9.

17. F.T. Marinetti, 'The Founding and Manifesto of Futurism' [1909], in Umbro Apollonio (ed.), *Futurist Manifestoes*, London: Thames and Hudson, 1973, p. 20.

18. First published as *Non-Lieux, Introduction à une anthropologie de la surmodernité*, Paris, Editions du Seuil, 1992.

19. 'Natacha Merritt in the nude: Cybersex and the "Generation @"'. But this all sounds better as Natacha Merritt herself once put it: in her view, she has found a new mode of masturbating her way into the next millennium.

20. Kate Hodges, 'Acting Like a Sex Machine', *Bizarre*, no. 89, September 2004, p. 42.

21. Yoichi Tsuzuki, *Sperm Palace*, Tokyo, Aspect Corp., 2001.

22. Robert Romanyshyn, *Technology as Symptom & Dream*, London: Routledge, 1989.

23. J. G. Ballard, 'Introduction to the French Edition of *Crash* (1974)', in *Crash*, Triad/Panther, 1985, p. 5.

Chapter 6. Sex and Nature

1. Sigmund Freud, *A General Introduction to Psychoanalysis*; quoted in Norman O. Brown, *Love's Body*, p. 36.

2. In conversation with the author.

3. Many scholars have also, rightly, interpreted Mendieta's works in terms of her exile from her native Cuba, reflecting a desire to return to the earth of her roots.

4. Quoted in Helaine Posner, 'The Self and the World: Negotiating Boundaries in the Art of Yayoi Kusama, Ana Mendieta, and Francesca Woodman', in Whitney Chadwick (ed.) *Mirror Images: Women, Surrealism, and Self-Representation*, p.164.

5. Quoted in Donald Kuspit, 'Ana Mendieta, Autonomous Body', in *Ana Mendieta*, Santiago de Compostela: Centro de Arte Contemporanea, 1996, p. 51; and re-quoted in Helaine Posner, 'The Self and the World: Negotiating Boundaries in the Art of Yayoi Kusama, Ana Mendieta, and Francesca Woodman' in Whitney Chadwick (ed.) *Mirror Images: Women, Surrealism, and Self-Representation*, p. 164.

6. Charles Merewether, 'From Inscription to Dissolution: An Essay on Expenditure in the Work of Ana Mendieta', in Moure, Gloria et al., *Ana Mendieta*, Barcelona: Fundació Antoni Tàpies, 1996, p. 118.

7. Helaine Posner, 'The Self and the World: Negotiating Boundaries in the Art of Yayoi Kusama, Ana Mendieta, and Francesca Woodman' in Whitney Chadwick (ed.) *Mirror Images: Women, Surrealism, and Self-Representation*, p. 167.

8. 'Departure: The Brazillian Project of Marina Abramovic', *Performance*, Spring 1992, no. 65/66, p. 64.

9. Annie Sprinkle, *Post-Porn Modernist*, p. 115.

10. Ibid., p. 106.

11. Camille Paglia, *Sexual Personae Art and Decadence from Nefertiti to Emily Dickinson*, London: Penguin, 1990, p. 5.

12. Camille Paglia, *Sexual Personae*, p. 39.

13. This certainly partly accounted for the poetic effect of the student placards of the May 1968 protests: 'au dessous le pavé, le mer!'

14. Algernon Charles Swinburne, 'The Triumph of Time' ll. 257–64 and 297–304, in *Swinburne's Collected Poetical Works*, 2 vols, London: William Heinemann, 1924: I, pp. 34–47.

15. Sigmund Freud, 'Civilisation and its Discontents', *Penguin Freud Library, Vol. 12*, pp. 251 ff.

16. See Alexandra Munroe, *Japanese Art After 1945*, New York: Harry N. Abrams, 1994, p. 288.

17. Anne Marsh, *Body and Self. Performance Art in Australia 1969–92*, Melbourne: Oxford University Press Australia, 1993, p. 128.

18. http://www.tate.org.uk/britain/exhibitions/artofthegarden/artistsgardens_jarman.htm

19. http://www.newmuseum.org/more_exh_p_mccarthy.php

20. Supervert, 'Animal Sex Machines', BLAM!, vol. 3, cd-rom. Reproduced on http://supervert.com/essays/art/animal_sex_machines

21. Marie-Laure Bernadac, *Louise Bourgeois*, p. 119, n. 3.

22. Geoffrey Miller, *The Mating Mind*, London: Vintage, 2001.

23. Kathleen Raine, *Golgonooza City of Imagination: Last Studies in William Blake*, Ipswich: Golgonooza Press, 1991, p. 36.

24. Northrop Frye, *Fearful Symmetry: A Study of William Blake*, Princeton NJ: Princeton University Press, 1969, p. 348.

Chapter 7. Sex and the Sacred

1. Leo Steinberg, *The Sexuality of Christ in Renaissance Art and in Modern Oblivion*, Chicago: University of Chicago Press, 1996.

2. Philip Rawson, *The Art of Tantra*, London: Thames & Hudson, 1973, pp. 9–10.

3. Waldemar Januszczak, 'Jumping the Mystic Wall', *Guardian*, London, 10 Sep 1986.

4. Norman O. Brown, *Love's Body*, p. 58.

5. 'Shrimp: a symbol of the vast sea of the unconsciousness and of evolutionary beginnings: meat: the manifest earth of human and landbased awareness; grain: the essence of higher consciousness to supra-subtle vibratory realms; wine: the mystical fluid of living transformation from state to state: and cardamom seeds: within which the two are one.' Barbara T. Smith, 'Birthdaze', *High Performance* 15, vol. 4, no. 3, Fall 1981, p. 23.

6. According to Sprinkle, Norman Mailer called him 'America's foremost erotic writer'. Annie Sprinkle, *Post-Porn Modernist*, p. 104.

7. Ibid., pp. 118–19.

8. Ibid., p. 112.

9. Ibid.

10. Trog, 'Edinburgh Festival Report', *Ballet* Magazine, reproduced on Shakti's website http://www.shakti.jp/ text/English/critics/ballet%20magazine.htm

11. Elinor W. Gadon, *The Once and Future Goddess*, San Francisco: Harper, 1989, caption to Colour Plate 15. See also Barbara T. Smith, 'Art and Ceremony', *High Performance*, no. 40, 1987.

12. See William Peterson, 'Of Cats, Dreams and Interior Knowledge: An Interview with Carolee Schneemann', in *Performance* no. 59, Winter 1989/90, pp. 10–23.

13. August Wiedmann, *Romantic Art Theories*, Henley-on-Thames: Gresham Books, 1986. See especially Chapter IV: 'The Hierophantic Conception of Art', pp. 66–88.

14. By contrast, a more recent exhibition entitled 'Dionysiac: Art in Flux' (2005), at the Centre Pompidou, Paris, contained little, apart from a certain messiness and some mild scatology, that lived up to its title.

15. Bataille, Georges, *Eroticism*, trans. Mary Dalwood, London and New York: Marion Boyars, 1987; originally published as *L'Erotisme*, Paris: Editions de Minuit, 1957.

16. Quoted in Gary Morris, 'Hallelujah and pass the steak knife! cutting up with Ron Athey', *Bright Lights Film Journal*, no. 24, April 1999.

17. Quoted in Gary Morris, 'Hallelujah and pass the steak knife! cutting up with Ron Athey', *Bright Lights Film Journal*, no. 24, April 1999.

18. The most significant appearance of the angel in modern literature is in the work of Rainer Maria Rilke, notably his *Duino Elegies* (1912–22). Among the best-known more recent examples in drama and film are Tony Kushner's *Angels in America* and Wim Wenders' *Wings of Desire*. Examples in the visual art of the first half of the twentieth century include Paul Klee's drawings of angels and his watercolour *Angelus Novus* (1920), made famous by Walter Benjamin. See Anguéliki Garridis, *Les anges du désir: Figures de l'Ange au xxe siècle*, Paris: Albin Michel, 1996. For the basis in Romanticism of the idea of the artist as priestly figure, see August Wiedmann, *Romantic Art Theories*, Henley-on-Thames: Gresham Books, 1986, especially chapter 'The Hierphantic Conception of Art'.

19. Bice Benvenuto, *Concerning the Rites of Psychoanalysis or The Villa of the Mysteries*, Cambridge: Polity Press, 1994, p. 149.

20. Other contemporary artists, not included in the exhibition, include Ansuya Blom and Bill Viola.

21. Arturo Schwarz, in Anne d'Harnoncourt and Kynaston McShine (eds), *Marcel Duchamp*, New York: Museum of Modern Art and Philadelphia Museum of Art, 1973, pp. 81–98.

22. http://www.adrien-sina.net

23. Paul Ricoeur, *Freud and Philosophy: An Essay on Interpretation*, New Haven and London: Yale University Press, p. 3.

24. Ibid., p. 493.

25. Ibid., pp. 496–97.

Chapter 8. The Theatre of Cruelty

1. Sigmund Freud, '"A Child is Being Beaten": A Contribution to the Study of the Origin of Sexual Perversions', *Penguin Freud Library, Vol. 10*, pp. 159–93.

2. *Penguin Freud Library, Vol. 10*, p. 175.

3. *Penguin Freud Library, Vol. 10*, p. 187.

4. Freud used the terms 'das Ich', 'das Über-Ich' and 'das Es' ('the I', the 'over-I' and 'the it'). Bruno Bettelheim, in *Freud and Man's Soul*, 1982, argues that, although Freud sanctioned the standard English translation replacing the familiar vernacular pronouns with Latin ones, this makes the concepts seem more abstract and technical, thereby losing the emotional force of the original; and that the effect of this on the development of psychoanalysis in the English-speaking world has been unfortunate. While I am persuaded by Bettelheim's argument, it seems more appropriate in a book of this nature to adopt the usual English terminology – though I do so with some regret.

5. Sigmund Freud, 'The Ego and the Id', *Penguin Freud Library, Vol. 11*, p. 390.

6. 'Kant with Sade' [1963], *Ecrits*. Freud had actually made this link himself in 'The Economic Problem of Masochism' (1924). Discussing how the super-ego can become 'cruel and inexorable against the ego', he observed that 'Kant's Categorical Imperative is... the direct heir of the Oedipus complex.', Penguin Freud Library, vol. 11, p. 422.

7. Roland Barthes, *Sade, Fourier, Loyola*, Paris: Editions du Seuil, 1971.

8. Camille Paglia, *Sexual Personae*, pp. 230–47.

9. Georges Bataille, *Eroticism*, p. 11.

10. Ibid., p. 91. For a compelling attack on Bataille's assimilation of Sade's thinking to his own, see Annie Le Brun, *Sade: A Sudden Abyss*, trans. Camille Naish, San Francisco: City Lights Books, 1990, pp. 89–93. For a development, but in a sense complete reversal, of Bataille's perspective on sacrifice, see René Girard, *Things Hidden Since the Beginning of the World*, trans. Stephen Bann and Michael Metter London and New York: Continuum, 2003 and *Violence and the Sacred*, trans. Patrick Gregory, London and New York: Continuum, 2005.

11. Antonin Artaud, 'The Theatre and Its Double', in *Artaud on Theatre*, ed. Claude Schumacher, London: Methuen, 1989, p. 105.

12. In conversation with the author, August 1998.

13. My, possibly inadequate, translation. The original French reads: 'Le corps est le lieu de tous les marquages, de toutes les blessures, de toutes les traces. Dans les chairs s'incrivent les tortures, les interdits des classes sociales, les violences des pouvoirs, dispersés mais jamais abolis.' http://www.journiac.com/sang/textmarq.html

14. Rachel Rosenthal and Elaine Barkin, 'Conversation in Two Parts with Rachel Rosenthal', *Perspectives of New Music*, vol. 21, no. 1/2, Autumn 1982–Summer 1983, p. 572.

15. Kathy O'Dell, *Contract with the Skin: Masochism, Performance Art and the 1970s*, Minneapolis: University of Minnesota Press, 1998, p. 4. The piece by Burden she refers to is *Shoot* (1971) in which the artist was shot at with a pistol.

16. As with 'sadism', it was Kraft-Ebbing who coined the term 'masochism'. Unlike Sade, however, Masoch was alive at the time, a well-published author on a wide range of topics, and not best pleased to have his name used in this way.

17. Gilles Deleuze, *Masochism; Coldness and Cruelty*, New York, Zone Books, 1991, p. 12.

18. Ibid., p. 33.

19. See Morse Peckham, 'Eroticism=Politics: Politics=Eroticism', in *Victorian Revolutionaries: Speculations on Some Heroes of a Culture Crisis*, New York: George Braziller, 1970, pp. 235–305. The immediate subject is Algernon Charles Swinburne but the implications are far wider.

20. It was at Rose's insistence that the couple's sadomasochistic activities were documented and exhibited in an art context.

21. New Museum, New York, September–December 1994. 'Visiting Hours' was first held at Santa Monica Museum of Art, December 1992.

22. Bob Flanagan, 'Why:', *Re/Search*, People Series: vol. 1, 1993, p. 65.

23. Ibid.

24. In conversation with the author.

25. Quoted in Marie-Laure Bernadac, *Louise Bourgeois*, p. 105, from Paola Ignori, *Entrails, Heads & Tails*, New York: Rizzoli, 1992.

26. This motif appeared as early as 1947. However, the versions of 1987 and 1992 are much more figurative.

27. Shown in the US Pavilion when she represented the USA at the Venice Biennale in 1993. There is a bronze sculpture of the *Arch of Hysteria* (1993), where the figure, still male, is in a slightly different pose, in the National Gallery of Canada, Ottawa.

28. 'Mortal Elements', interview with Pat Steir, *Artforum*, Summer 1993.

29. See Linda Noclin's article using that quotation as its title, reviewing Mieke Bal's book *Louise Bourgeois's 'Spider': the Architecture of Art-Writing*, in *London Review of Books*, 4 April 2002.

30. Literally, 'the delights of the bishops'. Horn's use of French for the title of this work made possible an analogy between *délices* ('delights') and *supplices* ('tortures').

31. *Das gegenläufige Konzert* ('*Concert in Reverse*') (1987).

32. *Rebecca Horn, The Glance of Infinity*, p. 342.

33. We do not know his exact methods of murdering, since they were thought too horrible for publication.

34. See Adrian Stokes, *Painting and the Inner World, including a dialogue with Donald Meltzer*, London: Tavistock Publications, 1963.

35. Norman O. Brown, *Love's Body*, p. 11.

36. Norman O. Brown, *Love's Body*, pp. 9–21. Freud first advanced the idea in his ill-starred foray into anthropology, *Totem and Taboo* (1919). He acknowledged its supra-historical, mythical status in *Moses and Monotheism* (1939).

37. Norman O. Brown, *Love's Body*, p. 15. Brown cites Ortega y Gasset, 'The Sportive Origin of the State', in *Towards a Philosophy of History*, New York: 1941, p. 32.

38. 'Sad and Blue: Gilbert & George interviewed by Gray Watson', *Artscribe International*, no. 65, September/October, 1987.

39. Wilhelm Reich, *The Mass Psychology of Fascism*, New York: Farrar, Straus & Giroux, 1970, p. 344 and Harmondsworth, Middlesex: Penguin Books (Pelican), 1975, p. 375.

Chapter 9. Stories of the Eye

1. Hannah Wilke and Joanna Frueh, *Hannah Wilke: A Retrospective*, p. 52; p. 101, n. 5.

2. Sigmund Freud, 'Three Essays on the Theory of Sexuality', *Penguin Freud Library, Vol. 7*, p. 69.

3. Ibid., p. 81.

4. In an extended footnote near the beginning of Chapter IV of 'Civilization and Its Discontents', *Penguin Freud Library, Vol. 12*, p. 288; and, to a lesser extent, in another extended footnote near the end of the same chapter, *Penguin Freud Library, Vol. 12*, p. 295 ff. Although this was the first published version of the idea, Freud had mooted something very similar in a letter to Wilhelm Fliess as early as 1897. See Editor's notes in *Penguin Freud Library, Vol. 12*, p. 247.

5. See Martin Jay, *Downcast Eyes: The Denigration of Vision in Twentieth-Century French Thought*, Berkeley, Los Angeles, London: University of California Press, 1994, p. 10.

6. My pluralisation of Bataille's title is borrowed from the exhibition 'Fémininmasculin: le sexe de l'art', Centre Georges Pompidou, Paris, 1995–96, which contained a section entitled 'Histoires de l'œil'.

7. It is, among other things, one of the reasons for his use of algebra as a means of formulating psychoanalytic theory. Another motive was to acquire a more scientific status for psychoanalysis. For a forceful attack on Lacan's and other French thinkers' scientific pretensions, see Alan Sokal and Jean Bricmont, *Intellectual Impostures*, London: Economist Books, new ed. 2003.

8. Jacques Lacan, *The Four Fundamental Concepts of Psychoanalysis*, ed. Jacques-Alain Miller, trans. John Forrester, New York: Vintage, 1998, pp. 118–19.

9. Martin Jay, *Downcast Eyes*, p. 530 n. 136.

10. Susan Felleman, 'Dirty pictures, mud lust, and abject desire: myths of origin and the cinematic object – art and artists in the movies', *Film Quarterly*, Fall 2001.

11. André Breton, *Manifesto of Surrealism*, in *Manifestoes of Surrealism*, trans. Richard Seaver and Helen R. Lane, University of Michigan Press: Ann Arbor Paperbacks, 1972, p. 21.

12. Noritoshi Hirakawa, *The Reason of Life*, New York, Deitch Projects, September–October 1998, press release.

13. Laura Mulvey, 'Visual Pleasure and Narrative Cinema' [1973], *Visual and Other Pleasures*, Basingstoke, Hants: Palgrave, 1989. Originally published in 1975 in *Screen*.

14. Ibid., p. 21.

15. Linda Williams, *Hard Core: Power, Pleasure and the 'Frenzy of the Visible'*, London: Pandora, 1990, p. 77.

16. Quoted in Amelia Jones, *Body Art/Performing the Subject*, p. 151.

17. Hannah Wilke and Johanna Frueh, *Hannah Wilke: A Retrospective*, pp. 52–54.

18. Skip Arnold, 'In Conversation with J.S.M. Wilette', 1992, reproduced in Tracey Warr and Amelia Jones, *The Artist's Body*, London: Phaidon, 2000, p. 91.

19. http://www.digitalgirly.com

20. The name was adopted from a review by C. Carr in the *Village Voice*.

21. *Annie Sprinkle Post-Porn Modernist*, p. 109.

22. Ibid., p. 109.

23. James Hillman, *Kinds of Power: A Guide to its Intelligent Uses*, New York: Doubleday, 1995, p. 128.

24. Ibid., p. 128.

25. Tihomir Milovac, *Sanja Iveković: Is This My True Face*, Zagreb: Museum of Contemporary Art, 1998, p. 28.

26. Bojana Pejić, 'Metonymical Moves', *Sanja Iveković: Is This My True Face*, p. 30.

27. Camille Paglia, *Sexual Personae*, p. 33.

Chapter 10. Beauty and Beastliness

1. Marina Warner, *From the Beast to the Blonde. On Fairytales and their Tellers*, London: Vintage, 1995, p. 273.

2. See, for example, Robert Bly, *Iron John: A Book About Men*, 1990; and Angela Carter's screenplay for the film *The Company of Wolves* (1984), based on two short stories from her collection *The Bloody Chamber* (1979).

3. Marina Warner, *From the Beast to the Blonde*, p. 280.

4. Ibid., p. 295.

5. Ibid.

6. Sigmund Freud, 'Über die allgemeinste Erniedrigung des Liebeslebens.' (1912). Translated as 'On the Universal Tendency to Debasement in the Sphere of Love', *Penguin Freud Library, Vol. 7: On Sexuality*, pp. 245–60.

7. Georges Bataille, *Eroticism*, p.140.

8. Ibid., p. 145.

9. Camille Paglia, *Sexual Personae*, p. 16.

10. Umberto Eco, *On Beauty. A History of a Western Idea*, trans. Alastair McEwen, London: Secker & Warburg, 2004.

11. Clark also traced the continuation of the Classical tradition of beauty in Hollywood, but only in relation to women, in his largely pictorial book *Feminine Beauty*, London: Weidenfeld & Nicolson, 1980.

12. Abigail Solomon-Godeau, *Male Trouble. A Crisis in Representation*, London: Thames and Hudson, 1997, p. 7.

13. Germaine Greer, *The Boy*, London: Thames & Hudson, 2003.

14. Umberto Boccioni, Carlo Carrà, Luigi Russolo, Giacomo Balla, Gino Severini, 'Futurist Paintings: Technical Manifesto 1910', in Umbro Apollonio (ed.), *Futurist Manifestoes*, London, Thames & Hudson, 1973, p. 31.

15. This notion was first raised in *Nadja* (1928) and later developed in *L'Amour Fou* (1937).

16. Wendy Steiner, *Venus in Exile: The Rejection of Beauty in 20th-Century Art*, Chicago: The University of Chicago Press, 2001. Steiner also laments the contempt apparent in modern art for the domestic, so that there are times when one wonders whether her exiled goddess is closer to the figure of Vesta than to Venus.

17. Jeremy Gilbert-Rolfe, *Beauty and the Contemporary Sublime*, New York: Allworth Press, 1999, p. 41.

18. Interview with Hugh Cuming, *The Classical Sensibility in Contemporary Painting and Sculpture, Art & Design* profile, London: Academy Editions, 1988, p. 17.

19. For the study of this phenomenon with regard to Nazi art, see Klaus Theweleit, *Male Fantasies*, 2 vols, Cambridge: Polity Press, 1989.

20. Interview with Hugh Cuming, *The Classical Sensibility in Contemporary Painting and Sculpture*, p. 19.

21. Marina Warner, *From the Beast to the Blonde*, p. 371.

22. Julia Kristeva, *Powers of Horror: An Essay on Abjection*, New York: Columbia University Press, 1982. Originally published as *Pouvoirs de l'horreur*, Paris: Editions du Seuil, 1980.

23. Julia Kristeva, *Powers of Horror*, p. 4. In this respect, Kristeva largely agrees with Mary Douglas' analysis. See Mary Douglas, *Purity and Danger: An Analysis of the Concepts of Pollution and Taboo*, London and Henley: Routledge & Kegan Paul, 1966.

24. Ibid., p. 71.

Notes

25. 'Of Word and Flesh. An Interview with Julia Kristeva by Charles Penwarden', *Rites of Passage. Art for the End of the Century*, London: Tate Gallery, 1995, p. 24.
26. http://www.johnduncan.org/bd-essays.html
27. Julia Kristeva, *Powers of Horror*, p. 3.
28. The iconography of *Heidi* relates to McCarthy's hyperealist kinetic sculpture *Alpine Man* (1992), in which a man with his trousers down is humping, not a tree as in *The Garden*, but a massive beer barrel.
29. Chiharu Shiota [1999], http://www.chiharu-shiota.com/work99a.html. My translation.
30. Joanna Frueh, *Erotic Faculties*, Berkeley, Los Angeles, London: University of California Press, 1996, p. 143.
31. See Helena Reckitt and Peggy Phelan (eds), *Art and Feminism*, London: Phaidon, 2001, pp. 166–67.
32. 'Franko B interviewed by Gray Watson', in B, Franko et al., *Franko B: Oh Lover Boy*, London: Black Dog, 2001.
33. Julia Kristeva *Powers of Horror*, p. 27.
34. Ibid.
35. Sondra Horton Fraleigh, *Dancing into Darkness. Butoh, Zen and Japan*, Pittsburgh: University of Pittsburgh Press, 1999, p. 6.
36. Elaine Scarry, *On Beauty and Being Just*, London: Duckworth, 1999, p. 96.
37. James Hillman, ed. Thomas Moore, *The Essential James Hillman: A Blue Fire*, London: Routledge, 1990, p. 298. Hillman is in almost total agreement with Kristeva on the necessity of keeping the psychic wound open. See, for example, Chapter 7 'Pathologizing: The Wound and the Eye', in *A Blue Fire* and James Hillman, *Re-Visioning Psychology*, New York: Harper Perennial, 1992, especially Chapter 2 'Pathologizing or Falling Apart'. Cf. also Joseph Beuys' admonition to 'show your wound'.
38. James Hillman, ed. Thomas Moore, *The Essential James Hillman: A Blue Fire*, p. 292.
39. Ibid., p. 304.

Bibliography

Abramović, Marina, *Artist Body. Performances 1969–98* (Milan: Charta, 1998)

Abramović, Marina, *Balkan Epic*, ed. Adelina von Fürstenberg (Turin: Skira, 2006)

Araki, Nobuyoshi, *Self. Life. Death.* (London and New York: Phaidon, 2006)

Armstrong, Carol and Catherine de Zegher, *Women Artists at the Millennium* (Cambridge, MA and London: MIT Press, 2006)

Artaud, Antonin, *Artaud on Theatre*, ed. Claude Schumacher (London: Methuen, 1989)

Augé, Marc, *Non-places. Introduction to an Anthropology of Supermodernity*, trans. John Howe (London and New York: Verso, 1995)

B, Franko et al., *Franko B: Oh Lover Boy* (London: Black Dog, 2001)

Barbin, Herculine, with an introduction by Michel Foucault, trans. Richard McDougall, *Being the Recently Discovered Memoirs of a Nineteenth-Century French Hermaphrodite* (New York: Pantheon Books, 1980)

Bataille, Georges, 'The Solar Anus' [1927], in *Visions of Excess: Selected Writings*, 1927 – 1939, trans. and ed. Allan Stoekl (Manchester: Manchester University Press, 1985), pp. 5–9

Bataille, Georges, *Eroticism*, trans. Mary Dalwood (London and New York: Marion Boyars, 1987); originally published as *L'Erotisme* (Paris: Editions de Minuit, 1957)

Benvenuto, Bice, *Concerning the Rites of Psychoanalysis* or *The Villa of the Mysteries* (Cambridge: Polity Press, 1994)

Bernadac, Marie-Laure, *Louise Bourgeois* (Paris, New York: Flammarion, 1996)

Bernadac, Marie-Laure and Bernard Marcadé (eds), *Fémininmasculin: le sexe de l'art* (Paris: Centre Georges Pompidou, 1995)

Bettelheim, Bruno, *Freud and Man's Soul* (London, Penguin Books, 1982)

Blessing, Jennifer et al., *Rrose is a rrose is a rrose: Gender Performance in Photography* (New York: Guggenheim Museum Publications, 1997)

Breton, André, *Manifesto of Surrealism*, in *Manifestoes of Surrealism*, trans. Richard Seaver and Helen R. Lane (University of Michigan Press: Ann Arbor Paperbacks, 1972)

Brown, Norman O., *Love's Body* (Berkeley, Los Angeles, Oxford: University of California Press, 1966)

Buck, Louisa et al., *Cathy de Monchaux* (London: Whitechapel Art Gallery, 1997)

Butler, Cornelia and Lisa Gabrielle Mark, *WACK! Art and the Feminist Revolution* (Los Angeles: Museum of Contemporary Art and Cambridge, MA and London: MIT Press, 2007)

Butler, Judith, *Gender Trouble* (New York and London: Routledge, 1990)

Caplan, Pat (ed.), *The Cultural Construction of Sexuality* (London: Routledge, 1987)

Chadwick, Helen and Marina Warner, *Enfleshings* (London: Secker & Warburg, 1989)

Chadwick, Whitney (ed.) *Mirror Images: Women, Surrealism, and Self-Representation* (Cambridge, MA and London: MIT Press, 1998)

Chich, Cécile, *Klonaris/Thomadaki. Le cinéma corporel. Corps sublimes/Intersexe et intermédia* (Paris: L'Harmattan, 2006)

Cruz, Amanda et al., *Cindy Sherman: Retrospective* (London: Thames & Hudson, 1997)

Deleuze, Gilles, and Leopold von Sacher-Masoch, *Masochism: Coldness and Cruelty and Venus in Furs* (New York: Zone Books, 1991)

d'Harnoncourt, Anne and Kynaston McShine (eds), *Marcel Duchamp* (New York: Museum of Modern Art and Philadelphia Museum of Art, 1973)

Douglas, Mary, *Purity and Danger: An Analysis of the Concepts of Pollution and Taboo* (London and Henley: Routledge & Kegan Paul, 1966)

Dumas, Marlene et al., *Marlene Dumas* (London: Phaidon, 1999)

Eco, Umberto, *On Beauty. A History of a Western Idea*, trans. Alastair McEwen (London: Secker & Warburg, 2004)

Elger, Dietmar (ed.), *Dieter Roth and Dorothy Iannone* (Hanover: Sprengel Museum and Berlin: Holzwarth Publications, 2005)

Emin, Tracey et al.,*Tracey Emin: Works 1863–2006* (New York: Rizzoli, 2006)

Ford, Simon, *Wreckers of Civilisation. The Story of COUM Transmissions & Throbbing Gristle* (London: Black Dog, 1999)

Foster, Stephen et al., *Gina Pane* (Southampton: John Hansard Gallery and Bristol: Arnolfini, 2002)

Freud, Sigmund, *Penguin Freud Library, vol. 7: On Sexuality* (London: Penguin, 1977)

Freud, Sigmund, '"A Child is Being Beaten": A Contribution to the Study of the Origin of Sexual Perversions', in *Penguin Freud Library, vol. 10: On Psychopathology* (London: Penguin, 1979) pp. 159–93

Freud, Sigmund, 'The Ego and the Id', and 'The Economic Problem of Masochism' in *Penguin Freud Library, vol. 11: On Metapsychology. The Theory of Psychoanalysis* (London: Penguin, 1984), pp. 339-426

Freud, Sigmund, 'Civilization and Its Discontents', in *Penguin Freud Library, vol. 12: Civilization, Society, and Religion* (London: Penguin, 1985) pp. 243-340

Frueh, Joanna, *Erotic Faculties* (Berkeley, Los Angeles, London: University of California Press, 1996)

Garidis, Arguéliki, *Les anges du désir: Figures de l'Ange au XXᵉ siecle* (Paris: Albin Michel, 1986)

Gilbert and George and Carter Ratcliffe, *The Complete Pictures 1971–1985* (1986)

Gilbert-Rolfe, Jeremy, *Beauty and the Contemporary Sublime* (New York: Allworth Press, 1999)

Goldin, Nan, *The Ballad of Sexual Dependency*, ed. Marvin Heiferman, Mark Holborn and Suzanne Fletcher (New York: Aperture, 1986)

Goldin, Nan, *Nan Goldin: The Other Side* (New York: Scalo, 1993)

Göttner-Abendroth, Heide, *The Dancing Goddess: Principles of a Matriarchal Aesthetic*, trans. Maureen T. Krause (Boston, MA: Beacon Press, 1982)

Green, Malcolm (ed. and trans.), *Brus, Muehl, Nitsch, Schwarzkogler. Writings of the Viennese Actionists* (London: Atlas Press, 1999)

Greer, Germaine, *The Boy* (London: Thames & Hudson, 2003)

Haenlein, Carl (ed.), *Rebecca Horn: The Glance of Infinity* (Hanover: Kestner Gesellschaft, and Zurich, Berlin and New York: Scalo, 1997)

Hall, Donald et al., *Corporal Politics* (Cambridge, MA: MIT List Visual Arts Center and Boston: Beacon Press, 1993)

Herles, Elizabeth, 'Helen Chadwick, One Flesh: Christian Iconography and Motherhood', *Exposure Magazine*, vol. 2, no. 3, April 1997

Hillman, James, 'Pink Madness, or Why Does Aphrodite Drive Men Crazy with Pornography?', *Spring*, no. 57, special edition 'Archetypal Sex', 1995

Hillman, James, *Kinds of Power: A Guide to its Intelligent Uses* (New York: Doubleday, 1995)

Hillman, James, ed. Thomas Moore, *The Essential James Hillman: A Blue Fire* (London: Routledge, 1990)

Hodges, Kate, 'Acting Like a Sex Machine' *Bizarre*, no. 89, September 2004

Horton Fraleigh, Sondra, *Dancing into Darkness. Butoh, Zen and Japan* (Pittsburgh: University of Pittsburgh Press, 1999)

Hughes-Hallett, Lucy, 'The Battlefields of Love: Insights in the Work of Roberta Graham' in *Performance*, no. 65/66, Spring 1992, pp. 18–27

Hunter, Jack (ed.), *Moonchild: The Films of Kenneth Anger* (New York: Creation Books, 2002)

Irigaray, Luce, *The Sex Which Is Not One*, trans. Catherine Porter with Carolyn Burke (Ithaca, NY: Cornell University Press, 1985); Originally published under the title *Ce sexe qui n'en est pas un* (Paris: Editions de Minuit, 1977)

Jay, Martin, *Downcast Eyes: The Denigration of Vision in Twentieth-Century French Thought* (Berkeley, Los Angeles, London: University of California Press, 1994)

Jones, Amelia, *Body Art/Performing the Subject* (Minneapolis: University of Minnesota Press, 1998)

Juno, Andrea and V.Vale (eds), *Bob Flanagan: Supermasochist* (San Francisco: Re/Search, People Series: vol. 1, 1993)

Karabelnik, Marianne (ed.), *Stripped Bare: The Body Revealed in Contemporary Art* (London and New York: Merrell, 2004)

Kelly, Mary, *Post Partum Document*, with a forward by Lucy R. Lippard (Berkeley, Los Angeles, Oxford: University of California Press,1999)

Kent, Sarah and Jacqueline Moreau (eds), *Women's Images of Men* (London and New York: Writers and Readers Publishing, 1985)

Kim, Yu Yeon, *Translated Acts: Performance and Body Art from East Asia 1990–2001* (Berlin: Haus der Kulturen der Welt and New York: Queens Museum of Art, 2001)

King, Margery, 'Public Faces, Private Parts' <http://www1.uol.com.br/bienal/23bienal/especial/iewa.htm>

Klonaris, Maria and Katerina Thomadaki, 'L'Insaissable/The Ungraspable', in *Performance*, no. 62, November 1990

Koons, Jeff and Robert Rosenblum, *The Jeff Koons Handbook* (London: Anthony d'Offay Gallery, 1992)

Kotik, Charlotte (ed.), *The Locus of Memory: Louise Bourgeois* (New York: Brooklyn Museum, 1994)

Kristeva, Julia, *Desire in Language: A Semiotic Approach to Literature in Art*, ed. Leon S. Roudiez, trans. Thomas Gora, Alice Jardine and Leon S. Roudiez (Oxford: Blackwell, 1989)

Kristeva, Julia, *Powers of Horror: An essay on Abjection*, trans. Leon S. Rodez (New York: Columbia University Press, 1982); originally published as *Pouvoirs de l'horreur* (Paris: Editions du Seuil, 1980)

Lacan, Jacques, *The Four Fundamental Concepts of Psychoanalysis*, ed. Jacques-Alain Miller, trans. John Forrester (New York: Vintage, 1998)

Le Brun, Annie, *Sade: A Sudden Abyss*, trans. Camille Naish (San Francisco: City Light Books, 1990); originally published as *Soudain un bloc d'abîme, Sade* as an introduction to a new version of Sade's *Oeuvres Complêtes* (Paris: Jean-Jacques Pauvert, 1986)

Lebel, Jean-Jacques, 'On the Necessity of Violation' in *The Drama Review (TDR)*, vol. 13, no. 1 (T41), Fall 1968

Lichtenstein, Therese, *Behind Closed Doors: The Art of Hans Bellmer* (Berkeley, Los Angeles, London: University of California Press, 2001)

Lloyd, Fran (ed.), *Consuming Bodies: Sex and Contemporary Japanese Art* (London: Reaktion, 2002)

Mahon, Alyce, *Eroticism and Art* (Oxford: Oxford University Press, 2005)

Mahon, Alyce, *Surrealism and the Politics of Eros: 1938–1968* (London: Thames & Hudson, 2005)

Marsh, Anne, *Body and Self. Performance Art in Australia 1969–92* (Melbourne: Oxford University Press Australia, 1993)

McDonald, Helen, *Erotic Ambiguities* (London: Routledge, 2001)

Mercer, Kobena and Chris Darke, *Isaac Julien* (London: Ellipsis, 2001)

Merck, Mandy and Chris Townsend (eds), *The Art of Tracey Emin* (London: Thames & Hudson, 2002)

Merritt, Natacha, *Digital Diaries* (Cologne: Taschen, 2000)

Milovac, Tihomir (ed.), *Sanja Ivekovic: Is This My True Face* (Zagreb: Museum of Contemporary Art, 1998)

Miller, Geoffrey, *The Mating Mind* (London: Vintage, 2001)

Montano, Linda (ed.), *Performance Artists Talking in the Eighties* (Berkeley, Los Angeles, London: University of California Press, 2000)

Morgan, Stuart and Frances Morris, *Rites of Passage: Art for the End of the Century* (London: Tate Gallery, 1995)

Morris, Gary, 'Hallelujah and Pass the Steak Knife! Cutting up with Ron Athey', *Bright Lights Film Journal*, no. 24 (April 1999)

Moure, Gloria et al., *Ana Mendieta* (Barcelona: Fundació Antoni Tàpies, 1996)

Mueller, Roswitha, *Valie Export: Fragments of the Imagination* (Bloomington and Indianapolis: Indiana University Press, 1994)

Mulvey, Laura, 'Visual Pleasure and Narrative Cinema' [1973], *Visual and Other Pleasures* (Basingstoke: Palgrave, 1989)

Munroe, Alexandra, *Japanese Art After 1945: Scream Against the Sky* (New York: Harry N. Abrams, 1994)

Nixon, Mignon, *Fantastic Reality: Louise Bourgeois and a Story of Modern Art* (Cambridge, MA and London: MIT Press, 2005)

O'Dell, Kathy, *Contract with the Skin: Masochism, Performance Art and the 1970s* (Minneapolis: University of Minnesota Press, 1998)

Orlan et al., *Carnal Art* (Paris: Flammarion, 2004)

Paglia, Camille, *Sexual Personae: Art and Decadence from Nefertiti to Emily Dickinson* (London: Penguin, 1990)

Peckham, Morse, 'Eroticism=Politics: Politics=Eroticism', in *Victorian Revolutionaries: Speculations on Some Heroes of a Culture Crisis* (New York: Geroge Braziller, 1970) pp. 235-305

Pejić, Bojana and David Elliott, *After the Wall: Art and Culture in post-Communist Europe* (Stockholm: Moderna Museet, 1999)

Perchuk, Andrew and Helaine Posner, *The Masculine Masquerade: Masculinity and Representation* (Cambridge, MA and London: MIT Press, 1995)

Petersens, Magnus af et al., *Paul McCarthy: Head Shop/Shop Head* (Stockholm: Moderna Museet and Göttingen: Steidl, 2006)

Petit, Pierre, *Molinier, une vie d'enfer* (Paris: Editions Ransay/Jean-Jacques Pauvert, 1992)

Phillips, Anita, *A Defence of Masochism* (London: Faber & Faber, 1998)

Pichler, Cathrin (ed.), *:Engel :Engel. Legenden der Gegenwart* (Vienna and New York: Springer, 1997)

Pierre et Gilles, *Pierre et Gilles* (Cologne: Benedikt Taschen, 1993)

Prinz, Ursula (ed.), *Androgyn: Sehnsucht nach Volkommenheit* (Berlin: Dietrich Reimer Verlag, 1986)

Quinn, Marc, *Incarnate* (London: Booth-Clibborn Editions, 1998)

Rawson, Philip, *The Art of Tantra* (London: Thames & Hudson, 1973)

Reckitt, Helena and Peggy Phelan (eds), *Art and Feminism* (London: Phaidon, 2001)

Reich, Wilhelm, *The Mass Psychology of Fascism* (New York: Farrar, Straus & Giroux, 1970 and Harmondsworth, Middlesex: Penguin, 1975)

Rheims, Bettina and Serge Bramley, *Chambre Close* (Munich: Gina Kehayoff Verlag, 1994)

Ricoeur, Paul, *Freud & Philosophy: An Essay on Interpretation*, trans. Denis Savage (New Haven and London: Yale University Press, 1970)

Rist, Pipilotti et al., *Pipilotti Rist* (London: Phaidon, 2001)

Riviere, Joan, 'Womanliness as Masquerade', *The International Journal of Psychoanalysis* (IJPA), vol. 10, 1929

Romanyshyn, Robert, *Technology as Symptom & Dream* (London: Routledge, 1989)

Rosenberg, Harold, 'The American Action Painters', *Art News*, December 1952, pp. 22 ff.

Roth, Moira (ed.), *Rachel Rosenthal* (Baltimore and London: Johns Hopkins University Press, 1997)

Ruff, Thomas, *Thomas Ruff Nudes*, with text by Michel Houellebecq (New York: Harry N. Abrams, 2003)

Russ Kirchner, Judith (ed.), *Vito Acconci: A Retrospective 1969 to 1980* (Chicago: The Museum of Contemporary Art, 1980)

Scarry, Elaine, *On Beauty and Being Just* (London: Duckworth, 1999)

Schmitz, Britta (ed.), *Herman Nitsch: Orgien Mysterien Theater Retrospektive* (Cologne: Walter Koenig, 2006)

Schneemann, Carolee, *More Than Meat Joy: Performance Works and Selected Writings* (New York: McPherson & Co., 1979)

Schneemann, Carolee, *Imaging Her Erotics: Essays, Interviews, Projects* (Cambridge, MA and London: MIT Press, 2001)

Schwartz, Ellen, 'Vito Acconci: "I Want to Put the Viewer on Shaky Ground"', *Art News*, Summer 1981

Shinhat, Molly, 'Black History and Desire', *FUSE*, June/July 1990

Simmons, Sherwin, 'Ernst Ludwig Kirchner's Streetwalkers: Art, Luxury and Immorality in Berlin 1913–16', *The Art Bulletin*, vol. 82, no. 1, March 2000

Smith, Barbara T., 'Art and Ceremony', *High Performance*, no. 40, 1987

Solomon-Godeau, Abigail, *Male Trouble: A Crisis in Representation* (London, Thames & Hudson, 1997)

Sontag, Susan, 'Notes on "Camp"' in *Against Interpretation* (New York: Random House, 1990)

Spira, Anthony and Sarah Wilson, *Pierre Klossoski* (London: Whitechapel Art Gallery and Ostfildern: Hatje Cantz, 2006)

Sprinkle, Annie, *Annie Sprinkle Post-Porn Modernist* (Amsterdam: Art Unlimited, 1991)

Sprinkle, Annie, *Hardcore from the Heart: The Pleasures, Profits and Politics of Sex in Performance*, ed. Gabrielle Cody
 (London and New York: Continuum, 2001)

Steiner, Wendy, *Venus in Exile: The Rejection of Beauty in 20th-Century Art* (Chicago: The University of Chicago Press, 2001)

Stokes, Adrian, *Painting and the Inner World, including a dialogue with Donald Meltzer* (London: Tavistock
 Publications, 1963)

Stokes, Adrian, *Reflections on the Nude* (London: Tavistock Publications, 1967)

Theweleit, Klaus, *Male Fantasies*, 2 vols (Cambridge: Polity Press, 1989)

Townsend, Chris, *Francesca Woodman* (London: Phaidon, 2006)

Tsuzuki, Yoichi, *Sperm Palace* (Tokyo: Aspect Corp., 2001)

Vergine, Lea, *Body Art and Performance: The Body as Language* (Milan: Skira, 2000)

Warner, Marina, *From the Beast to the Blonde: Fairytales and their Tellers* (London: Vintage, 1995)

Warr, Tracey and Amelia Jones, *The Artist's Body* (London: Phaidon, 2000)

Watson, Gray, 'Legitimate Journey', *Performance*, no. 18, August/September 1982, pp. 15–16

Weiermair, Peter (ed.), *Das Bild des Körpers* (Schaffhausen: Stemmle, 1993)

Weintraub, Linda (ed.), *Art on the Edge and Over. Searching for Art's Meaning in Contemporary Society 1970s–1990s*
 (Litchfield, CT: Art Insights, Inc., 1996)

Whitford, Margaret, *Luce Irigaray: Philosophy in the Feminine* (London and New York: Routledge, 1991)

Wiedmann, August, *Romantic Art Theories* (Henley-on-Thames: Gresham Books, 1986)

Wilke, Hannah and Joanna Frueh, *Hannah Wilke: A Retrospective* (Columbia, MO: University of Missouri Press, 1989)

Williams, Linda, *Hard Core: Power, Pleasure and the 'Frenzy of the Visible'* (London, Pandora, 1990)

Wilson, Sarah, 'Monsieur Venus: Michel Journiac and Love', in Katie Scott and Caroline Arscott (eds), *Manifestatations
 of Venus: Art and Sexuality* (Manchester and New York: Manchester University Press, 2000), pp. 156–72

Wilson, Sarah, *Evelyn Axell: Erotomobiles* (London: Mayor Gallery, 2003)

Wollen, Roger (ed.), *Derek Jarman: A Portrait* (London: Thames & Hudson, 1996)

Zelevansky, Lynn et al., *Love Forever: Yayoi Kusama, 1958–1968* (Los Angeles: Los Angeles County Museum of Art, 1998)

Index

Abramović, Marina 9, 65, 79, 91, 120; and Ulay 46–47, 79, 84; Rest Energy (1980) 46

Acconci, Vito 5, 9, 12, 48, 91, 110

Adonis 116

Agullo, Thierry 36

Ailey, Alvin 65

alchemy 84–85

Alpern, Merry 105–106; Untitled #2 from Dirty Windows series (1994) 105

angels 82–83

Anger, Kenneth 29, 37, 99

Antoni, Janine 22, 25

Aphrodite (Venus) 57, 68, 79, 117, 123–124

Apollinaire, Guillaume 81–82

Apollo/Apollonian 80, 116, 125

Apuleius 114–115

Arachne 25, 71

Aragon, Louis 52

Artemis (Diana) 79

Araki, Nobuyoshi 2, 12, 53, 94; Untitled from Lucky Hole (1997) 53

Armstrong, Rachel 14

Arnold, Skip 109

Artaud, Antonin 3, 5, 8, 10, 81, 90, 96

Athena 71

Athey, Ron 2, 9, 32, 38, 82, 93–94; Solar Anus (2006) 32

Atta Kim 44, 109

Augé, Marc 59

Axell, Evelyne 18, 59

B, Franko 2, 9, 95, 124; I Miss You (2005) 124

Bachelard, Gaston 15, 84

Bacon, Francis 30, 124

Ballard, J.G. 59, 62, 94, 125

Bamber, Judy 123

Banham, Reyner 59

Barbin, Herculine 36

Bardot, Brigitte 36

Barish, Jonas 112

Barthes, Roland 89

Bataille, Georges 3, 10, 32, 80–81, 87, 89–90, 102–103, 115, 129

Baudelaire, Charles 52, 54, 62, 115

Baudrillard, Jean 59

Bausch, Pina 48–49

Beauvoir, Simone de 17

Bellmer, Hans 1, 3, 9, 89, 102

Benjamin, Walter 52, 54

Benvenuto, Bice 82–83

Bernadac, Marie-Laure 71

Bernini, Gian Lorenzo 74

Berquet, Gilles 94

Betterton, Rosemary 24

Beuys, Joseph 82, 84

Björk 61

Blake, William 72–73, 97

Body Art 4, 7–9

Boltanski, Christian 83

Boty, Pauline 18

Bourdin, Guy 58

Bourgeois, Louise 9–11, 15–16, 25, 45, 49–51, 63, 70–71, 79, 95–96; Fillette (Sweeter Version) (1968–99) 11

Bowery, Leigh 32

Bowie, David 36

Brakhage, Stan 41

Breton, André 2–3, 52, 104, 116

Breuer, Josef 95

Bright, Susie 35

Brontë, Emily 97
Brown, Cecily 44
Brown, Norman O. 8, 12, 25, 49–50, 76, 98
Brus, Günter 9, 90
Burden, Chris 91
Butler, Judith 17, 39
Butoh 8, 124

C.O.Y.O.T.E. (Call Off Your Tired Old Ethics) 55
Cage, John 28
Cahun, Claude 18
Califia, Patrick (Pat) 38
Calle, Sophie 47, 107
camp 37
Canova, Antonio 117
Casetta, Giovanna 120
Castex, Gérard 36
Carnegie, Gillian 11
Carrington, Leonora 18
Castelli, Luciano 36
Chadwick, Helen 13–15, 24, 85, 120; Piss Flower #1
 (1991–92) 15
Chapman, Dinos and Jake 10
Charcot, Jean-Martin 95
Chen Lingyang 23, 64
Chicago, Judy 17, 22, 78
Christ (Jesus) 68, 74, 85
Churchill, Winston 99
Clark, Kenneth 116
Clark, Michael 32
Clemente, Francesco 15, 75–76; Geometrical Lust
 (1985) 75
Cocteau, Jean 115
Collishaw, Matt 64, 70
Communism 98, 119
Conceptual Art 3–4
consumerism 56–58
Corinne, Tee A. 34
Cornwall, Anita 34
Cosey Fanni Tutti 21–22, 54–55; 'Journal of Sex'
 Magazine Action (1978) 54
Cottrell, Honey Lee 35
Courbet, Gustave 104
Coverley, Merlin 54
Crow, Leigh 37
Cui Xiuwen 56
Cunningham, Chris 61

Cunningham, Merce 28
Currin, John 44, 117–118, 120

Dalí, Salvador 89, 112
Damiano, Gerry 55
Day, Josette 115
Debord, Guy 104
Degas, Edgar 54
Deleuze, Gilles 10, 92
Deneuve, Catherine 56
Derrida, Jacques 104
Descartes, René/Cartesian 104
Dick, Kirby 93
Dickson, Jane 53
Dietrich, Marlene 36
Dillon, Kathy 48
Dionysus/Dionysian 80, 82, 125
Duchamp, Marcel 8, 13, 21, 61, 84, 99, 101, 104,
 106–107
Dumas, Marlene 43–44, 108; Stripper (1999) 108
Duncan, John 121–122
Dürer, Albrecht 104
Dwoskin, Stephen 92–93, 111
Dyer, George 30

Eco, Umberto 116
Edelson, Mary Beth 78
Eiblmayr, Sylvia 25
Ekberg, Anita 120
Eliade, Mircea 84, 86
Ellis, Bret Easton 98
Emin, Tracey 48
Eno, Brian 36
Ernst, Max 81
Euripides 80
Export, Valie 21

Fascism 99–100
fashion photography 58
Felleman, Susan 104
Fellini, Federico 68, 120
Feng Jiali 24
Ferenczi, Sandor 67
Fischl, Eric 50–51
Flanagan, Bob 93
Fleury, Sylvie 56
Fluxus 4

Foucault, Michel 33, 36, 104
Fourier, Charles 89
Frazer, James 80
Freud, Sigmund 2–3, 8–9, 11–14, 25, 63, 68, 86–87, 88–90, 94–95, 98, 102
Friday, Nancy 69
Frueh, Joanna 107
Frye, Northrop 72–73
Fujiwara, Takahiro 57
Futurism/Futurists 59, 116

Garbo, Greta 36
Genet, Jean 81
Giacometti, Alberto 54
Gilbert and George 14, 31, 53, 64, 85–86, 98–99; *Cunt* (1977) 99
Gilbert-Rolfe, Jeremy 117, 130
Giorgione 63
Goddess (Great Goddess) 74, 78–79
Goldin, Nan 37, 50–51
Grace, Della (Del LaGrace Volcano) 38; *Tongue in Cheek* (1992) 38
Graham, Roberta 96–98, 123; *Whether the Storm?* (1982) 97
Graham, Martha 65
Grahn, Judy 34
Greer, Fergus 32
Greer, Germaine 116
Grotowski, Jerzy 8
Guatarri, Felix 10
Guderna, Martin 44
Gurianov, Georgy 119–120

Haacke, Hans 117
Hahn, Clarisse 58–59
hair 25, 120–121
Halberstam, Judith 37
Hamilton, Richard 3, 56
Hasegawa, Yuko 57–58
Hatoum, Mona 14–15, 120–121
Heilman, Gloria (Heilman-C) 44
Hemphill, Essex 32–33
Henderson, Victor 77
Hepworth, Barbara 63
Hermes (Mercury) 76, 83
Hijikata, Tatsumi 124
Hiller, Susan 23–24

Hillman, James 57, 110, 113, 125–126
Hirakawa, Noritoshi 105–106
Hitler, Adolf 99
Hockney, David 30
Hoffmann, E.T.A. 61
Horn, Rebecca 45, 71–72, 84–85, 96, 100, 125; *Feathered Prison Fan* from *Der Eintänzer* (1978) 72
Horton Fraleigh, Sondra 124
Houellebecq, Michel 60
Hughes, Langston 32

Iannone, Dorothy 42–43; *I Begin to Feel Free* (1970) 42
Irigaray, Luce 18, 26–27, 104
Ishtar 78
Iveković, Sanja 110–111

Januszczak, Waldemar 75
Jarman, Derek 30–31, 68
Jay, Martin 103–104
Joffe, Chantal 58
Johns, Jasper 28
Jones, Allen 56
Jones, Amelia 48
Journiac, Michel 36, 81–82, 90–91
Julien, Isaac 32–34; (and Sunil Gupta) *Looking for Langston: Nudes with a Twist 1953* (1989) 33
Jung, C.G. 84, 86
Jwala 77

Kahlo, Frida 78
Kali 77–78
Kapoor, Anish 15
Kaplan, Jo-Ann 102–103
Kant, Immanuel/Kantian 2, 89
Katarzyna, Kozyra 123
Kelly, Mary 24
Kelly, Mike 122
Kim, Willyce 34
Kirchner, Ernst Ludwig 54, 112
kitsch 43, 56, 119
Klauke, Jürgen 36
Klein, Melanie 9, 13, 50, 98
Klein, Yves 13, 44
Klonaris, Maria and Thomadaki, Katerina 26–27, 35–36, 83; photograph from series *Angélophanies (The Angel Cycle)* 83
Klimt, Gustav 43

Klossowski, Pierre 89

Kooning, Willem de 13, 44

Koons, Jeff 43, 56–57, 119; *Manet* (1991) 43

Kraft-Ebbing, Richard Freiherr von 89

Kramer, Joseph 77

Krider, Chas Ray 60

Kristel, Sylvia 36

Kristeva, Julia 12, 24, 32, 121–122, 124

Krystufek, Elke 111

Kubota, Shigeko 19

Kusama, Yayoi 20–21, 26

Kulik, Oleg 70, 112

Kundalini 79

Kuspit, Donald 64

L'Isle-Adam, Villiers de 61

Lacan, Jacques/Lacanian 24, 82, 89, 103–104, 113

Lahire, Sandra 34

Lamsweerde, Inez van 112

Lapper, Alison 10, 24

Lang, Fritz 61

Larkin, Philip 7

Lau, Grace 94

Lee, Rona 70

Lee, Sadie 37

Lehndorff, Vera (Veruschka) 64

Leonard, Zoe 123

Leonardo da Vinci 85

Lieberman, Tanya 64

Lin Tianmiao 25

Lisle, Vivien 36, 83

Longo, Robert 62

Loyola, St Ignatius of 89

Lüthi, Urs 36

Lynes, George Platt 32–33

Maccheroni, Henri 11–12

Mack, Rainer 104

Magritte, René 104

Mahon, Alyce 53–54

Manet, Edouard 43, 54

Mann, Sally 112

Mann, Thomas 124

Mao Zedong 98

Mapplethorpe, Robert 9, 12, 31–32

Marder, Malerie 68

Mariani, Carlo Maria 119–120

Marinetti, Filippo Tommaso 59

Markopoulos, Gregory 29

Marković, Milovan 56

Marx, Karl/Marxism 52, 86

Masson, André 89, 102

Masson, Françoise 90

masturbation 110–111

Matisse, Henri 43

Matta, Roberto 14, 89

Maybury, John 30

McCarthy, Paul 13, 69–70, 122; *The Garden* (1991–92) 69

Mekas, Jonas 29

Mendieta, Ana 26, 64–65, 78; *Imagen de Yagul* (1973) 65

Meltzer, Donald 98

menstruation 22–23

Mercer, Kobena 33

Mercury (Hermes) 76, 83

Merewether, Charles 64

Merritt, Natacha 60, 109

Messager, Anette 83

Michelangelo 12

Miller, Geoffrey 71

Millot, Catherine 35

Minelli, Liza 36

Molinier, Pierre 1, 32, 36, 81, 94

Monchaux, Cathy de 125

Monroe, Marilyn 36

Montano, Linda 22

Moorman, Charlotte 4

Morimura, Yasumasa 36–37

Morrisey, Paul 29

Muehl, Otto 90

Mueller, Otto 112

Mueller, Roswitha 21

Mulvey, Laura 26, 106–107

Mustajbasic, Selma 117

Napoleon Bonaparte 98

Neoclassicism/Neoclassical 9, 31, 117, 119

New York Dolls 36

Newhouse, Carol 34

Newton, Helmut 58

Nietzsche, Friedrich/Nietzschean 80–81, 86, 124

Nishimura, Mieko 77

Nishiyama, Minako 57

Nitsch, Hermann 80, 90; *107. Aktion* (2001) 80

Nixon, Mignon 50
Nochlin, Linda 17
Norman, Nadine 55–56
Novikov, Timur 119
nude, tradition of 116–118

O'Dell, Kathy 91
O'Keefe, Georgia 63
Oldenburg, Claes 4
Ono, Yoko 11
Opie, Catherine 38
Oppenheim, Dennis 48
Oppenheim, Meret 18
Orlan 21
Orr, Jill 65, 68
Ortega y Gasset, José 98
Oshima, Nagisa 12
Ouroboros 76
Ovenden, Graham 112
Ovid 71

P.O.N.Y. (Prostitutes of New York) 55
Pacheco, Nazareth 125
paedophilia 39, 111–112
Paglia, Camille 18, 66–67, 89, 107, 113, 116, 129
Paik, Nam June 4
Palmer, Samuel 63
Pan 69
Pane, Gina 9, 90–91
Parker, Pat 34
Pasolini, Pier Paolo 99–100
Peckham, Morse 92
Pejić, Bojana 110–111
Perera, Anoli 25
Performance Art 3–4, 8, 91
Phillips, Peter 56
Picabia, Francis 61
Picasso, Pablo 54
Pierre et Gilles 37
Plath, Sylvia 34
Plumb, Hannah 119
Pollock, Jackson 13
Pop Art 3–4, 18, 56
pornography 1–2, 43, 54–55, 58–59
P-Orridge, Breyer (Genesis Breyer P-Orridge and Lady
 Jaye Breyer P-Orridge) 39
Posener, Jill 35

Posner, Helaine 26, 64
post-structuralism/post-structuralist 7–8
pregnancy 23–24
Pre-Raphaelites 124
Priapus 69
prostitution 53–56
Prouveur, Jean-Marc 31, 53
Pucill, Sarah 34

Quillian, Kathleen 69
Quinn, Marc 10, 24, 117, 119; Another Kiss (2006) 118
Queer theory 28, 39

Raine, Kathleen 72
Ramos, Mel 4
Rauschenberg, Robert 28
Rawson, Philip 74
Rechy, John 53
Reed, Lou 36, 50
Reich, Wilhelm 99, 129
Renoir, Pierre-Auguste 13
Rheims, Bettina 59–60
Richard, Cliff 30
Ricoeur, Paul 86–87
Riefenstahl, Leni 119
Rist, Pipilotti 23
Riviere, Joan 17, 29
Robespierre, Maximilien 98
Robotdoll 60–61
Rodin, Auguste 117
Romanticism/Romantic 9, 79–80, 82, 112
Romanyshyn, Robert D. 61–62
Rose, Sheree 93
Rosenbach, Ulrike 65, 68–69, 79, 82–83
Rosenberg, Harold 8
Rosenthal, Rachel 91; Performance and the Masochist
 Tradition (1981) 91
Roth, Dieter 42–43
Rousseau, Jean-Jacques 89
Ruff, Thomas 60; ma27 (2001) 61
Rule, Jane 34

Saalfield, Catherine Gund 82
Sacher-Masoch, Leopold von 92
Sade, Marquis de 89, 92, 99
St Theresa of Ávila 74
Sartre, Jean-Paul 103

Scarry, Elaine 125
Schechner, Richard 80
Schlegel, Friedrich, von 9
Schneemann, Carolee 9, 19–20, 22–23, 27, 40–42, 60,
 79–80, 108, 127; *Fuses* (1964–67) 41; *Interior
 Scroll* (1975) 20
Schwarz, Arturo 84
Schwarzkogler, Rudolf 90
Serrano, Andres 13
Shakti 65, 68, 77–78
Sherman, Cindy 59, 106, 121
Shiota, Chiharu 25, 122
Shonagon, Sei 77
Shu Lea Chang 61
Sieverding, Katherina 36
Siib, Liina 112
Simmel, Georg 54
Sina, Adrien 85
Slocombe, Romain 94–95
Smith, Barbara 76–77
Smith, Jack 29–30, 37
Smith, Kiki 12–13, 23–24
Snapper, Juliana 93
Socialist Realism 119
Solomon-Godeau, Abigail 116
Sontag, Susan 37
Sophia 78
Spero, Nancy 83
Sprinkle, Annie 2, 21–22, 55, 66, 77, 109–110, 123;
 Sluts and Goddesses Workshop (1992) 22
Staller, Ilona (La Cicciolina) 43
Stehli, Jemima 108–109; from *Flirt* (1999) 109
Steinberg, Leo 74
Steiner, Wendy 117
Stokes, Adrian 10
striptease 107–108
Supervert 70
Surrealism/Surrealists 2–3, 9, 18, 25–26, 52, 54, 61,
 81, 89, 104
Sutcliffe, Peter 96–98
Swinburne, Algernon Charles 67–68
Symbolists 9

Tanning, Dorothea 18, 26
Tantra 74–77
Taylor, Valerie 34
Taylor-Wood, Sam 26, 43, 47

Tenney, James 19, 40–41
Teshigawara, Hiroshi 68
Thew, Anna 42, 127
Thiebaud, Wayne 4
Toulouse-Lautrec, Henri de 54
Toyoura, Masaaki 94
transgression 81
Trülzsch, Holger 64
Tsuzuki, Yoichi 61
Tursic, Ida and Wilfried Mille 58
Tzara, Tristan 3

Uebelmann, Cleo 92
Ulay and Marina Abramović 46–47, 79, 84

VasantaMala Dance Company 65
Vasso, Marco 77
Velázquez, Diego 47
Venus (Aphrodite) 57, 68, 79, 117, 123–124
Vergine, Lea 7–8
Viennese Aktionists 9, 90, 95
Villeneuve, Gabrielle-Suzanne Barbot de 114
Virgin Mary 68, 79
Volcano, Del LaGrace (Della Grace) 38; *Tongue in
 Cheek* (1992) 38

Warhol, Andy 4, 28–29, 36, 56, 60
Warner, Marina 114–115, 120, 126
Wein, Chuck 29
Wesselmann, Tom 4
Westwood, Vivienne 56
Whitman, Walt 30
Wiedmann, August 79–80
Wilde, Oscar 119
Wilke, Hannah 21, 101–102, 107–108, 122–123;
 S.O.S. *(Starification Object Series)* (1974) 122
Wilkinson, Chris 111
Williams, Linda 107
Winckelmann, Johann Joachim 119
Woodman, Francesca 26
Wordsworth, William 67

Yanagi, Miwa 57
Yuskavage, Lisa 118–120

Zaretskaya, Nina 64
Zee, James van der 32–33